T0272363

THE
ESTRANGEMENT
PRINCIPLE

Ariel Goldberg

THE
ESTRANGEMENT
PRINCIPLE

Nightboat Books
New York

Design and typesetting by HR Hegnauer
Text set in Minion and Franklin Gothic
Cover art: Ariel Goldberg, *Triangle Microphone*, archival ink-jet print,
 12x18", 2012

Cataloging-in-publication data is available from the Library of Congress

Nightboat Books
New York
www.nightboat.org

To Jess Barbagallo

A ROUTINE OBSESSION

whoever would constantly make distinctions erasing what ever was possible and creating less blatant statements than what was said before, such as using a knife as a screwdriver, or letter opener as a wedge for an underdeveloped table, which had more to do with "not," than "is," or "is not" than "is not is," the blessed and defiled, and or the oddball exemplifier that would step away from bell curve weather news and remain unmentioned. but still whatever would go about a conversation even if no one heard. it was duty, or at least that is what whatever stated…

—kari edwards[1]

it wasn't a word

but a plosive cluster

burst
through my lips

—Stacy Szymaszek[2]

I had a defining moment on the toilet while looking at a library copy of *Lesbian Words: State of the Art*, an anthology of essays from 1995. I wanted to rip off the cover's LGBT sticker with the gusto of a rebellious streak. I then reasoned such a gesture would tear through a face in the grid of author photos that adorned the book's cover. I stared longer and felt the word "lesbian" in the title transform into an heirloom kept on the mantle of an electronic fireplace, the flames below glowing with the word "queer."

In 2010, I began collecting the phrase "queer art" in all its sweaty megaphone pronouncements. I felt pricked by "queer art," which I heard being uttered all around me in the titles of group shows, dance parties, anthologies, mission statements, press releases. I had to get close to this description, like I get close to frames in museums, breathe on their glass and notice the dust. I wanted to get so close my vision would blur. I was also collecting palpable silences around events that could have used the word "queer" as a descriptor, but didn't. Before this obsession began, I had never taken a class on "queer literature" or "queer art (history)" or "women and gender studies." When I saw academic books that used "queer" in their titles, the word seemed either empty or as unruly as a question mark. I was proud of my roving autodidacticism, but all of a sudden I had to rush.

Where else to theorize but the dance floor? I felt high from the temporary sense of majority on Pride weekend in 2011, amidst the routine marches, parades, and puking. I paid the door fee for Los Homos, a mega-party featuring Bay Area queer DJs that Sinclair helped organize. Celebrating Pride was new to me still and I participated

vigilantly. I offered to buy someone a drink after they told me about their doula training, but they promptly signaled to their date nearby. My notebook became my companion. I scribbled in the large font I use when writing under low light. About how this queer party was not at a queer-owned bar; about how offensive rainbow merchandise sold out of shopping carts can be.

Meanwhile, I danced close to someone dressed in saran wrap with a rainbow painted on their chin like blood drool. Attached to their shaved head were Mardi Gras beads. A haphazard toupee of bird shit. I imagined they had acquired the beads in an underhand lob from a corporate bank's float during the parade. Or they had walked off a lo-fi vampire short film shoot. I wanted the huge letters scrawled in eyeliner on their arms and back to say something profound. I paused to see the letters in staccato lines come into focus; they built the word "beautiful." I felt utterly disappointed. I was into the outfit, but not its caption. Then I saw a duo in black denim shorts and blue denim vests with pins. Their uniform matched my idea of the early 90s, except the rallying cry *Silence=Death* was missing from their pink triangle T-shirts. I danced in a sort of despair and thought about how history gets costumed. How toiling over language feels like transcribing sky-writing made of dotted lines.

The term "queer art" is both persisting and failing at a rapid pace, and for multiple reasons. Different versions of queer float up in this book, and more specific identifiers come into sharper focus. I am piecing together scraps, including the pact of the word queer, to resist the task of definition altogether.

With "queer" as shorthand for the expanding LGBTQITSGNC acronym, wordplay hums in the background. Homoground is a weekly radio podcast in New York.[3] Homobiles is a donation based car service in San Francisco.[4] The Lesbian Lexicon Project takes queer slang words, sets them into a dictionary printed on 8.5 x 11 paper folded four times and bound by one staple.[5] The goal of this road trip game is to riff off word combinations for contagious neologisms. "Queer," in relation to art, constantly reinvents itself. Loosely aligned with a range of identity positions counter to mass culture, "queer" resembles an umbrella one buys that falls apart shortly after a rainstorm. Anything can be interpreted and argued for as "queer."

In fall of 2011, I saw Laurie Weeks perform at San Francisco's RADAR Reading Series that explicitly labels and promotes itself as queer. RADAR also funds a writers retreat and chapbook contest with its non-profit arm muscles. After hearing Weeks's crush-on-straight-best-friend plot line, I hurried to buy her first novel, *Zipper Mouth*. I am hungry for books by dykes, books about dykes.[6] Weeks's writing is unmistakably urgent—the narrative spins and dives with interruptions of letters to her friends and Sylvia Plath. I read her book like I would devour a sandwich on the subway, always hungry to escape the straight world around me. The empathy I felt for Weeks's narrator kept me hooked on a challenge: don't expect her to prevail past unfulfilled longings. Reading the crush-on-best-friend plot line felt like an old band-aid dangling half on, half off a gash on my hand. As if I could banish my own best friend crushes of yore. As if the

reader, in an audience of one, could lift the narrator out of her heartbreak.

But I couldn't just think about the writing in *Zipper Mouth*. I became obsessed with the Feminist Press's choice to place a blurb by Michelle Tea on the back cover and a blurb by Eileen Myles on the front. The blurbs focus on how wide Weeks's expressions of desire manifest in the formal storm of the prose. Myles: "Laurie Weeks's *Zipper Mouth* is a short tome of infinitesimal reach, a tiny star to light the land." Tea: "*Zipper Mouth* is a brilliant rabbit hole of pitch-black hilarity, undead obsession, the horror of the everyday, and drugs drugs drugs."[7] The blurbs themselves don't mention queer or lesbian content outright; instead, these blurb writers' names function as codes. It's possible the Feminist Press used the blurbs because Myles and Tea are friends and contemporaries of Weeks. It's possible the Feminist Press used Myles's and Tea's blurbs as a form of queer marketing. I then admit to myself, I am that market.

So began a period of feeling inundated with the text that lines book covers. On the back of *The Wild Creatures: Collected Stories of Sam D'Allesandro*, I found the category Gay Fiction in the upper-right corner. And then Alvin Orloff's blurb: "This is what queer literature looks like freed from pretension and banality."[8] Suspect Thoughts Press chose to excerpt this sentence to stand alone on the back cover. Orloff's paragraph-long description of the collection is included in the book's interior.[9] I don't know which writers Orloff would malign with "pretension" and "banality," inviting unlimited preconceptions to lurk around the book's outermost edges. There is always good writing and bad writing and then writing that speaks to

you and writing that doesn't. Why is Orloff tempted to let "queerness" get tied up in run-of-the-mill disappointment with the "banal" and "pretentious"? Publicity often reduces its subject to a cringe-inducing cliché. "Queer literature" is clearly not exempt from any sales pitch, yet should this be more or less shocking?

Orloff leaks his disdain for the sappy coming out story. Literature with content that rides the line of "queer" is not inherently shameful to Orloff. He is just being provocative about expanding this supposedly tiny space of "queer literature." But "queer literature" has never been a tiny space. Orloff aims to distinguish D'Allesandro from the cheerleader-type support that sometimes attaches itself to *any* writing that calls itself "queer." In D'Allesandro's bio, the publisher states the brevity of his life, which ended at age thirty-one, when he died of AIDS. Context is to inextricable as blurb is to subjective. Orloff's "queer" signals the language shift heralded by those who adamantly distanced themself from the word "gay" in the early 90s.

In her 1990 essay, "To(o) Queer the Writer—Loca, Escritora y Chicana: Queer Labels and Debates," Gloria Anzaldúa writes "the term lesbian es un problema" because it operates from a white-middle-class norm.[10] Anzaldúa rejects "lesbian" from her multiple perspectives as "a working-class Chicana, mestizo—a composite being, amalgam de culturas y de lenguas—a woman who loves women." While Anzaldúa argues that there are no "lesbian writers," she contends there are specific points of entry, specific moments that make sense as "lesbian perspectives, sensibilities, experiences and topics."[11] Anzaldúa greatly influenced the academic and non-academic use of "queer,"

with her embrace of the word for its inherent multiplicity. Notably, "queer" is put in both verb and adjective form in her essay title. Anzaldúa's title crafts an adjective *from* the verb form as if to promote the dictum action first, description second. The "to(o)" of her title proposes a state of also-ness that appears parenthetical, but is always present. "To(o) Queer the Writer" continues to reflect on the power of self-determination and how it differs from tokenization and the expectations from those who share parts of your perspective to write exclusively from the point of view of that perspective. Anzaldúa documents how she came to revel in the differing experiences of various audiences of her work, which depended on the specificity and also the unpredictability of readers' backgrounds.

I write from a jewish, white, lesbian, trans, middle-class, able-bodied, and united statesian perspective. I started writing this book in the Bay Area and continued writing it in New York City. This book is not finished. Labels function as a starting point from which to disentangle myself, and also to outline the limitations of my perspectives. Sometimes all these perspectives cram into the suitcase of queer. But, I struggle with using just one word. "Queer" has proliferated in usage, all the while aggregating divergent histories. Labeling art and writing "queer" affirms the power of those who are consistently silenced. The decision *not* to label art and writing "queer" could arguably be arrived at through the exact same motivations.

In other words, how much "queer literature" is not being thought of as such because it is both cross-genre and represents multiple subjectivities? None of Renee Gladman's book covers (to date) employ Orloff's phrase

"queer literature." Small Press Distribution, meanwhile, begins its online catalogue copy for Gladman's *Newcomer Can't Swim* with "Fiction. LGBT Studies. African American Studies." How are Gladman's genres and identities acting as both political tools and metadata? Gail Scott's blurb on *Newcomer* tips readers off to lesbian content when she recounts how "two women make love in a restaurant bathroom (and are invited to leave)." Scott is making a joyous public service announcement. In John Keene's blurb on *Newcomer,* he writes of Gladman's "treks through and across variegated, mysterious soulspaces and dreamscapes, troubling the surfaces and boundaries of story and genre." Keene reflects on Gladman's relentless challenging of language's architecture and the spaces that surround language. Evie Shockley writes of *Newcomer*'s "textual world that configures issues of personal agency and social relations in geographical terms."[12] Keene and Shockley, both prominent black writers, do not explicitly describe Gladman's work through the lens of black identity or experience; they exercise their affinity for Gladman's mastery of the cross-genre to zoom in on her resistance to categories derived from form and content.

My act of examining descriptions on a book cover, before, during, and after reading a book, is an artificial exercise in trying to contain a writer and their book. Gladman's body of work resists this exercise. I notice now that I fixated on Scott calling out Gladman's use of lesbian content because I was searching for moments where lesbian sexuality was being articulated in experimental literature. I had a feeling the writer Gail Scott was a dyke when I first read *Newcomer*'s blurbs. But I didn't know. I had no one to

ask. Then I read Scott's book *Heroine*. I borrowed *Heroine* from a dyke. I figured it out pretty fast—and then what? Cheena tells me about a Queer Poetics class they took at Mills College where the whole semester was clouded with the same ping-pong I went through with Scott. I imagine the class's conversation felt like treading water, as if exhausting energy to pass a swim test when promised deep-sea diving.

Why was I not asking, is Scott white? She is. Why was I not asking, is John Keene queer or gay? He is. Why was I not asking, is Evie Shockley straight? I think she is. It feels wrong to say someone *is*, as if I am narrating the end of the story. Social and personal modes of identifying always matter. The question, is the author "queer"?, looms a little bit like gossip and a little bit like survival. At times this question appears like a crucial diversion from the complexity of textual readings. At times this question vibrates with exactly what makes textual readings so complex.

Maggie Nelson's book *The Art of Cruelty: A Reckoning* is categorized as Cultural Studies on the upper-left corner of the back cover. Perhaps in its most blatant moment of "queer content," Nelson confesses to initially dismissing Nao Bustamante's performance *Indig/urrito* for its aura of "identity politics." In the performance, white men in the audience are invited to take a bite of a burrito the artist wears as a strap-on "in penance for 500 years of white-male oppression of indigenous people."[13] Nelson connects her own dismissal of Bustamante's work to Eve Kosofsky Sedgwick's writing on "preemptive dismissal of inquiry into queer issues" in art that deals explicitly with an identity its viewer may or may not share. Nelson argues for experiencing dissonance, via her own transformation from

low expectation to highest praise of Bustamante's satirical command over the enormity of oppressive histories.

What allowed *The Art of Cruelty* to avoid taglines of "queer art" or "feminist criticism" in its marketing? Nelson's Thank You page tipped me off to her queerness for the first time: Thank you RADAR for taking me on a writers retreat. Thank you my love, Harry Dodge, whose name conjured scenes of *By Hook or By Crook* (2001), a film Dodge and Silas Howard wrote, directed and starred in as friends who bonded over their trans-masculinity in San Francisco. In *The Art of Cruelty*, Nelson's queerness is not hidden, but it's also not publicized. What does it mean to pour out gratitude for queers in the back pages of your book but not to be labeled as queer by Norton? Nelson acts as an usher for "queer content" into the mainstream because she is white, cis, and could pass as straight.[14]

When I was rummaging through the San Francisco Public Library's poetry stacks, I encountered Aaron Shurin's *A Door* (2000), and sensed a frightening waft of assimilationist marketing permeating the cover. Perhaps with a straight audience in mind, Talisman House used this version of Shurin's bio: "Nationally recognized for his recent collection of essays, *Unbound: A Book of AIDS* (1997), Shurin was well known among post-Stonewall gay writers before he achieved his current standing in the American poetry community, and his work is considered pivotal within the traditions of both gay writing and innovative poetry."[15] How could a writer even choose aesthetics over identities? I find it unforgivable to treat "gay writers" as a step on a ladder that takes Shurin to the larger, more farcically legitimate stage of the "American

poetry community." I find it unforgivable to separate "gay writing" from "innovative poetry" as if they are two different teams within the same hometown. To announce a divide in communities of readers, by sexuality or by style, acts as a suspicious tactic because it implies the authority of one bland norm a writer should aspire to.

kari edwards pushes beyond the reification of categories as evincing ready-made narratives that represent the commodification of self:

> recently I went to a "I am a _____(fill in
> the blank) and I am beautiful and sexy and I am
> okay with who I am no matter what you say"
> performance. the fill in the blank in this case could
> be any word that describes a category or any group
> of nouns that describe a category that is recognizable
> within the repeatable patterns of situated narratives.
> this is not a judgment. the "I am a _____(fill
> in the blank)?" is a first step in seeing one's self as
> other than formlessness situated in social shame.
> but should this be the stopping point? does it do
> anything more than reinforce the "I" as the ultimate
> achievement, where the endgame is the epiphany
> of late capitalism—to become a consuming self-
> controlling anorexic life form on automatic.[16]

I/eyes unravel to have no comfortable stopping point between these examinations of the explicit and implicit. Or, as Akilah Oliver asks: "In which pocket did I leave that 'I'/ Is 'I' ever a thing to miss, a personage to mourn, if the 'I' still lives in the physical body and is capable of re/articulation? If it desires mirrors? History? Or and then narrative sensibility."[17] The "I" is the slipperiest guise. The

trope of proclamation, at times manifesting in the coming out story (COS), has a lot in common with a blurb writer's task to hint at what "this book is about..." The cover of a book is—at best—a realm of foreplay. Can I tell how it will be to sleep with someone when they shove their tongue in my mouth—can I tell from their breath? And then there are the realities of how publishers represent their authors. Of those times I actually *can't* tell based on promotional materials how it will be to have brain sex with the actual book. Or "who" the author "is." Bios and blurbs suggest an incompleteness, one that propels me to the complexity of kari edwards's life and work. Trace Peterson's essay "Becoming a Trans Poet: Samuel Ace, Max Wolf Valerio, and kari edwards" notes that edwards was "a harsh opponent of identity writing or 'queer literature.'" Trace explains:

> edwards was constantly demonstrating in poems
> how language and the self were implicated in
> capitalism, commodification, and injustice.
> Refusing to see trans identity as transcendent,
> edwards depicted it as alternately embattled and
> unremarkable through tones of exasperation and
> camp humor. edwards's answer to the problems
> of identity writing was to experiment with
> incoherence and fragmentation by using ellipses and
> ungrammatical pauses.[18]

As I work from edwards's literary legacy of "incoherence" and "fragmentation," I notice the way "Trans" stands in front of "Poet" in Trace's title. However, within this naming, there is a disassembling of a smooth trajectory and a resistance to the very terms in use. Trace

writes in *Violet Speech*, "If the boxes shtick gets old and the rules underlying them change, like natural selection, would hurt adapt? Would the ability to be art? . . . Identity is so messy, like an essay."[19]

I never felt interested in writing my COS. Recently I tried to write it, as if for a home science experiment. I had this problem: I found the stories totally uninspiring. Each time I tried to conjure a COS, I came up with a different scenario, where I had a confrontation with a system. I had what felt like too many stories that I couldn't package sleekly. One story was about how most of my friends "came out" before me and I had to befriend them while watching their impatience as I moved in slow motion. As if I was just getting pubic hair at age twenty-two. But does one ever shake being a supposed outsider in a group of supposed outsiders? I am completing this book a decade after being high on painkillers from wisdom tooth extraction and telling my mother that I was deeply in love with Sara Asadullah, whose name now represents my myth of first-love heartbreak. This book continues the performance of catching up. When I started presenting more masculine, being a dyke was presumably written on my body, and the expectation for me to mark "a coming out story" in language faded.

I don't have good plot skills. I adhere to the non sequitur. It's not just that I find my COS boring; *trying* to write these "stories" means facing years of internalized homophobia mixed with the blood on my hands from being a u.s. citizen. Janani Balasubramanian and Alok Vaid-Menon of DarkMatter wrote a piece entitled "The U.S. Is So Behind the Times" after their 2013 solidarity visit to Palestine hosted by alQaws, a queer organization

focused on social and cultural change around gender and sexuality in the context of Palestinian Liberation:

> Many queer folks in Palestine are not actually invested in "coming out" or being "visible." Movement emphasis does not prioritize the ritual of "coming out" and does not pressure Palestinians to "come out" in order to be involved with movement work. People are critical of the idea that there even is a "closet" let alone how the West associates being a "bad" queer with being closeted (repressed) and a "good" queer with being out (liberated?). What is more, coming out narratives rely on the personal choices of individuals — a framework that largely does not make sense for Palestinians who may see themselves as part of a larger family and community structure.[20]

The expectation "to be out" neatly fits within an imperialist narrative of *I am here*. DarkMatter deconstructs the assumptions a "coming out narrative" depends on: that one needs to break with their "straight" past and that sexuality is their only mode of difference from white-hetero-patriarchy. This model does not account for how people are part of extended highly personalized and shifting communities that may or may not coalesce around queerness. Importantly, various communities may need to coalesce around other identifications that may or may not include queerness. DarkMatter utilizes their keen fashion and social media presences to advocate for trans and non-binary people of color, combined with a tour calendar of performance gigs at high profile and grassroots activist venues, combined with poetry-chapbook-fueled fundraising to go beyond a theoretical critique of the

backwash of white supremacy in the ocean of queerness.[21] The dizzying tug of being "out" runs into conflict with the linear narrative arc of a climax to move on from. For me to borrow the coming out story as form, to superimpose the act of completion, would be the highest order of representational blasphemy.

Where does all the writing go that falls through the cracks of the gay niche, experimental poetry, and mainstream fiction? Since the late 70s, New Narrative writing has emerged as one language around this gray area. Robert Glück, a founder of New Narrative, tells Sarah Rosenthal in her book of interviews *A Community Writing Itself: Conversations with Vanguard Writers of the Bay Area*: "I've never published a book with a trade press—they don't want me. But on the other hand, my biggest fiction publications have been in gay mainstream anthologies, most of whose readers are not interested in experimental writing."[22]

I began looking for models of narrative that existed thoroughly in between genre and articulations of identities. I wondered if Pamela Lu's contribution to the online journal *Narrativity* could serve as a resistance to a coming out story:

> First there was this thing, this experience, that I felt myself having at last. I had felt the experience coming on for some time, without knowing quite what it was about to be, what it might resemble, or when exactly it might arrive. Perhaps I had read about it once, glimpsed a description of it catching a character, a familiar protagonist, a stand-in, in its sure, capable hands. . . Then I was sure that it had happened, not

merely to a surrogate, but to me personally, that I had
not only jumped into its hands but entered it in total,
inhabiting its limits with the whole of my being.[23]

Lu's "inhabiting," defined by its limits, is *not* named because it is deeply understood as being a language problem. The reader is invited by the writer to blur into a force of *I can relate to this experience*. In Lu's writing, the vagueness of the unclear pronoun referent is always intentional so as to leave its doors open. Lu writes of having an experience before one learns of how that experience is typically translated into words that may not feel accurate, which explains why her language remains so vague. One could alternate between interpreting Lu's "narrative" as about "realizing" you're queer, and realizing you're a writer—not a fiction writer and not a poet, but something in between. "My Narrative" concludes with the suggestion to "abandon the regret of your current, expiring ghost." One doesn't so much come out as jump into the realm of literary simulacra, bending awkwardly at such tasks of creating a narrator and protagonist.

In order for the coming out story to shatter and reformulate, I had to undo my expectations about ways coming out stories populate the prose of writers who are "queer" identified. I remember seeing Tisa Bryant's *Unexplained Presence* on Syd's bookshelf. The cover features artwork by Wura-Natasha Ogunji, of an outlined nude female figure among drooping half-circle shapes that resemble layered theater curtains. The image is composed with dotted lines of red and turquoise thread on canary-colored paper. The figure's hands cup around her eyes as if building the mental focus of binoculars.[24] At the time,

our unspoken routine consisted of Syd's lending me every book I should read, and these books formed the first bridge I had between my gay life and my writing life. Syd said, no, you can't borrow Bryant's book yet; it just came out. So I borrowed Amanda's copy, when our libraries merged in (one of) the most glorious moments of domesticity. Then I got my own copy to study Bryant's radical mode of captioning. In her own words, she "write[s] what it means to see"[25] while hybridizing criticism, fiction, and poetry all at the same time. The narrative's voice is developed not through one person's story, but through multiple narrators acutely assessing specific pieces of cultural production.

Unexplained Presence changed the way I think. Bryant pushed me to examine the contradictory silences in narratives and images in which black figures hold "a distinct, racialized function"[26] in Eurocentric film, television, and art over multiple centuries of collapsing time. Renee Gladman's publishing project Leon Works categorizes the book as "literature" before its ISBN, not "queer literature," though Bryant is often noticing and expanding silenced ruptures within heteronormativity. The voice of this book takes the reader through a museum with its low lights and hedgehog-shaped climate control machines that keep the art from crumbling. The reader gets to sit on the couch next to Bryant's narrator as they watch a reality TV show involving a historical reenactment where the producers brazenly enter the nineteenth century but treat slavery as an afterthought.

A seemingly straightforward description of Bryant's selected film, television, and visual art begins and resurfaces

in her prose, whether it's following the troubling "Moor" in Virginia Woolf's *Orlando*, that queer classic, or watching the 1985 London riots through the eyes of an interracial open relationship in Stephen Frears's *Sammy and Rosie Get Laid*. Bryant's text explores and resists how black characters who have been "underdeveloped or cut out"[27] function in regenerating and undoing "myths about race, sexuality, and storytelling."[28] Without providing any film stills or reproductions of works of art, Bryant invites readers to layer their reading with internet searching or memory foraging to imagine the visuals that match her prose. This foregrounding of her textual renarrations importantly destabilizes the original work's supposed authority. *Unexplained Presence* slows down reading because it goes back in time while staying in the ever-present moment of witness. Bryant builds referent on squirming referent. She explains to readers in the book's introduction that she will switch between the modes of description and polemic, a methodology of communication with her subjects she compares to the covertness of "lovers" or "spies." The reader sees art with a spotlight on the artifice that originally glued it together.

In the chapter "Under Cover of Darkness," Bryant introduces the characters Younger Sister and Older Sister inside their recently deceased mother's home, where in the early stages of grieving they watch a VHS of François Ozon's *8 Femmes*. The Sisters are frustrated and fascinated with the portrayal of the character Madame Chanel, played by Firmine Richard, who inhabits two roles, maid to the white women of the house and lover to one of those white women. Older Sister has a flashback to a conversation with

her French friend over cocktails: what did the director *mean* by "deliberately using these stereotypes"[29] of a black housekeeper? The friend dismisses the question and so it beats on like the chapter's heartbeat. After the decisive scene where Madame Chanel is exposed as a sapphist (but her white lover isn't) *and* becomes the lead suspect in the murder of the man of the house, Older Sister interjects with a memory of her own:

> Somehow Red Rose is not a sapphist. Older Sister smirks. She too is a sapphist. She remembers the Southie Irish girl from high school who sat on top of the dryer in the basement, asking, *daring*, Older Sister to give her pleasure. She hesitated then, immediately feeling that once the inevitable happened (word got out), and the finger pointed (sapphist!) she would never be seen in the pink-white light of innocence, of youth, as one of two equally culpable participants. Older Sister knew, as she bit her lip and made a move, that she would be seen as inexplicably dark and singularly corrupting.[30]

Bryant similarly contends that Ozon "uses Firmine's body as a shield,"[31] all the while silencing and ignoring the complexity of her character in the film. Bryant's narrators are not shy about interpolating their life experiences as a form of theory. The text swerves away from describing Bryant's subjects in plot summary, character development, and play-by-play to question when and how agency is stripped from representation. Bryant scrutinizes seconds in order to resist the surface image and thus slows down the mode in which art is often both consumed and described.

The reader may or may not be familiar with the source material in Bryant's *Unexplained Presence*, or here, in this collection of art labeled and not labeled as queer. I am tasked with narrating a range of art and writing already present and reverberating in a continuum of interpretations. I use Bryant's devotion to description as a model, as a form of resistance to subjects' ready-made and incomplete representations.

I asked Camille Roy during the Q&A at her RADAR reading in April 2011: what is the role of the coming out story in your writing now that you have been out for years—is it a ghost? How does the coming out story haunt your reading of younger writers, or how do you watch the recurring coming out story as a trope of queerness? It was too many questions to answer, as if one question needed to reproduce maniacally in order to survive. Or this is the scripted version of the question plus my memory trying to enhance the question. Camille paused. The depth of her unspoken thoughts transfixed me. My hand reached out to accept the bacon chocolate chip cookie Michelle Tea offered. I was a vegetarian and I ate it anyway. Camille talked about coming out as the making of a community. It was a tremendous time for her. She implied that it wasn't at all contained in a piece of writing. I began to note the difference between the marketing of queer, and the mentioning of it. It's not always a story—just as "queerness" is not always on the cover but waiting on the pages.

The problem with "queer" as a label to describe art doesn't ever fade away. AA Bronson curated "Queer Cinema from the Collection: Today and Yesterday" in

March 2011 at MOMA. It took an hour and fourteen minutes after he posted the program notes on his facebook page for Barbara Hammer to ask, "Why are all the filmmakers in your curatorial program men?" AA Bronson replied to the brewing controversy: "I am a man, so I only curated men. I propose that they should ask a woman to curate women." Which provoked the response from Ree Dykeulous: "OWN yr separatism and misogyny! Butt no cawllin it queer . . . otherwise tis a tad riDICKulous."[32] The series should have been called "Gay Guys," or something, but it was too late to change the press materials. And "queer" was clearly chosen because it is mod right now; it *is* the now.[33] The phrases "queer art" or "queer literature" or "queer cinema" can be dangerously limiting as a space in language to be inside of—or outside of.

Queer spaces can be fraught with many of the same problems around race and gender and class and ability as supposedly straight spaces. Yet my life and work depend on official and unofficial spaces named as queer. Survival is embedded in the outright mission of separatism. The exuberance is imperfect, impermanent but self-sufficient and strong. A lot is at stake in what spaces you enter and who you spend your time with. What do you have the patience for? Who do you want to be vulnerable around? And who is it you want to flirt and maybe fall in love with? There is always going to be someone who will arrive and need a map. There is always going to be an artist with new work who needs to show that work. There are the spaces that end up being "queer" by virtue of who organizes that space and who is invited to present work there. The codes are often in people's names, and that takes time to learn.

In an email interview, Ted Rees wrote to me about a poetry reading he gave with Kevin Killian, where he reported that "most (if not all) of the writers who showed up were queers . . . but I also wondered why a lot of straight poets and writers didn't show."[34] This reminds me of when I saw Eileen Myles and Stacy Szymaszek billed together in Dia Art Foundation's Readings in Contemporary Poetry, which is invested in bridging poetry and art worlds in the vague echo of the New York School. The pairing made me wonder, how do event organizers treat supposed identities as a theme? I started to become slightly paranoid that the curator, Vincent Katz, paired Myles and Szymaszek together not because of their writing and roles in poetry communities (they have in common directing The Poetry Project), but because of notions of a shared white-lesbian identity. But how could I know? I wasn't even at the reading.

In 2010 I drafted questions like these and emailed artists and writers who identify as queer to see if anyone wanted to chime in. I had the definite feeling that asking these questions about how events were organized and attended was uncool. I realized a few years later that my form letter was not how I would get my answers, even when people did respond generously and beautifully. Those who took the time to divulge their lived experiences often reported an increasing frustration with the practice of categorizing. I asked Paul Mpagi Sepuya: "Can you map the support for your work from a queer arts community as opposed to just an arts community?" To which he responded:

> Almost 100% of the support of my work as I
> began making portraits came from the queer arts

community. Making my own zines, 2005-2007, led to the inclusion of my work in many other collaborative queer zine projects and publications . . . I began showing in group shows; gay subject matter and queer community was the central curatorial focus of all of the shows I participated in. Printed Matter . . . was a VERY queer-friendly institution and played a very large role in getting my work exposure. Over the past few years, as vital as the initial support was, I began to feel a bit suffocated by a single note that seemed to get played over and over again. I want my work to be engaged from formal, methodological, and other angles equally with its queer foundations and am consciously trying to push my exposure and involvement in future shows in that direction.[35]

Questioning "queer art" only seemed to reinstate the labeling practice. I felt like a sloppy performance of the census.

Naming based on identity is at times a necessity, as Barbara Smith's "catalytic" 1977 essay "Toward a Black Feminist Criticism," originally published in the lesbian feminist journal *Conditions*, demonstrates. Smith reflects on this essay in her collected writings published twenty years later: "I felt that it was absolutely necessary to provide a general analytical framework for approaching this just beginning field. Black women writers, especially Black lesbian writers, were virtually invisible in the context of women's literary studies and were also included in only token numbers, if at all, in the context of Black studies."[36] Smith discusses the work of Alice Walker, Zora Neale Hurston, Ann Petry, and Toni Morrison. She also

looks at these authors' work through the lens of how well-circulated reviews and critical writing on Walker, Hurston, Petry, and Morrison fails to see and read the complexity of the subjectivities represented within their work. Smith also critiques the feminist literary theory of Ellen Moers and Patricia Meyer Spacks, both of whom had books released in the late 70s that only discussed white women writers in the body of the text. Smith notes that within these tomes "there is absolutely no recognition that Black and female identity ever coexist."[37] Smith shows how critics (broadly identified as white male, black male, white female) dismiss texts as a way to deny the labor of in-depth readings. The essay fittingly ends with Smith's close reading of the lesbian undertones in Morrison's *Sula*, a book that had never before been interpreted publicly that way. Smith has made space for black, feminist, and lesbian writers by naming these identifiers; she has also produced over four decades of writing and publishing under this critical lens.

Journals, anthologies, and group shows are often where space is most visibly initiated and sustained for artists and writers who are at the margins. Anthologies have always wrangled with questions of representation and exclusion. As Elizabeth Alexander writes, the gathering impulse of who's in and who's out is more a portrait of the editor than anything else. To conclude her essay "The Black Poet as Canon-Maker: Langston Hughes and the Road to *New Negro Poets: USA*," Alexander contends, "the anthology offers a vision of the creative landscape a writer wishes to live in and wants to foster. The anthology is akin to the living room: the inner self revealed through the presentation of the representative space."[38]

Trans, as an identifier, splinters off from queer but remains equally impossible to define as a group, despite ongoing attempts. Trace Peterson and TC Tolbert state, in their 2011 call for submissions to a provisionally titled *Anthology of Trans and Genderqueer Poetry*, that this will be "the first" of its kind.[39] Transgender Poetry was finally added as a category for the The Lambda Literary Awards (Lammys) in 2016. I wrote this book in a time when there was a battle to simply recognize the existence of "trans poetry."[40] This absence of "trans poetry" as a category in the Lammys was one motivation for Trace and TC to compile their anthology.[41] The necessity of "firsts" stands in contrast to Jen Benka and Carol Mirakove's call for work in 2008 for a *GenXX Anthology* of lesbian writers and artists to "debunk some of the stereotypes of our generation promoted by marketers and pundits, namely, that we are apathetic and that we are passive consumers."[42] Jen and Carol told me in an interview how they pitched a grouping of eight writers and artists to publishers who have a history or mission of publishing LGBT work. One publisher said a lesbian anthology would only sell if you tailor it to "the L-word" crowd. Memoirs are selling. Write a memoir. As I sat in their living room, drinking herbal tea in a yellow *Democracy Now* mug with a graphic of birds flying away from the metal net of a microphone, I was overwhelmed with the impression that in the year 2008, an anthology with a focus on lesbians was deemed not only out of date, but the most undesirable thing on the publishing market. The anthology never did find a publisher.

In a perfect-bound, ISBN sense of the word, my poetry was first published in what Trace and TC titled *Troubling*

the Line: Trans and Genderqueer Poetry and Poetics. I went to the Associated Writing Program (AWP) conference in 2013 to be a part of the anthology's launch, affectionately termed by many as "history in the making." In the corporate hotel complex adjoined to a mall, where the official conference takes place, I lasted a little under three hours roaming the seemingly endless booths and panel discussions. Amanda and I got pleasantly lost along a street of brick houses I was certain all had built-in bookshelves on our way to the offsite reading. We arrived at the gay bar, where a bartender directed us to a back room featuring a miniature stage with a sequin-lined curtain and building-block extensions pressed up to its edge to resemble a catwalk. All-gender signs on computer paper were adhered with scotch tape to the bathroom doors. Two microphones of different heights stood alongside a tall cocktail table to accommodate both taller and shorter readers. Some poets in this thirty-person reading exceeded the five-minute time limit. Someone had to read with laryngitis. Someone couldn't make it. Someone read from an iPad. Someone ordered fish-and-chips while a reader announced with hesitancy, "This is sort of a political poem." I had never been grouped with poets, some I knew, most I didn't, who I became *a part of something* with. But I was distracted by the thought that at least ten writers, *friends*, weren't in the anthology who could have been or should have been for a myriad of reasons.

Jess and I have talked about why he was maybe "rejected" from this anthology because he is more of a playwright than a poet. It's nothing personal. Trace and TC duly note the bounty of amazing submissions they received

and the difficulty editors face in excluding work. Jess then reminds me it's a good thing to not always be included in various forms of cultural production, because it allows a different perspective. I was complaining about Andrew Durbin's eponymous "Queer Division" reading series at the Bureau of General Services, which I was never invited to read in, and fixated on how people I wouldn't call queer *were* invited to read. Rachel pointed out to me he just invited his friends; the word "queer" is often defined by the social. I came to value *not being included* so I could watch myself briefly slip into that pernicious role of policing what is "queer," which doesn't result in making anyone more or less queer.

In 2011, I visited the Invisible-Exports gallery Ridykeulous show "The Hurtful Healer: The Correspondence Issue."[43] Ridykeulous is a collaborative group that mixes humor into the reclaimed slur "dyke" in order to critique and embrace the separation/separatism of lesbians from the greater mainstream art world and its label-based economy. It's a compact mirror of holograms. For The Kitchen's 2007 "Evening with Ridykeulous," the promotional materials sound like the liner notes to a mess hall food fight:

> Founded by artists A.L. Steiner and Nicole
> Eisenman, Ridykeulous is a collaborative effort
> to capsize, contaminate, corrupt, debase, defeat,
> demolish, deprave, depress, destroy, extinguish,
> invalidate, invert, level, overthrow, overturn, pervert,
> poison, raze, reverse, ruin, sabotage, supersede,
> supplant, suppress, topple, tumble, undermine,
> upset, vitiate, and wreck the language commonly
> used to define Feminist or Lesbian art. Borrowing

heavily from subversion, Ridykeulous aims to distill
a cultural moment or tap into the blood and guts of
an underground movement.

The press release for the Invisible-Exports show begins
"Dear World" to introduce the show's text-based pieces on
the theme of irate letter to the editor. Usually one is able
to be jokingly mean if a base layer of intimacy or comfort
already exists. This type of intimacy was not provided like
3-D glasses that I could borrow from the gallery wall.

I gravitated to Ridykeulous's reworkings of the
Guerilla Girls' sarcastic poster detailing "The Advantages
of Being a Woman Artist," which hung above the gallery's
administrative desk. Just as rock stars have their merch
table, Ridykeulous's brand of feminism was for sale at
Invisible-Exports as a T-shirt for $20 and a screen print for
$75. Ridykeulous vandalizes but still keeps recognizable the
original Guerilla Girls poster that lists the *disadvantages*
facing cis-women artists, like "Knowing your career might
pick up after you're eighty" or "Not being stuck in a tenured
track position." Ridykeulous's redo uses handwritten
amendments, in thick cross-outs and margin scribbles to
perform anger that's funny/not funny. And, ta-da: "The
Advantages of Being a Lesbian Artist" reads in the spirit of
teenagers using profanity: "Working without the pressure
of sucking dick" and "Seeing your face live in the pussy of
others." And then a sort of opus collapse in "Fuck You,"
which stands near a whole line redacted to look like a brick
wall lined with a moat. Some items on the list are not even
worth comparative replacement or subtlety. The end result
mouths the historical rupture between white lesbianism
and white straight-feminism.

Ridykeulous uses rage like a horn's blast marks foul play at a sporting event. How does the horn go mute when these watchdogs glide into art world success? Similar to the coming out story, versions of rage, especially rage contained within the bounds of satire, get the spotlight. I want the rageful to stay, but not to be treated as the lead in the play just because they are the loudest. Rage is as much a trope of what gets stereotyped as "queer art" as sexual content, body art, or the fact of the trans and gender non-conformant body.

The "lonely lesbian" is also a trope I'd rather recast as someone searching for their history to better understand their present, characterized in Cheryl Dunye's classic 1996 film *The Watermelon Woman*. Dunye herself plays "Cheryl," a young "filmmaker" who at first stutters at calling herself such. With her best friend, Tamara (Valarie Walker), Cheryl works in a video store where she picks up women and special-orders VHS tapes of films from the 1930s and 40s to research an actress whose name was not even listed in the films' credits; in its place was "Watermelon Woman."[44] We learn that this actress's name is Faith Richardson; her stage name was Fae Richards. Dunye builds the film around finding details of Richards's work and life outside of the little recognition she received for stereotyped mammy roles. Richards acted in the white director Martha Page's films and sang at clubs in Philadelphia. Cheryl also discovers that Richards was a "Sapphic sister." Dunye reveals in the film's credits, "Sometimes you have to create your own history. The Watermelon Woman is fiction."

Throughout *The Watermelon Woman*, Cheryl and Tamara vacillate along the spectrum between affectionate

bickering and serious fighting. The suspense of the film derives not only from the search for Richards's life story, but from the ability of their friendship to survive conflicting views of artistic production and interracial dating. Save for a music-video-esque high-five dance interlude, Cheryl and Tamara appear to be in frequent disagreement. Their friendship's alternating strength and tenuousness has a parallel in the story of Cheryl's constant doubts and struggles to get enough information on Fae Richards to complete the film.

The opening scene shows Tamara and Cheryl working on location as videographers (a side job they share to support their own filmmaking) at a wedding between a black man and a white-jewish woman. Tamara pops up in front of the camera expanding a circular reflector and asks with nudging impatience, "Where do you want it? Where do you want, where you want it?" Perspective is everything. The white photographers are shown bumbling with their heavy sagging equipment. They are quick to steal Cheryl and Tamara's painstaking formation of a large group shot by plopping their lighting equipment right in front of them, to which Cheryl exclaims, "Don't you even see the video equipment? Why don't you just wait your turn?"[45]

Cheryl knows her film "has to be about black women, because our stories have never been told." This film is not only Dunye's first feature but is also known for being the first feature film made by and about a black lesbian. Kara Keeling problematizes this notion of "firsts" in her essay "Joining the Lesbians," where, in writing on *The Watermelon Woman*, she emphasizes: "Each selection of what will be included in the category 'black lesbian,' of

what will be retained from the appearance of an image that is recognizable as 'black lesbian,' is simultaneously an exclusion of those elements that threaten the appearance of 'black lesbian.'"[46] *The Watermelon Woman* is largely about how amazingly challenging it is to make a feature-length film—"nearly 700 individuals and organizations" who helped Dunye are thanked in the credits.

Often Dunye's faux-documentary interviews about Richards end with confrontations about the charged history she is looking for. Tamara criticizes her film scholar uncle for not really knowing anything about women directors. Cheryl confronts the sister of Martha Page (Richards's maybe lover) about her racism and denial of her sister's lesbian relationships. Cheryl's mother corrects her daughter's tone of voice when asking about the clubs she hung out at in the 30s with Fae and all the "weirdos." Shirley Hamilton is the first to tell Cheryl of Fae Richards's real name and about how Richards "used to sing for all of us stone butches" at the clubs. While trying to make a record of a history that has been erased and hidden, Cheryl's camera-facing confessionals, also a hallmark to her 2009 film *The Owls*,[47] punctuate the difficulties in her process. The aloneness that permeates Cheryl's video-diaries feels urgent but temporary, as it's ultimately a tool to build camaraderie with her film's viewers.

When the new white-lesbian employee at the video store, Annie, alerts Cheryl of a black lesbian collection at the C.L.I.T. Archives, they drive up to a parody of the Lesbian Herstory Archives in Brooklyn, New York. MJ, a volunteer played by Sarah Schulman, repeatedly apologizes for the archive's disorganization as she dumps whole boxes out on

a table. Cheryl immediately finds a photo of Fae Richards in the pile. She turns the photo over to read the dedication scrawled on the back to a "special friend," June Walker. This leads Cheryl to Richards's partner of over twenty years. Instead of having the opportunity to interview June, Cheryl is left with a package of ephemera about Richards and arrives at traces of history as opposed to answers. At the C.L.I.T. Archives, Cheryl gets reprimanded for shooting footage of the photographs of Fae.[48] MJ exclaims, "Excuse me, you do not have permission to photograph this. This is confidential. This is a safe space." Cheryl proceeds to hurriedly encourage Annie behind the camera: "I am so glad we came. Get it all."

SIMPLICITY CRAVING

There was a dyke story in one of Max's porn magazines. It was my favorite, but not because I liked it exactly. Reading it by the light of my flashlight was like examining a photograph of dead relatives.

—Camille Roy[1]

Help us poison position.

—Dawn Lundy Martin[2]

I got a speeding ticket from a surveillance camera on my way to what was being talked about as the biggest and most controversial show featuring artists who represented homosexuality. Half a year later, my father handed me a blurry photo he got in the mail with his car's license plate and the amount due. I am willing to confess I harbored a strange enthusiasm for "Hide/Seek: Difference and Desire in American Portraiture." I thought it would be an easy target to exercise the nascent argument of this essay— "it's dangerous to label art queer." The show was curated by Jonathan D. Katz and David C. Ward, two white gay men, and presented an overwhelming majority of gay male artists and subjects. In 2010, "Hide/Seek" was not "new" or historic outside its tenuous government walls and focus on portraiture. It was record-breaking only in terms of how many tax dollars funded it.[3] The show compelled me to ramble through recent histories on my own, not only by way of the curators.

Through interlibrary loan I ordered the catalogue "Extended Sensibilities: Homosexual Presence in Contemporary Art," the New Museum's now trendy sounding 1982 show. Some artists refused to be a part of this show; they refused to be thematized, or to be outed. Then I read the catalogue for the 1995 Berkeley Art Museum/Pacific Film Archive's "In a Different Light," which announced itself as the "first queer art show" that included artists who did not necessarily identify as queer, but the curators interpreted their work as queer. Robert Atkins reflects on how "In a Different Light" "rejected the notion of identity politics in favor of an amorphous notion of queer sensibility."[4] To include artists and writers who

didn't identify as queer was a decision that appeared to Atkins "apolitical" and "over-aestheticized."

A lukewarm form of irrelevance characterized the "Hide/Seek" show in its adherence to a flawed canon. Yet this canon still exuded risk within the context of the National Portrait Gallery. Many arts organizations across the country responded in protest to The Smithsonian Institution's baffling decision to censor David Wojnarowicz's *A Fire in My Belly* from "Hide/Seek," of which I saw an "emergency screening" at San Francisco Camerawork, directly after the work was removed from the show.[5] The super-8 film collages scenes familiar to Mexico City (but not to the tourist) with staged gestures in private tableaus. *A Fire in My Belly* contrasts how violence is performed for the voyeur of mass entertainment (Lucha Libre wrestlers) against emanations of pain (a hand sewing a mouth shut, blood slowly dripping). Destruction and pleasure slowly brew: an effigy of Jesus Christ appears at times with ants crawling on it, as does a flickering view of a person jerking off. The flashing images accumulate into a crescendo of a map of North America burning. Mexico's fire spreads to its northern neighbor. A spinning toy eyeball that opens the film, covered in bulging red veins, combusts. Coins fall into a bowl of blood (splash) and a bandaged hand (ow). Wojnarowicz's visual ingredients mix to tell overlapping stories of how colonialism and capitalism inflict and lick their wounds. Wojnarowicz shot the film between 1986 and 1987; it was left unfinished at the time of his death, in 1992. The film now exists in two versions, one thirteen minutes, the other seven. I sat on the floor of SF Camerawork taking in this work, thinking

about the steady but frantic images of violence and witness refracted onto the standing-room-only crowd.

I had visited SF Camerawork a handful of times already in fall 2010 to see the exhibit "Suggestions of a Life Being Lived," which represents the more common "queer art" show, one at a small non-profit in a city with no shortage of gay and queer culture. I was eager to see a show, as the press release promised, that was "unconcerned with coming-out narratives." In contrast to the looming 1995 precedent of the organizational structure of "In a Different Light," the curators, Danny Orendorff and Adrienne Skye Roberts, wanted to address "how a sense of liberated queerness is pursued and mediated within public spaces and behaviors."[6] Gay Shame protest documentation and Killer Banshee ephemera hung in the entrance to the gallery; records of direct action activism served as the entry point of the show.

Adrienne gave me a guided tour of the exhibition as I interviewed her. I held on to her catch phrase: "What I'm interested in is a queer set of political alliances." I was admittedly flirting a little with Adrienne, and hoping to impress her with my handheld tape recorder. She had mentioned a partner, but I wondered if that also meant an open relationship. When I asked her why, on encountering this show, I felt so frustrated with the phrase "queer art," she told me she could relate. She had just been interviewed for the web series *Culture Wire*, where Meg Shiffler of the San Francisco Arts Commission asked, "What's the show about? What is queer photography?" Adrienne responded: "I don't know. I have a better sense of what queer means to me. Queer art is what makes that sense of queerness

visible."[7] Shiffler's proposition to define something hit as the gravest offense.

When wall texts, press releases, and artist statements are littered with the word "queer," I start to grow suspicious of what the word is trying to say, as if temporarily fooled into the word functioning as a measuring tool. The word "queer" easily loses its gunpowder when used effusively. In what ways can language persist as "radical" when the language is being used in a predictable routine?

My primary apprehension about "Suggestions of a Life Being Lived" was based on the concern that this was the one chance a San Francisco alternative art space gets at a "queer" show, outside the month of June, when there are always multiple "queer art" shows. What did I want from this show? For there to be art with no trace of stereotypical "queerness"? That stereotype is both too wide and too subjective to understand. Knee-jerk associations with queerness are often what shows like "Suggestions" are working to resist. I had to shake that feeling that there wasn't enough space for artists who are queer.

A catalogue for "Suggestions" went to print after the exhibition so that the curators could include their evolving thoughts on the work they'd curated. They reflect on the process of making the exhibit in the contemporary climate of assimilation and violence. Adrienne describes how the illusion of "police officers escorting [gay pride parades] rather than raiding our bars . . . completely denies the reality that there still exists state-sanctioned violence against minority subjects, including queer people, in our cities, on the streets, and through the prison system."[8] Halfway through their conversation, which spans the entire

length of the catalogue, Adrienne says to Danny, "I think we should also talk about our ambivalence towards the category 'queer art.'"[9] I have found this ambivalence toward the category to be its most common characteristic.

When I first saw "Suggestions," I crudely tried to put the work on a spectrum of "queer content" to imagine *if* a curator of a "queer art show" ever evaluated how much "queerness" was in a work. The show was organized around themes such as the public sphere, intentional communities, utopia, and self-determination. Kirstyn Russell's large-scale photos of landscapes are whispers of "queer content." Her photo series *Where We Are Not Known* features gay bars or building exteriors with traces of a word that can be read as queer, even if only by the recontextualizing frame of the camera. The "Dyke" on signage for a store shows a fraction of a business owner's last name. I imagine how people may watch Russell when she is constructing or finding gay signposts, how that live action of cropping is a quiet but powerful performance. The viewers in the gallery, when looking at the pictures framed on the wall, stand removed from the scene. But postcards of the images, on a rack free for the taking, are ready to travel outside the gallery. Aay Preston-Myint represents a seemingly louder version of "queer content" with *SMILE II*, a photobooth installation that "invites visitors to imagine themselves within a post-apocalyptic family portrait studio where gender and sexuality have become fluid." Crocheted beards, wigs, and other textile costumes made by Preston-Myint reroute gender norms to riff on the conformity underlying the portrait studio. As opposed to Russell's finished photos, visitors must

ultimately produce Preston-Myint's work at the site of the gallery.

The failed endeavor of quantifying queerness calls on the verb capability of "queer" as a lifeline to escape the fixity of an adjective. At least verbs need action to be performed. I have watched the unsavory trends of the art market temporarily crown ever-incomplete versions of "the political" or "the queer" as fashionable. In order for "queer" or "political" to also be risky adjectives, they must fall out of fashion. One cannot control all the language that swarms around art. Especially unrealistic is the possibility of control over which word form (adjective versus verb) is used. I am reminded of the game rock, paper, scissors. An adjective is the paper that covers the rock, suffocating it, a verb the scissors splitting the paper into a new shape. I hope the demarcation of work that critiques hegemonic discourse is not the only work named "political." I like to use the word political to describe work that isn't "counter-whatever-the-culture-is" but hides its opinions—if the art has any at all—and maneuvers to mirror the safety of the status quo.

"Suggestions of a Life Being Lived" does not use the word "queer" or "gay" in the title, nor does "Hide/Seek: Difference and Desire in American Portraiture." I cannot parse the words "difference" and "desire" as euphemism or rejection. Many of the smaller-scale group shows that thematize queerness play effusively with the word queer. For example, San Francisco's SOMArts June 2011 show was named "Queer It Yourself—Tools for Survival." But "Hide/Seek" did not serve an explicit queer community. More than one friend told me that they saw the show with

their parents. The national exhibition brought a discussion to supposedly not "queer" or "gay" spaces or relationships. This gesture to produce "culture" felt dizzying because the national government's dominant culture has been to keep artists who are gay or queer without funding—in other words, to keep artists who are gay or queer as unseen as possible, which ultimately has threatened the most basic survival of artists who are gay or queer, especially those without independent wealth or patrons.

"Hide/Seek" could afford to produce a perfect-bound catalogue that, in its girth, resembles the level in *Super Mario Brothers* when everything is enlarged. Long after the guards gently reminded me the National Portrait Gallery was closing, I studied the show's every decision about how to present information. I was torn between learning new things and feeling frustrated by the curators' blind spots. The wall text, reproduced to face all the plates in the "Hide/Seek" catalogue, is concerned with decoding the "desire" embedded in the portraits by pointing out either that the artist was known to be gay/queer or the subject was gay/queer. Katz and Ward's quantification was that simple, which I find devastating. Berenice Abbott, whose portrait of Janet Flanner adorns the "Hide/Seek" catalogue cover, once responded to questions about her homosexuality with the statement: "I am a photographer, not a lesbian."[10] Abbott vociferously denied "homosexual" framing of both her life and her wide-ranging body of work, which includes New York City in its constant state of transformation, physics textbook illustrations, and portraits of artists and writers in 1920s Paris. Her early portraiture documents what history now refers to as a formidable cadre of

lesbians, though Abbott and her contemporaries did not call themselves that.

The image in "Hide/Seek" that continues to haunt me is Peter Hujar's portrait of Susan Sontag. The wall text reads: "[Sontag] later regretted that she had not spoken more publicly about her lesbianism, but that kind of personal revelation was at odds to her cool analytical tendency."[11] In Hujar's portrait, she is on her back, glancing upward over her shoulder, supremely self-satisfied. Her chest appears almost flat in a ribbed turtleneck. Drips of hardened white paint are visible on the imperfect wall behind her. When writing about this image from memory, I saw endless drafts of paper with messy handwriting strewn about her like a fan, which is actually a photo Annie Leibovitz took of Sontag but I saw it as a double exposure onto Hujar's portrait.

In 2012, Sunita and I made it off the waitlist to see The Builders Association's premier of *Sontag: Reborn*, her adapted journals. A video of an older Sontag plays throughout, talking back to the younger Sontag. Moe Angelos, who has been working as an out lesbian in downtown New York theater since the early 80s, plays Sontag at both ages. The adaptation highlights the entries where Sontag struggled painfully with lovers, soaked up philosophy, wandered helplessly as a prodigy in Europe, and whoops, got married. Having just read the first published journal in the trilogy, I mouthed along to the line I had transcribed into my journal: "My desire to write is connected with my homosexuality. I need the identity as a weapon, to match the weapon that society has against me."[12] I left the play unsure of how to maintain my criticism of Sontag's not being out enough and of the

historical dishonesty of the "Hide/Seek" exhibit's focus on the fulcrum of out versus not out. I started to understand how Sontag came of age in a different time, a time when the word "queer" wasn't actively used as a label to describe a potential aesthetic, a time when she coded a related endeavor with the word "camp."

Sontag's journals send me to an uncomfortable memory of seeing Leibovitz's retrospective at the Brooklyn Museum in 2007. Looking at the many pictures of Sontag felt like I'd suddenly found a yellowing lesbian newsletter past its heyday of circulation. Sontag is pictured in bed, in a bath, in the hospital, on vacation. Leibovitz also shot still lifes of Sontag's literary traces, such as an early apple computer alight with a chapter to her book *The Volcano Lover*. Standing in the galleries, facing the photos on the wall, I learned for the first time that Sontag was staring into Leibovitz's camera as her lover. I strained to remember my photography history classroom, the lights turned off, where a slide projector hummed next to my guide, Shelley Rice, who thrives on adding brassy gossip to her memorized lectures. I couldn't recall if Shelley digressed into a story about Sontag and Leibovitz. It was much easier for me to associate the slides of Claude Cahun's self-portraits with lesbian history than Sontag's *On Photography*.

I reread Sontag's *New York Times* obituary, which clearly maps her marriage to a man, and their divorce, which, in the scheme of her life, was a blip. In the year of her death, 2004, the *Times* mentioned absolutely nothing about her lesbian partnership. Only an insulting trace: "She was photographed by Annie Leibovitz for an Absolut Vodka ad." *The Believer* ran an article on how divisive the

international-straight-mainstream-media's obituaries were for Sontag: the overtly supportive and then the overtly undermining of her writing and thinking.[13] One point remained united in these obituaries: no mention of her dykehood. I think of AA Bronson, thirteen years Sontag's junior. Bronson's career as a successful gay male artist is credible in the art world. He is a sort of inspiration to mostly young gay male-identified artists, while Sontag is a problem for me to reckon with.

Now that Sontag is dead, her lesbian relationships seem to be all people want to talk about. When Sontag writes, "Being queer makes me feel more vulnerable,"[14] she takes on both the "strange" and the "slur" of the word queer's official definitions. "Queer" sounds quaint in the context of her journals, but Sontag's irresolute relationship with her sexuality and its relationship to her work is far from outdated. I imagine her handwriting as I read her mass-produced journals, the typeset words working like a stencil to help me draw a line between Sontag's choice not to "come out" and the zero pressure I feel to be silent about my sexuality. Sontag's rock-star intellectual status complicates her desire for privacy. Which begs the obvious question: Would she have had so many book contracts with mainstream publishers if she had been "out"?

And then my mom calls to tell me how the Poet Laureate is a lesbian *and* she teaches basic skills English, like I do. She read an article about it in *The New Yorker*. I forgot about this news flash for what felt like a year. When I finally looked up Kay Ryan, Library of Congress, I was surprised to see Ryan's salt-and-pepper hair trimmed in a scruffy James Dean just-back-from-a-whirl-on-a-mountain-bike look.

My butch vocabulary is surprisingly limited. In her author photo, Ryan's fingers rest on her chin in a classic pensive pose while her white shirt pops against the professional photographer's red backdrop. Her blue eyes asked me to *see* her, to which I promptly replied, not just any poet who is also a lesbian is necessarily relevant to me.

But then I was haunted by the question, how does a dyke get to be the Poet Laureate? The obvious answer: she keeps her mouth shut about it. Dogma has its blind spots—how does "lesbian poet" feel in my mouth—this identification doesn't make much sense when applied to Ryan. Sarah Schulman flings me into urgency when she writes in 2009, "Lesbians are being treated as though we are not human and do not deserve representation—in literature or anywhere else."[15] Kay Ryan has plenty of "representation," but she is not explicitly representing "lesbians" with her language. It's not unfathomable for a Poet Laureate to be gay (Elizabeth Bishop). What's unfathomable is for the very lesbian content that I keep problematizing to be present in a Poet Laureate's work. The Library of Congress's description of Ryan on her profile page reads:

> Unlike many poets writing today, [Kay Ryan] seldom writes in the first person. Ryan says: "I don't use 'I' because the personal is too hot and sticky for me to work with. I like the cooling properties of the impersonal." In her poem "Hide and Seek," for instance, she describes the feelings of the person hiding without ever saying, "I am hiding."[16]

I feel suspicious of how distant Ryan's "personal life" is from her work. Ryan is out by virtue of her frequent

reference to her late partner Carol Adair, who died of cancer when Ryan was in residence at the Library of Congress. Ryan dedicates all her books to Carol. In *The Poet's View* documentary, which claims "unprecedented access into the life and work of America's Finest Poets," Ryan says she likes to write "personal poems in such a way that no one has to know *that*." Then, on her plush beige couch, she tells a story about reading the Sunday paper in bed with Carol, who found an Aaron McGruder *Boondocks* comic that happened to quote one of Ryan's poems about the "sustainability" of "waiting."[17]

Ryan's first book of poems, *Dragon Acts to Dragon Ends*, was published in 1983, the year I was born. Ryan's early work was slightly more willing to get into "the hot and sticky." In the poem "Letter from the Front" she writes:

> I have enlisted in a
> disbanded army—always
> attracted to the supernumerary—
>
> . . .
>
> Louise, I am not welcome as I enter the city.
> Mothers do not hold their children up to see me.
> What would be the point of remembering one;
> no single costume is a uniform.[18]

While this poem narrates a tale of a male soldier in some European war, I was eager to read it otherwise. I want to know, who is Louise? She is addressed in the first person, followed by a metaphor about being invisible and misunderstood. "Letter" does not rhyme. The poem has less of a children's book vibe (an oft-cited muse for Ryan) and more a tenor of what adults talk about after the children go to bed. The majority of Ryan's work is devoted to an

air of constancy. As if to intuit there is no unknown in her work, she will choose one poem to read twice at her public appearances, interjecting with explications on the second reading. On the page, I find her poetry's confidence grating. Yet Ryan's banter at readings rouses ample laughter from the audience, mostly because of her lighthearted, self-effacing jokes.

Ryan's poetic language matured to become more vague, as if to unite human behavior with such tidying formal motifs as recombinant rhymes. She adores wisdom derived in hindsight. Her vocabulary includes words like "innocence," "god," "truth," "savior," and "man." In Ryan's poem "Outsider Art" the narrator produces an ars poetica in reverse. The lines react against cluttered art, characterized by such eyesores as "burnt matches" and "glue on charms." The "dense admonishments" that adorn the art are rendered "too small to be read" perhaps because they were written in with the illegible pen of "nail polish."[19] The poem portrays a set of artists who have excessive desire or complaints:

> Most of it's too dreary
>
> or too cherry red.

Ryan mocks the "outsider artists" whose work drips beyond flat two-dimensionality to "the backs of things." I understand this poem as a disparagement of a supposedly uncrafted, undisciplined aesthetic that only gets shown because of the social ties that support it.

> There never
>
> seems to be a surface equal
>
> to the needs of these people.[20]

I have no idea what Ryan means by "Outsider Art" and find this poem to be a confused portrait. Perhaps Ryan

penned the poem after being irritated at what she thinks is bad art in a Marin strip mall café.

I am not interested in going on a journey tracing the label "Outsider Art." Instead, I pause at the word "outsider," as a loaded and derisive term because of its blanket othering of groups of people and stabilizing an unspoken "inside." I wonder if this poem is a way for Ryan to distance herself from stereotypical associations of "Outsider Art" because she came to be a successful poet "outside" of well-trodden routes. Ryan did not take poetry workshops. She never narrates an entry into a social scene of readings to share her work with a local audience, which is the route I see many poets take. Instead, she taught herself writing by doing it every day. For years, she faced rejection from sending poems cold to nationally-established publications and contests. The succinctness of Ryan's poetry aligns with her restricted public persona.

The more I encounter Ryan in interviews repeating the same punch lines, the less and less I care that she is gay. Ryan does claim allegiance to the teachers and students in free and low-cost higher education. She poured her energy as Poet Laureate into the Community College Poetry Project, initiating a National Poetry Day on community college campuses and a website featuring students' work from colleges across the country. She made a point of doing most of her public events when Poet Laureate at community colleges. Ryan and Adair taught for over thirty years at Marin Community College. Ryan identifies as working-class and attributes her success to the education she received at Antelope Valley College in Lancaster, California, which she insists provided a better education than the one she

received once enrolled at the massive UCLA, due to the personal relationships she had with her teachers.

Ryan rejects various poetry establishments in favor of the unpretentious hermit trope of the poet. In doing this, she disassociates herself from being a writer within a community of writers. Ryan admits, "I never read poetry" and "I like to read my poems, but I don't like to hear other people read theirs."[21] At public events, she makes fun of poets as a way of connecting to her audience, which is apparently sparsely populated by poets. I might as well be asking how a poet rises to national recognition in this country—which is relevant to how someone dodges certain notions of identity in their public persona and embraces others.[22] I sense a connective tissue between how Ryan maneuvers around the lesbian label and the poet label and her separateness from their associated, overlapping communities.

More familiar and admirable to me is the poet who embeds in every aspect of their work their systems of survival as dependent on communities of writers. In their essay "Poetry in the 80s," Eileen Myles writes about running The Poetry Project for two and a half years. The sexism and homophobia they dealt with every day defined their experience and influenced how they used their position of power. Myles recalls how Tim Dlugos, who edited the Project's newsletter, ran paintings of his friends who died of AIDS. Readers actually complained, asking what does this have to do with poetry, with The Poetry Project? Myles witnessed the sudden appearance of art galleries and limos in the East Village amidst the neighborhood's cheap rent, homelessness, and crime. Meanwhile, the NEA was figuring out ways to defund the arts by encouraging

non-profit organizations to turn to corporate funders. In "Poetry in the 80s," Myles describes their visit to the Library of Congress to defend The Poetry Project as an organization that (still) serves poets and audiences in ways more infinite than calculable. They document how the Project's programming was read as unknown:

> Tim O'Brien screamed why doesn't anyone
> read Shakespeare anymore. Stanley Elkin [sic]
> in response to the fact that 20,000 people used
> our programs each year—I did the math—had I
> exaggerated. What if it was twenty. What if it was
> two. He screamed is this a literary institution or a
> gymnasium. It gave you sort of a racist feel. More
> bad public smell. The bodies were unavoidable in
> the 80s. That was the problem. Cynthia Macdonald
> raised a list of all the people who had read at the
> Project since 1966. Who are these people she
> screamed and she really did scream. At the break
> everyone calmed down. We walked around and
> schmoozed people we liked which were few.
> Heather McHugh came over to me and explained
> kindly and sweetly I really like street theater. I was
> thinking she meant Nuyorican poets but I really
> didn't know what she meant. I remember her purple
> clothes and that she was nice and meant well. She
> was not them, she was us was what she wanted to
> say. But the flag of us and them had been utterly
> raised over the room and what I had learned was
> the central poetics of American life as I understood
> it was now one stream next to a roiling corporate
> affiliate, the mainstream.[23]

What this stuffy wing of the government snubbed most was the notion that poets could run an organization for poets. Existing outside the mainstream brands, the Project was deemed threatening in its unquantifiable-ness. Poets had taken on a form of self-government. I link this account of Myles's brush with the state's highly exclusionary version of literary support to how they ran for president in 1992 as a performance piece. This intervention might as well have been saying, I'll never be Poet Laureate but I'd rather be the president anyway.[24]

I have a memory of Guillermo Gómez-Peña performing at Charlie Jane Anders's Writers With Drinks series in San Francisco. In between pieces, he told the story of his fraught relationship as a correspondent with National Public Radio's *All Things Considered*. Gómez-Peña reflected on how NPR tried to steer him toward talking *only* about art and culture. Not politics. As if current events aren't an artist's realm of expertise. Similarly, poets put in proximate association with the state are often in a promotional exchange with the state and therefore too compromised to make much of a statement.[25] Barack Obama chose Elizabeth Alexander to read at his first inauguration. Kevin Quashie, in his book *The Sovereignty of Quiet: Beyond Resistance in Black Culture*, examines how Alexander's reading stands as an important moment of "quiet" as opposed to "resistance," which he argues is the dominant expectation of black culture:

> Many people felt underwhelmed by her reading, largely because Alexander is a poet who reads with measured emphasis rather than dramatic performativity. Perhaps she did not match this

moment when the whole watching audience
wanted an expressiveness that would speak to their
excitement, to the historic elation of the country's
first black president, to the hope brimming around
the corner and the desperations lingering in the air.
Perhaps she did not—or even could not—match the
public expectations of the moment.[26]

Four years passed. In the winter of 2013, I heard
the word "poet" spoken on the radio, which felt like a
shocking news story in and of itself. The voice belonged
to Richard Blanco. The interview cut to a clip about his
experience of being invited to read a poem at Obama's
second presidential inauguration:

Of course, the first impulse was—because I was the
youngest, first openly gay, first Hispanic or Latino—
the first impulse was: I have to represent all this in
the poem, and sort of be more of an in-your-face
kind of poem. Then I took a step back from that and
I realized, well, yes, it's all those things, but I think
there's a larger platform here.[27]

The word "first" repeats as if trying to convince Blanco of
something. He is not "the first" of any of these identifications
outside the context of reading a poem at the inauguration.
And so, "the first" becomes contingent on the delivery of
a nugget of literature, not on the literature itself or the life
producing the literature.

I had a dream that Sarah Schulman attempted to clarify
how Ryan's absence of lesbian content is as predictable as a
clock's second hand. Time is upside down. Minutes don't
add up. Things are moving slowly like gravity nodding
its head no. I said what about Eileen Myles's aesthetic of

complete straightforwardness, where the "lesbian" cannot exactly be excised? Schulman demanded eye contact; look at me, "I have been censored because I say what no one wants to hear." I tried to reply, "But it's also how you say it." In the dream, Schulman's voice grew soft after this gust of polemic. "All I really want are for my lesbian protagonists to be with all the other protagonists." I then dreamt of going to my playground of a bookstore and finding the "LGBT section" (or "queer section") gone and Schulman's books shelved in "fiction" and "nonfiction." I panicked. I wanted the section back. I woke up and thought of the Bureau of General Services, with its separate shelves for all the various identity and genre based subdivisions a queer bookstore houses, like neighbors who may or may not say hi to each other.

Then I was actually scouring a used bookstore in Lincoln, Nebraska, for books to help me write this one, on a stop along the cross-country drive that pulled me back to New York. I asked the bookseller to point me to the LGBT section, which was tucked away in the back, a cove akin to the porn section of a video store. I found Schulman's *My American History: Lesbian and Gay Life During the Reagan/ Bush Years* on a stack yet to be alphabetized and shelved. Then I walked across to the poetry section and found a few of Kay Ryan's books. I told Jocelyn Saidenberg about this problem as we sat in the packed audience of a screening for *T'Ain't Nobody's Bizness: Queer Blues Divas of the 1920s.*[28] Jocelyn asked: "Can't we have both?" Ryan and Schulman's books should be located in "both" sections.

Jocelyn was one of the first people to answer my awkward call for interviews about how art is labeled

"queer." She invited me over for dinner in her amazingly adult home. I remember cabinets encasing books, to reduce dust and enhance archival endurance. Jocelyn served me a nourishing vegetable curry while I asked her to tell me about how she came to be a poet in San Francisco. I didn't turn on my tape recorder. I left the conversation understanding how queerness is extremely valuable because she told me about the ways her queerness has been honored, not marginalized. I was shedding my internalized homophobia as she spoke. She recalled being welcomed into the Small Press Traffic poetry community where fellow queers, Kevin Killian and Dodie Bellamy, invited her to read. Jocelyn told me about Kris Kovick and her 17 Reasons reading series at the Red Dora's Bearded Lady Café. Kovick introduced Jocelyn to the audience as a geeky brainy poet—which I translate to mean Jocelyn did not read autobiographical prose. When Jocelyn began curating at Small Press Traffic and later at New Langton Arts, she looked to Kovick as a model for how she brought together different aesthetics at the risk of the audience's discomfort. Five years after this conversation, I emailed to ask about what exactly she learned from Kovick. She wrote about the importance of alliances: Kovick "never championed a particular aesthetic to the detriment of other kinds of writing. She was loyal to her friends and also very inclusive."[29]

Jocelyn's life as a poet, she told me, is really a lot about friendship. I began to understand "queerness" in poetry functioning similarly to the ways friendship unfolds in the life of the writer. At the early stages of writing this book, I read Jocelyn's work fervently because I identified with it. Like my bad experiment to quantify the "queerness" of the

art in the "Suggestions of a Life Being Lived" exhibition, I started to study Jocelyn's poetry by locating the "queer" content as though tracing a map. I was massaging the question of, am I trying to theorize the untheorizable? Jocelyn traverses a range that includes Ryan's feigned "hot and sticky" of lesbian subjectivity in the first person, as well as challenging the gender binary altogether. Jocelyn begins her first book, *Mortal City*, by addressing the process of resisting the impulse to name something:

> this is called
>
> the impermanence of things
>
> of nothing shows
>
> behind the image
>
> except the nail
>
> and the wall[30]

Artistic production is a routine and so Jocelyn's poem shows us the image's backside. In asking how visual representations operate in codes, the narrator turns their attention to the structural support underneath "the image." In the contractual poem entitled "SIGN HERE," Jocelyn instructs the reader to "desert the surface" and "wrestle platitudes."

I do have a theory about Jocelyn's poetry after reading it over the past five years: she steadily uses the language of weather patterns to express how individuals and groups navigate turbulent emotional atmospheres. The narrator in *Mortal City* struggles to activate a singular voice as though lost in a fog; they are studying a place by emphasizing its disparate parts. I pretend to be a meteorologist and find restlessness in Jocelyn's poetics, not unlike the Bay Area's mix of microclimates. Themes

of gender, desire, politics might seem quantifiable, but the writing is more about the permeability of all of the above, like the way glitter sticks on a pillowcase after lightly poking your eyelids.

In Jocelyn's fourth book, *Dead Letter*, she tells the story of Herman Melville's Bartleby the Scrivener from the tormented and inexplicable copyist's point of view, not the boss's. On Jocelyn's terms, Wall Street becomes the stage for a failed romance between the path of least resistance lawyer and Bartleby, whose refusal to work has no perceptible logic. Jocelyn's narrative begins where Melville's story ends, with the realization that Bartleby's previous job was in the dead letter department of a postal service in a time of more robust mail activity. Bartleby announces, "I am the dawn." Then, I am "atmospheric" and finally, "I am as weather shadow cloud and as weather shadow cloud I depart." [31] The poetry chants a reflective opaqueness that suggests cause and effect but resonates instead as fixed generalities of "weather shadow cloud." Sunlight, and the lack thereof, shapes Bartleby as disposable. He dies of a hunger strike in jail. *Dead Letter* circulates around the poetics of fending off and embracing vulnerability and perception after one has received the secret missives of so many bodies through undelivered personal letters.

Jocelyn's context is the fairly insular world of Bay Area experimental poetry. She has published with small presses, which operate with a different type of visibility than Kay Ryan's publisher, Grove Press, does. This is a crude division and one based on the numeric quantifiers: book sales and distribution, grants and awards. I was interested in Jocelyn's work because she accepted my invitation to ask her about

how and why she wrote it. I am always reckoning with the reality that poets are rarely household names in this country and that the relative notion of a queer's invisibility is not so different than a poet's invisibility. For a person who is queer and a poet (among many other "things") their potential "invisibility" becomes a long division equation with a trail of numbers stretching past the decimal point. By invisibility, I do not mean to make visibility the goal; I'm invested more in "invisibility" as an honorable un-doing of the popularity routine. "Visibility" with a capital V often prioritizes the lowest common denominator of the masses as opposed to prioritizing the material needs of a poet who is queer.

This book has been a cover for what feels like many urgent and messy conversations. When I began writing, I was desperate to feel swaddled in dyke mentorship. But I never admitted that to myself, exactly. Instead, I did things like get Judith Butler's haircut. I brought a picture of Butler to Male Image, a barbershop in the Castro. Butler poses as if to end up in the neat grid of a yearbook. Her hair is gray and side parted in a graceful mushroom cut. Her smile complies with conventions of the school portrait studio. I covertly printed the picture at the Academy of Art Writing Center when a student didn't show up for their session to fix grammar mistakes. I ripped the paper around Butler's portrait to make my haircut stamp-size and portable in my wallet. The barber was slightly irritated when I pulled it out; a tension radiated between his scissors and me. Was it that a dyke interfered with the man-on-man vibe of the space? I said the haircut was for a performance. He asked when it was. I said, I don't know, soon.

I retold this story at a holiday party filled to the brim with queers and I felt a sense of victory when the room responded with roaring laughter. Then I felt like I had to start really reading Butler, past her pop song essays. I was relieved when no one quizzed me on Butler's recent work on precarity. I then found a French documentary about Butler, where a soundtrack of klezmer music plays as she attests to not knowing what "queer theory" was until people were telling her she had a hand in making it.[32] She started out in feminism and gender and now adamantly writes a philosophy that considers feminism and gender but is mostly about the dehumanization of people the u.s. is waging war against. Starting in 2013, she became active in the Boycott, Divestment, and Sanctions (BDS) movement for Palestinian Liberation.

Jacqueline Francis's *Making Race: Modernism and "Racial Art" in America* brings up Harold Rosenberg's "famous" question from the 1960s, "Is there a Jewish art?" Francis notes "in subsequent decades many exhibition catalogue writers and survey text authors have taken up the question as well in discussions that answer Rosenberg's query in the negative and simultaneously expanded the notion of Jewish Cultural Production."[33] The questioning of labeling is so firmly planted in history, yet the reappearance of the question isn't exactly redundant. It's like tourists going through the motion of taking the same picture of a beautiful site. Everyone needs their own copy. Why did I pretend, with the flimsiness of a haircut, to look like Judith Butler? I criticize myself now for choosing a famous philosopher to be in imagined dialogue with. She's packaged as a hero, ready to be adored by the newly queer. Why did I study

Jocelyn's writing? Why did I parse Sontag's obituaries? I think about the bizarre façade in ethnic longing. So what if I am drawn to these white jewish lesbians of varying generations away from mine? There was a moment when talking to Jocelyn and reading her work that helped me fit some pieces into place: the legibility of art labeled as queer depends on highly specific localized groups of people and the individuals supporting each other within these communities. "Queer" means little when stripped from its context. There was a moment of trying to reach Kay Ryan through her agent and giving up. I had to remind myself I'm not searching for long-lost family—I'm trying to build my own.

Perhaps it is not that I want to stop critiquing what is called "queer art" but just to recover from being barraged by it. My eyes grow tired when any word repeats. I lose interest. I don't want reinvention. I want more specific language. This particular naming needs a counterpart of always asking about all the art that falls outside the "queer" category that might really be sharing something with this category. When I first began this book, a friend warned me about how I was using the word "scene," not "community," in my understanding of social and artistic landscapes. I asked, "What's the difference?" not yet understanding how cynical and critical the word "scene" sounded. Like I was locked out. But really, I was young(er) and hadn't been in one place long enough to contribute to various communities built around shared interests and experiences. I could only have been compelled to write this book at that acute moment of estrangement.

RICOCHET SHUTTLE

Tapes jammed in the recorder; batteries ran low without my knowledge. Some people spoke too softly to be recorded, or their words were muffled when their clothing rubbed against the lapel microphone which we used. Thus some information was lost and there were gaps in what I recorded despite the fact that the participants were generous enough to answer my questions.

—Aaron H. Devor[1]

The question is banal but one of the real troubles with living is that living is so banal.

—James Baldwin[2]

I decide a rainbow printed on a license plate latched with zip ties between two metal gates isn't a good photo. The outer gate is built of large musical notes; the inner gate like a flattened net of metal. This system protects the square of the window on a tall warehouse door, which is also marked with a numbered address. The scene is recognizable: an industrial street in a neighborhood being rebranded as the center of artistic activity in a city too expensive for most artists to have time to work on their art. The rainbow arches to resemble a scratch-and-sniff sticker more than a gay flag. The paint on the license plate is cracked and filled with gray dirt. I could come back with a zoom lens but I don't have a zoom lens. I could bring the broken ladder from my landlord's side of the basement, but someone might emerge at the moment I would be blocking the door. I could explain that I am just trying to get closer to this license plate, to add it to my collection of pictures that transmit ambivalence about the rainbow flag as a symbol.

When I was looking for videos of poet Judy Grahn, I found her reading "A History of Lesbianism" as a voice-over to a slide show of flags cluttering the front lawn of a house. Variations on the rectangular flag included wind socks and feather shapes; one flag was overlaid with a woman symbol, another with a BDSM symbol. I grew nervous at the sight of the rainbow flag borrowing the united states flag's top corner of little white stars. Anything but patriotism. Grahn's "A History of Lesbianism" was originally recorded on *Lesbian Concentrate: A Lesbianthology of Songs and Poems*, a record of folk music and spoken word made in 1977, organized around an orange juice theme in response to Anita Bryant's antihomosexual "Save Our Children" campaign. I looked

up the record and tried to buy it online for $7 even though I don't own a record player. Then I forgot my ebay password, which was a welcome roadblock to the impulse to buy this song. Knowing is easily confused with owning. I clicked the facebook link below the slideshow to Denise Eaker's page. She has more videos of lawn-flag-displays as part of "Project Flyin Pride," which also makes stamps you can buy to mark your money and tax papers with phrases like "Dyke Dollars," "Lesbian Loot," "Gay Green," "Trans Tender," "Rainbow Revenue," and "Bi Buck."

The ads on the side of the browser made me realize I've never done a product search for a rainbow flag. I was eating half of a carrot muffin I found down the hall from the office I share with a rotating group of other visiting and full-time instructors. Miraculously, I was alone. Though at any moment someone could have walked in to see me staring at a tablecloth of a rainbow flag that is part of a bundle deal with a flag featuring metal holes on its side for easy hanging. I drifted into the default encyclopedia. The flag's history is like the drone of a plane that pulses above a low-toned conversation. The colors hot pink *and* turquoise were removed from the original rainbow flag, which was designed in 1978 by Gilbert Baker for a San Francisco Pride March. Supposedly, there was a shortage of hot pink fabric when the flag became a popular consumer item. The pink stripe represented sexuality. Turquoise, which represented magic and the arts, also got dropped from the common rainbow flag. For a short time in the late 80s and early 90s, a black stripe was added to flags to represent people who died of AIDS.

I read these recent thoughts about rainbow flags out loud at a Queer Detainee Empowerment Project (QDEP)

fundraiser at the Bureau of General Services in New York City.³ Janani Balasubramanian, who at the time worked for QDEP, began their set by commenting on the news that a white man from California had placed a rainbow flag at the top of Uganda's highest mountain. To accompany his action, Neal Gottlieb, the flag erector, wrote in an open letter to President Yoweri Museveni of Uganda: "If you don't like said flag on your highest peak, I urge you to climb up and take it down." The rainbow flag, and all it may represent, is clearly not exempt from imperialist tendencies. However omnipresent the rainbow flag is in the u.s. as a symbol welcoming one to a gay-friendly home, neighborhood or business, it is not at all a universal symbol and it is very dangerous to assume it as such.

Gottlieb was apparently unaware that erecting this flag would not only endanger gay people in Uganda but also resemble violent imperialism. Frank Mugisha, of Sexual Minorities Uganda, and Geoffrey Ogwaro, co-coordinator of the Civil Society Coalition on Human Rights and Constitutional Law opposing the Anti-Homosexuality Act, both made public statements about the brazenness of this act in contrast to their models of activism, which do not even remotely resemble western colonial frameworks.

The pictures I've taken of rainbows that I think of as *good pictures* show the flag as ridiculous or pathetic. The multiflag the length of a fence in front of pine trees guarding a house on Cherry Grove, Fire Island; the flag in an altar in the back patio at El Rio in San Francisco that crumbles like a piece of dirty laundry; the squiggly children's drawing of a rainbow in Gupie's living room in Mexico City; the halfway arch of a rainbow outside a money exchange store in the

tourism district on the way to Gupie's apartment. I wonder if my collection is now complete when I am repelled by the many rainbow flags in Asbury Park, New Jersey, the first suburban context where I saw rainbow flags protrude sturdily from poles affixed to shingles. I felt no interest in photographing them.

What is the relationship of a flag to a word? I want language to be breathable, a room with good circulation. The questioning of "queer" feels all the rage. Carlos Motta's series of film essays *Nefandus*, for example, is designed to explore "pre-Hispanic and colonial monoeroticism and expose the imposition of European categories of knowledge, including sexuality, through violence and force during and after the conquest of the Americas." A screening was organized in March 2014 at Malin Arnell's Brooklyn home, where she hosts The Oncoming Corner, a monthly series described as "a space for sharing our makings, for communizing, for socializing, and for us to think together about what these terms can mean and how we can make use of their potential." After Motta's screening, Arnell's promotional materials promised a discussion "around the seemingly universal use of the term and concept 'queer;' an Anglocentric term and category that is amply used in the Global South often without considering how its conceptual frameworks (Western philosophy and critical studies) can potentially reproduce forms of colonial knowledge."

I glean this information from an email in my inbox. It feels like *I really missed something* because I wasn't there. And that is the feeling I have writing this book—the process of examining the labeling of art queer depends on

both transient social spaces and time to read, to think. I am writing from a moving bus on a slow loop. I wouldn't have time to write if I went to every event ruminating on or evading the word "queer." I barely have time to write because I go to a fraction of events ruminating on or evading the word "queer." The feelings that come from this word replicate or change every time the word is uttered or implied. Often I ramble about how this book takes forever to write and this will in effect expire the ideas.

Inevitably there are moments when a discussion around meaning is attempted, as if to quell certain anxieties about how to live under and with the word "queer." I work towards describing instances in my life, an unwieldy aggregate, to resist over and over again the question *what is queer art.* The offensiveness of this question to define, as opposed to simply align, was discussed at the previous session of The Oncoming Corner by the Norwegian group FRANK and theorist Mathias Danbolt. I could see everyone's face because of the circular formation of our chairs. In the discussion after presentations and break-away group work, one participant recalled the restrictive framing of the panel "Creating Queer/Curating Queer" that was a part of the 2013 Queer New York International Arts Festival.[4] Despite the "what is" question as a form of reduction or containment, *what is* continues to happen like a knee-jerk reaction to the presence of people who hold a particular space that is considered to function outside of a norm.

Queer Nation's Manifesto from 1990 inhabits a different context, the height of the AIDS epidemic, which is not over. This document stands in contrast to the rapidly professionalizing use of queer in the arts. Queer was, then,

a newer word introduced to challenge how overstuffed the word "gay" had become. Their manifesto reclaimed the derogatory:

> Well, yes, "gay" is great. It has its place. But when
> a lot of lesbians and gay men wake up in the
> morning we feel angry and disgusted, not gay.
> So we've chosen to call ourselves queer. Using
> "queer" is a way of reminding us how we are
> perceived by the rest of the world.[5]

Writing on the problem of specifically labeling art queer, I am preoccupied with how much the word "queer" has traveled from a manifesto to the language of the press release. For example, The Shandaken Project Summer Intensive was described as "a week-long, retreat-style conference [that] will investigate how the principles of queer theory can inform contemporary artists and art institutions. Our participants will gather in the early summer in a think-tank environment on our residency grounds."[6] Save for this gathering, The Shandaken Project, a residency founded in 2012, does not have an explicitly queer agenda in its mission statement or publicity, yet clearly supports artists and writers who identify as gay or queer.[7] Every person invited to participate in this "intensive" appears to have a professional role in the arts in New York. The "intensive" I imagine was comprised of people with social ties to Nicholas Weist, the founder of The Shandaken Project. The fact that this residency set up "a discourse" by publicly announcing an invite-only group of thinkers undoubtedly chafed those intellectuals and artists who were not invited. I also hold roles as a highly precarious art "professional" working as an adjunct professor and organizing readings at The Poetry

Project. Yet I resist a wholesale attitude of professionalism, which translates to being publicly uncritical of anything for risk of negative effects to jobs or friends. This suffocating reality seems to both predict and prevent voicing the cringe-inducing moments associated with the word "queer."

Why am I compelled to compare Queer Nation's 1990 manifesto to the events programming for an artist-run residency program that supports the work and lives of artists who are queer? My ideas of words like "activist" or "radical" are as slippery and subject to overgeneralization and romanticization as my critiques of the word "queer." Queer Nation was an outgrowth of ACT UP and began during a time of mass death, when direct action protest was used to win urgently needed health care and government attention. Is it even possible to compare a network of activists who helped achieve funding for drug treatment to an art non-profit? I could easily delete this question and strategically insert the possible answers, citing books written about HIV/AIDS activism and art. I have resisted some academic routines that turn to impersonal information over contact with people who have different life experiences than my own. When I embrace academic routines, I feel like the uncoordinated person mimicking the instructor's movements in an aerobic dance class then quietly walking out of the class. But one must be lucky enough to have mentors or friends to ask these publicly silenced questions that depend on historical and personal perspectives.

The Queer/Art/Mentorship Program (QAM) began its inaugural year in 2011 in New York City. One of the motivations that forged QAM's creation was to make up for the lack of mentors and the difficulty young artists who

are queer might have in finding mentors in part because the AIDS epidemic wiped out a whole generation of artists. QAM hopes to professionalize young artists so they have both the resources to be integrated into their respective "straight" art worlds *and* create self-sufficient queer communities. The official mission statement of QAM reads:

> QAM was founded by Lily Binns and Ira Sachs with the belief that the more vibrant and supported the queer artistic community is, the more porous its boundaries will become, thereby cultivating superior artistry and sustainable creative careers.
>
> Honoring the differences between the generations within the queer artistic community and the diversity of choices, values, esthetics, and opportunities in artists' lives, the program supports a rich communion, working against a natural segregation between generations and disciplines. Its goal is to build an interconnected web of queer artists of all generations and mediums who know each other and each other's work.[8]

At first I was suspicious of QAM's use of the word "career" (half rhymes with "queer"), as I associate the word with always advancing and appeasing a consumer-oriented art market. Mentors choose mentees based on a competitive application. I asked a friend in the program, Xeňa Stanislavovna Semjonová, a series of questions over email. Why did you apply to QAM? What positive experiences did you have in the program? Did the environment of the program ever feel forced? Can mentorship be professionalized? What other "mentors" do you have that emerged more informally, like friendships?

What was it like to work with Geo Wyeth, someone so close in age? Could the Queer/Art/Mentorship exist under any other name? How does the overtly "queer" focus of the organization affect your experience of being a mentee in it?

Xeňa wrote back about how generative it was to be in conversation with other artists in different mediums. She bonded with another mentee, Colin, who works in the adjacent genres of music and performance. Xeňa wrote to me about feeling less alone, less like a "loser" working on her tiny, tidy poems. Her mentorship provided her with deadlines and an audience. This to me seems more something to be jealous than critical of. In relation to the labeling or framework of queerness, Xeňa wrote:

> Well, being "out" is a double-edged sword. I
> come from a former satellite of the Soviet Union,
> Czechoslovakia. All my life when I lived there, my
> father who also happens to be a queer has always
> advocated being closeted. Of course, I would fight
> him on it, but ended up eating my words when the
> 2014 laws came into place under Putin and people
> were placed into prisons, were beaten, raped, or
> simply *disappeared*. My grandmother Eugenia (I am
> named after her) survived the Holocaust through
> hiding, so I don't take "being out" lightly.[9]

Reading about Xeňa's personal context, I am jolted out of the mindset of relative comfort and security I am afforded as a white person in New York City, a city where "being out" is something I often take for granted. I recontextualize my seed of discomfort with QAM's mode of institutionalized mentorship as a program that at the end of the day provides the introduction for intergenerational friendship that might

otherwise not occur within disparate artistic communities and social groups. The professionalism of mentorship is not something new—the entire higher education system is based on this model. At least QAM is completely free for the mentees.

QAM is an outgrowth of Queer/Art/Film (2009–present), a well-attended screening series where an artist introduces a film of their choice at IFC in Manhattan. The film Gregg Bordowitz hosted, *Famous*, was sold out. I tried to get a ticket to another film and sneak in but was told they were patrolling the door to prevent fire hazards. Co-hosts Ira Sachs and Adam Baran have a tradition of asking their guest to discuss how the film is "queer." Carlos Motta, in his introduction for João Pedro Rodrigues's *To Die Like a Man*, joked that he is grateful to be a part of this "queer art" "empire." I read this as both a jab and an embrace of how quickly QAM has developed a complex hierarchical support system for cultural production. Another outgrowth of QAM is Queer/Art/Brooklyn, "a monthly social gathering for queer NYC artists across disciplines (film, literature, performance, visual arts) to gather for drinks and conversation." Three different "queer artists" host the hang out. Trying to lure me into a "meet-up" one night, Dia described it as a party where everyone is nice. Established "queer artists" are available for you to just say hi to. When I finally made it to The West in Williamsburg, the chosen café and bar for the "meet-ups," a hired photographer (or were they an intern—were they a paid intern?) took pictures of people talking. I was never asked permission for my photo being taken. At times I feel in agreement about Motta's naming of QAM as an

"empire." At other times I feel grateful the mentorship program sends an email newsletter about all the artists and writers affiliated with the program. QAM is more invested in fostering interesting art events as opposed to defining "queer art." But I wonder if the twenty-first century arts organization mission has overflowed into the realm where the manifesto used to prowl.

I ran into Vanessa, who works for QAM, on the 6 train in April 2014. We recognized each other because I have been to enough QAM events to be considered a regular. I had just smoked pot on my way to Grand Central from the library in anticipation of the rush-hour crowd and the museum scene. We were both going to see Zackary Drucker and Rhys Ernst's live talk show "You'll Love It!," an event hosted by the Whitney Biennial. Vanessa told me QAM is in the final stages of gaining 501(c) non-profit status. I got her a ticket to the museum with my Pratt ID. We parted ways as I went to find the bathroom, where I paused to take a cell phone photo of the sign.

> About this All Gender Restroom: The Lower Gallery restrooms have been redesignated as "all-gender" for this program. This means that people of all gender identities and expressions are welcome in both restrooms, in the interest of providing a safe and welcoming experience for all visitors, artists, and staff at the Whitney. Gender specific restrooms are available on the second floor.[10]

I emailed the press person at this arts institution to ask why the bathrooms became all-gender only for specific events that were organized or initiated by trans artists and curators in the show. I asked if the Whitney will have

a permanent all-gender bathroom in the future. The new building, which opened in 2015, has several all-gender bathrooms, albeit in inconvenient locations. The press person pointed me to a blog post, which quotes Gordon Hall, who initiated the all-gender bathrooms when planning their Center for Experimental Lectures series in the Biennial. I g-chatted with Gordon from Mexico City to ask about how they succeeded in getting this landmark signage. Minutes before the museum put the "all-gender" sign up for a Lecture series event, Gordon recalled being policed by a woman who thought they were mistakenly in "the Ladies room." After an event, Gordon recalled "a baby queer" thanking them at the sinks, overjoyed about being in an all-gender restroom. Our conversation meandered. I warned Gordon about my uncharacteristic hangover. The night before I really got into posing in a pop-up porn booth at Casa Gomorra, a home and events space for queer and trans-feminist activists. I was satirizing an Amos Mac photo shoot but nobody noticed. Gordon explained the expensive intricacies of building codes: to qualify as an all-gender restroom, the stall needs to go all the way down to the ground, and this is more expensive to build. Furthermore, the codes are different depending on the city and state. Altering current bathrooms or constructing all-gender bathrooms (that are not single stalls) is an incredibly arduous process. We noted how connected the struggle for transgender rights is to the one for interdisciplinarity in art, and lamented how resistant institutions actually are to welcome the breakdown of categories in part because it's too risky for the power structure to dismantle the system of norm and other. Gordon's Experimental Lecture series is

another example of a very "queer" event that has a majority of artists and writers who are queer showing work and in attendance, but the organization does not explicitly name itself as "queer."[11] This seems to be a strategic effort of those with access to not necessarily queer-identified arts institutions to populate those institutions with artists who are queer.

In Spring 2015, I was sitting with Zoe Tuck and Trish Salah behind a table facing a room of mostly Mills College students. We each presented a paper and discussed "Trans Lit Now." We did not name the event that. Trish shared excerpts from her paper "Writing Trans Genres: Emergent Literatures and Criticism" on the "stakes and strategies at work in mapping and periodizing 'emergent' and/or minority literature, and reifications of genre and gender especially where identities appear/disappear though processes of translation."[12] Zoe gave a "trans" reading of Alice Notley's *The Descent of Alette* inside a talk on "mysticism as a traditional recourse for feminine subjects, how the context of publication venue alters the reception of work, and something about ghosts and time travel."[13] I spoke on the ephemeral nature of Jess Barbagallo's performance writing that critiques heteronormative masculinity in contrast to his work as an actor in many downtown theater productions over the last ten years. In the panel discussion, Zoe brought up the crisis of anti-transgender violence and the increasingly high number of murders of transgender women, particularly transgender women of color.[14] How did our paper topics reside inside a larger picture of the complex and ongoing work to end transphobia and transmisogyny? As someone who

does not experience material realities transwomen do, language was failing me. My mind flashed to footage of Sylvia Rivera in Washington Square Park in 1973 at the Christopher Street Liberation Day rally, when she spoke out against transmisogyny, racism, and classism in gay communities. Rivera told the crowd she was fighting with Street Transgender Action Revolutionaries (STAR) "for all of us…not men and women that belong to a white middle-class white club."[15]

My syntax-related inquiries about labeling art queer live inside STAR's history and the ongoing context of people using language to fight oppressive systems. Art is not separate from this fight. As much as "labels and categories"[16] may be used against people, in the context of self-determination, "labels and categories" are at times crucial tools for disseminating experiences and connecting communities. "Labels and categories" elucidate exactly how trans people, particularly trans women of color, fight to gain access to jobs and affordable health care while also fighting to survive amidst being rampantly criminalized by the state. The work that Sylvia Rivera and Marsha "Pay it No Mind" Johnson began, to more contemporary activist groups like the Audre Lorde Project (ALP), Fabulous Independent Educated Radicals for Community Empowerment (FIERCE), and the Sylvia Rivera Law Project (SRLP), to name a few organizations, challenges my rough thinking out loud. I continue listening rather than claiming to understand.

There is no shortage of precedents for thinking about how artistic production today is intertwined with urgent issues not called art but not separate from art, either.

Harmony Hammond reflects on the failures of the 1977 "Lesbian Art and Artists" issue of *HERESIES: A Feminist Publication on Art & Politics*: "To think politically doesn't mean we can't see creatively."[17] In 2012, I walked by the theater in Cherry Grove, on Fire Island, and stopped to talk to several volunteers who announced they were "getting ready to archive." It was the beginning of the off-season and people were preparing to close up their homes and businesses at this gay vacation spot. Inside the theater, folding tables were lined with scripts from plays performed there over the years. I gravitated toward a heap of discarded storage out front, which featured two boxes filled with eight-by-ten plastic frames. I asked if this was trash and the volunteers told me to take whatever I wanted. Each frame was emptied of its original picture. An orange piece of felt was left sandwiched between the plastic and its cardboard back, with a rectangular sweat stain outlining where the photo used to be; its borders announced a lighter orange. I took as many frames as I could carry back on the ferry. I stacked the frames on a shelf in my studio, waiting for the right moment to clean them of dust and mold. I put photos inside the frames under poor lighting, but the frames were so scratched that my photos didn't look good inside of them. I took the photos out. I gave some frames away as gifts. I put one in a show of small objects Alex organized at Molasses Books. I showed Helaine the collection. "This is art!" I crudely announced. I liked knowing a photo was there, but not knowing what the photo was of. I asked Helaine to take the sun-stained felt to the archive she keeps under her bed, but she refused, insisting that the felt needs to stay with the cheap box frames.

I am not the first to notice that the 2012 Fire Island Artist Residency appears to be male-dominated. I looked at a group photo of the artists online, which I realize is not an accurate way to source personal identifiers. Alex Fialho's two-part feature on *Art F City* about the residency examines the connection in each artist's work to queer identity and/or subject matter. Fialho reckons with the measuring of queerness as a faulty framework. However, exploring this framework is inevitable due to the residency's location and explicit mission to be in conversation with Cherry Grove's history and current communities.[18] Many artists who are queer have been "rejected" from this residency program. Working on my application was a mind-fuck— I have all this writing but my photos, they don't "look queer." Shouldn't it be enough to care and be engaged in queer communities and cultures and histories? The more I think about the question of "how much queerness is enough?" the more I am prone to replicating the impulse to define what is being called queer. I find an article online about AA Bronson's selection process as a juror for the residency: "Mr. Bronson, who has a house in the Pines,… said in an interview that he was looking for art that had a relationship to queerness and to Fire Island. He said a number of applications by artists who said 'I'm queer but my art isn't' were turned down."[19] Could it *really* be that simple? If the queerness does not come up in the work, then how could that read as a rejection of community, culture, and history?

The New York Public Library Picture Collection is a system that uses vague categories, most of which were chosen over a hundred years ago. This isn't much of a

problem for the cat and flower folders. In 2012, when I asked if they had a "queer" folder, I got redirected to "Bohemian Life" and "Homosexual." When I asked how I could find the "Transgender" folder I got directed to "Impersonators." The librarian told me about how in the early 2000s an artist used images in the Homosexual folder for collages, *then*, after he had a show in New York of this work, the folder got stolen from the library. It's still a mystery who took it. I had brought a photography class to visit the picture collection and I stayed after to do my own research. A student was at a nearby table looking at the Smoke folder. We had a brief conversation about the ways to do double exposures. Then we went back to looking at our respective piles of pictures. The library staff, slowly, in the past ten years, has begun to re-create the Homosexual folder, but it is horrifying, really, because most of the images are of people getting married or wearing military uniforms. The librarians build folders by cutting up magazines from subscriptions and books that are too damaged to be in circulation.

I learn that the artist who used images in the Homosexual folder is Christian Holstad. In an interview entitled "Homophobic," he chronicles his process of copying the Homosexual folder at a nearby kinko's. I had similar emotional responses to the images that Holstad had. With the protest documentation, we both felt sentimental pride. And then with the images of nudity, a nervousness about looking at (what might be termed) porn in a public library. Holstad noted that while he copied the images in the folder, he started organizing them into his own categories to prevent duplication. He talked about finding a lampshade inside the folder and looking for a penis on it before he realized it was misfiled.[20]

During the discussion after my first public reading of this book in Berkeley in 2012,[21] a poet said they would never be in a gay anthology or a queer one because their work doesn't deal with queer or gay issues. The airing of this sentiment felt like a rupture but it was also a routine. The problems of naming may seem near to any young artist figuring out how to talk about their art, but these are not new preoccupations: Langston Hughes lambasted Countee Cullen for refusing to be labeled a "Negro Poet" in his famous polemical 1926 essay "The Negro Artist and the Racial Mountain." Siobhan B. Somerville, in *Queering the Color Line: Race and the Invention of Homosexuality in American Culture*, tracks how writer Jean Toomer was, in the 1920s, "positioned as an authentic 'Negro' writer." Toomer began to challenge this characterization in the 1930s, when he declined James Weldon Johnson's invitation to reprint portions of his groundbreaking work *Cane* in *The Book of American Negro Poetry*. Somerville reflects on how *Cane*, to this day, is a "key modernist text firmly situated in the 'Harlem Renaissance' canon," while "Toomer himself is often portrayed as naïve, at best, or a race traitor, at worst."[22] In fall 2013, Toomer's sentiment was echoed when Adrian Piper pulled documentation of her mid-70s performance series *The Mythic Being* from the exhibition *Radical Presence: Black Performance in Contemporary Art*.[23] Piper wrote to the curator, Valerie Cassel Oliver:

> Perhaps a more effective way to "celebrate [me], [my] work and [my] contributions to not only the art world at large, but also a generation of black artists working in performance," might be to curate multi-ethnic

exhibitions that give American audiences the rare
opportunity to measure directly the groundbreaking
achievements of African American artists against
those of their peers in "the art world at large."[24]

A comprehensive, comparative study of moments of dissonance with labeling is beyond the scope of this book. The resistance happens so frequently, on so many different frequencies, it would be impossible to offer an account. To collapse different and multiple identity experiences into one generic resistance to labels is to make a label out of resistance. Historical and contemporary moments of resistance to identity-based labels may at times seem familiar and similar, but each instance is distinct. Modes of resistance live within view of each other.

I may critique "queer" as a label ad nauseam, but I am more than willing to participate in activities organized around the word. I danced in work-in-progress showings of Katy Pyle's piece *The Firebird, A Ballez*,[25] which describes itself as a "queering" of the classic Stravinsky ballet. I made friends with Regina and Cassie and Francis in *Ballez*. The piece is literally about building "communities," however fraught that word is. I realized, while flailing in rudimentary ballet moves, that my book about "the problem with labeling art queer," is not a critique of Katy's use of "queerness" *as* a primary material or for that word living in the description of the work. Instead my critique aims to lessen *the expectation* for artists who are queer to have this supposed identity so explicitly tied to their subject matter.

Meanwhile, I cannot find Jill Johnston in any bookstore in the East Village. It feels like I am making a prank call

asking, "Do you have *Lesbian Nation*?" When the answer is no, I feel a presence in that absence. I see Johnston winking at me while swinging upside down on a fat braided gym rope hooked to the ceiling of a loft space. Johnston's transcribed journal in *Lesbian Nation* includes this recap: "Tell gregory it's pointless to write for a gay paper. He should write gay stuff for a straight paper."[26] I ordered *Lesbian Nation* online for under $5 and reveled in covering my face with it on the subway.

José Esteban Muñoz narrates how he came across Ray Johnson, a founding force behind the New York Correspondence School of mail art, alongside Jill Johnston's irreverent and stylistically radical stream of consciousness columns in *The Village Voice*. Muñoz's chapter "Utopia's Seating Chart" in *Cruising Utopia: The Then and There of Queer Futurity* ties together these two spirits who utilized "antidisciplinary protocols"[27] in their work to consider "what was lost" after the Stonewall Riot and the process of "formalizing" "gay and lesbian identities."[28] Muñoz summarizes crucial questions that drive the discomfort around identity and language after revealing the intricacies and social ties that motivated his research process:

> I return to the Johnston of *Marmalade Me* and not
> the Johnston of *Lesbian Nation*—not because *Lesbian
> Nation* is not an admirable text and not because it is
> not important. The moment that Jill Johnston named
> herself and her sexual identity was important for the
> history of queer politics and thinking. Yet if we read
> that move alongside Johnston's refusal to name in
> *Marmalade Me*, we are faced with her salient question,
> "What does it mean to name something? Where do
> we get off giving everything a legal identity?"[29]

The double negatives make me reread. Double negatives combat the making of a stable discourse. Muñoz follows this passage by analyzing how confounding it is for Johnston to have called the dictionary her favorite book, while *also* calling the dictionary a mausoleum. Muñoz must hold together Johnston's argument for evading definition, and her praise of the unwieldy collection of definitions. Her contradictory swerves become "a queer practice worth calling attention to." Muñoz also participates in contradictory defining and labeling when using the word "queer," which in the context of a "practice" may be incongruent to Johnston's use of the word "lesbian." At the same time, the word "queer" I find, in a colloquial sense, is replacing and diverging from many utterances of the word "lesbian." Muñoz uses "queer" to think of shifting tactics, to imagine a future to look toward as oppressive systems still rule our consciousness. "Queer" feels a little helpless in Muñoz's usage, still slipping and sliding and expanding into a mythology.

Muñoz's repetitive use of the word "queer" flourishes in the language of all who read him and are influenced by him. Perhaps more important is how Muñoz's legacy is defined by his support of so many artists—to name a few, Vaginal Davis, Carmelita Tropicana, Marga Gomez, Marlon Riggs, Dynasty Handbag—in simultaneously intimate and academic ways. I learn from Muñoz a methodology to include the layers of sociality within theory and criticism. I followed the crowd to the overpriced diner next to the New Museum after participating in an event on Jill Johnston and the artist-as-critic, where I talked with Vanessa Anspaugh, who asked if I'd like to be in a new piece of hers. I said sure.

HerEyesOn HORIZON was an hourlong dance that took place in an abandoned floor of the old post office building at Thirty-third Street and Eighth Avenue in New York in an event called "The Future at the End of the World." Vanessa's was one of many performances housed in this bureaucratic wasteland. The performance began with Vanessa painting a blue line connecting all of our backs. She solicited a group of cis-women, trans, and gender-non-conforming people to face the walls, making a new perimeter to the dilapidated office. Our topless bodies swayed and moved one step to the right every ten seconds for an hour. She invited us to improvise from our positions on the line, which I did not partake in. The costume called for jeans and sneakers. The window frame of the room we performed in was lined with bird shit and pigeon feathers. After this experience of deep group meditation I felt resolved and inside my body like I never had before.

In 2013, I sat behind a long desk, facing an audience. I was an artist in residence at n/a, a new storefront-turned-white-box-gallery that promoted itself as focusing "on the queer experience in contemporary artistic practices." At a public event as part of my residency, a person I might as well identify as a straight white cis-man walked in and immediately announced he wanted to understand what *this* was about. It's a book in progress, I replied. When I tried to introduce the material to him, he wanted to talk about why gay bars should be abolished. *What?* We argued. As soon as my hourlong reading ended, he cornered me behind the desk and wanted to talk about how gay rights are doing fine, don't you think? I just needed water. When he aggressively said "LGBwhatever," not even trying to say

or ask about a version of the always-shifting acronym, I shouted, "I'm done talking to you." It was a scene. I was looking for the person who wanted to talk about Zoe Leonard's photographs. I didn't want to explain things that seemed so far away from my book—but what *isn't* contained in this book? People crowded around us. No one intervened in our conversation; it was as if we were onstage in a performance. His girlfriend was apologizing for him. He eventually apologized.

This encounter evinced a resistance to the idea of a "queer art space" showing work with "queer content" in a way that was quite different than how I had been resisting the phrase "queer art space," in my nuanced study of language and how art gets talked about. At first I didn't know how my inquiries would fit at n/a. I pored over the mission statement, which read:

> n/a is an exhibition and event space with a focus on
> the queer experience in contemporary art practice,
> centered in oakland, california. gathering individuals
> and communities of diverse social and political
> backgrounds, n/a's programming aims to encourage
> critical dialog, lend legibility and visibility to queer
> artists and ideas, and produce new imaginaries. it
> is curated by nicholas andre sung with a shifting
> community of organizers.[30]

I delayed a response to Nicholas's invitation for me to develop this book there. Then I wrote to them with some questions: What does it mean to call something queer and to bring together artists who are queer from your (newly queer) perspective? What does it mean to use an art space as a way to enter or introduce yourself to already existing

communities? How are you a part of a process of defining queerness and what does that mean inside a gallery space? Nick answered that nothing quite exists that they wanted to exist and they welcome my questions in their space. I found our projects to be not so different. I needed support and they wanted to give it to me.

After getting the press materials for my residency, I disagreed with Nick's rewrite of my bio. No, my practice isn't about "queerness," I just make art and it's about life. I am *not* writing *about* "queer artists," I don't assume that's a thing. I don't take that language for granted. I was in a huff about this but our communications were still nothing but amicable. I felt incapable of a mentality of "fixing" someone's syntax or word choice. I was interested in analyzing language but not interested in enforcing a language different than the one I preferred.

George Zimmerman was acquitted for murdering Trayvon Martin the day before I arrived at n/a for my residency. I was devastated and yet not surprised when the push notification appeared on my phone with the news. I was in the car with Sinclair as we drove back from the supermarket, up the Oakland Hills to her and Susanna's apartment. I looked out the window and saw the line at the Lake Merritt movie theater for *Fruitvale Station*, the feature film based on Oscar Grant's murder by BART police officer Johannes Mehserle in 2009. The following day, Jack Frost hosted the first red element / a queer reading series at n/a, where Brittany Billmeyer-Finn, O. Stevens, and Oki Sogumi read. I cried listening to O. Stevens read "Black *Boys* in Black Cars get Black Eyes from Black Guns in White Hands":

Steven Eugene Washington, 27

Aaron Campbell, 25

Sean Bell, 23

Oscar Grant, 23

Amadou Diallo, 23

Tim Stansbury, 19

Victor Steen, 17

Trayvon Martin, 17

Jordan Russell Davis, 17

Emmett Till, 14

George Stinney Jr., 14

Darius Simmons, 13[31]

Stevens arranges this memorial of names oldest to youngest. How much cannot be said about these murders, each singularly tragic, each part of a routine centuries old, speaks through the empty space on the page around the list. This poem appears in her chapbook *Black Noise: The Conscious Babble of O. Stevens*. What follows this memorial is a poem telling Sean Bell's life story, including the part about five New York City police officers who were acquitted in his murder. The next poem details Darius Simmons's funeral and his death, which his mother witnessed. The list of names appear like a table of contents before the poem "Too Many," where even more emptiness on the page encases the space between three lines of Stevens's text: "Did you hear about that Black boy who was killed by that White Man?/ Which One?/ Too Many," as if it is too painful and impossible for Stevens to write about the details of all these deaths. A rage fills the empty space on the page. Almost everyone at the reading left the "queer gallery" and went downtown for a second night of protests.

TO PROJECT PRESENCE AND RISK ABSENCE

How many masks have you seen hanging out of context? Collected by "experts."

—Tisa Bryant[1]

Realism—the view of one.

—Gail Scott[2]

I recited uneasily, "New Narrative was a small group of friends in San Francisco that coalesced in the late 70s and early 80s whose prose mixed fictionalized gossip with documenting their reading and writing practices. The first-person prose often embraced emotional and physical aspects of relationships from explicitly gay subject positions." As soon as I described in shorthand influential writers to me, I felt a part of them become invisible, even though I was trying to do the opposite. I was on the "Queer Temporalities" panel at a graduate symposium called The Non-state(s) of Queer Theory as the lone non-graduate student. I launched into this description after no one raised their hand when I asked if anyone was familiar with New Narrative. At first I felt a pang of disappointment. But that disappointment morphed into a curiosity with the power of obscurity. I began to wonder how New Narrative writers have instinctively evaded definition.

Ren told me over drinks later that night he had *wanted* to raise his hand and signal New Narrative writing as something he knows deeply. But I had given Ren my digital camera to document the talk and his arms remained sturdily at his sides. At first there is the history of virtual censorship of writing with gay content and then there are the ways New Narrative writers have not always blasted a gay content label. The intense localness of Bay Area writing communities, compounded by the highly ephemeral nature of small press publications, and further compounded by the AIDS epidemic, are potential reasons why New Narrative doesn't appear more in discussions outside its home in experimental literature.[3]

Biting the Error: Writers Explore Narrative serves as the New Narrative guidebook by way of collecting late-

twentieth and early-twenty-first-century experimental prose writers reflecting on their craft. The book is composed of short essays around such technically formal and inventive themes as "Approximate: Past to Present," "Dislocation," "My Other Self," "Methods," "The Novel," "Resistance," "A Story Is a Storage," "The Sentence," "Shiver," "The Buzz of Alternate Meanings." As if speaking to what New Narrative will not participate in, Camille Roy, a co-editor of *Biting the Error*, writes a staunch refusal of typical anthology categorizing:

> New Narrative. . . existed mainly inside the terrain of innovative poetry. There it was greeted warmly, but the seminal moment of New Narrative was not recognized elsewhere. Thus, this cannot be a New Narrative anthology. That moment has passed. It is also not an anthology of a nationality or generation or other identity category: those boundaries are trespassed in our collection.[4]

Biting the Error contains too many voices to stand as a cohesive manifesto, that infamous ingredient in the making of a literary or artistic movement. Meanwhile, reading *Biting the Error*, slowly, over many years, has informed how I write; the book is a twilight dance party in comparison to other writing guides like Strunk & White's *The Elements of Style*. It's the cheapest MFA program left in this country, after the handful of fully funded MFA programs.

If New Narrative tactics mine the self-as-literary-form, why did New Narrative not engender a name rooted in the self? The sentences of this experimental prose often contain proposals for a type of honesty that doesn't fit in the binary of closeted or out gay authors, yet New Narrative began

as a group of mostly white, lesbian, and gay authors. For Roy, to claim overarching consistency among contributors to *Biting the Error* would be impossible. Even to claim the book as *belonging* to New Narrative would be impossible. To "trespass" both inscribes the category of "identity," and enables its undoing. I am reminded of Audre Lorde, when she writes in *Zami: A New Spelling of My Name* (1982), "my experience with people who tried to label me was that they usually did it to either dismiss me or use me."[5] To Lorde, a "self-described 'black, lesbian, feminist, mother, poet warrior,'"[6] this naming is very much about how *she* was the one doing it *to survive*, in a time before and after the Stonewall Riots. Lorde differentiates self-determination from the deceitfulness of "people who tried to label her." Camille Roy's refusal to make "impossible" generalizations about New Narrative is an articulation of Lorde's distrust of labels, as though the blueprints of literary history are an inherently distrustful place.

New Narrative emerged when a group of students met in a free walk-in workshop Robert Glück ran at Small Press Traffic from 1977 to 1985. The group that gathered there fostered each other's work by contributing to magazines such as *SOUP* (edited by workshop participant Steve Abbott) and *Mirage Period[ical]* (edited by workshop participants Kevin Killian and Dodie Bellamy). There is no mystery, really. New Narrative is prime material for being called "queer art" now, even if it was not officially called "queer art" or even "gay art" at its time of inception.

In his introductory remarks to *Biting the Error*, Glück admits that evasion of naming was intentional. "By using the tag New Narrative, I am conceding there is such a thing. In the past I was reluctant to promote a literary

school that endured even ten minutes, much less a few years."[7] Glück's hesitancy to name the group of friends/ writers he witnessed take shape in and alongside his workshop is expressed tirelessly, throughout recitations of literary history. James Baldwin writes on this recurring difficulty in his 1949 essay "Everybody's Protest Novel." The sequestering of types of literature, relegating some of it to protest, is a sham to Baldwin. Part of his critique of the categorization of genre is a comparison to the emptiness of character development within Harriet Beecher Stowe's *Uncle Tom's Cabin* and Richard Wright's *Native Son*, which he argues reaffirm dangerous stereotypes of their black protagonists. The impulse to separate a literature and call it "protest" is a specifically American tendency, and deeply related to the united states's "passion for categorization," which Baldwin notes causes "paradoxical distress; confusion, [and] a breakdown of meaning."[8] Ultimately categories, especially those relating to literature and its terrain of wild thought, "have boomeranged us into chaos; in which limbo we whirl, clutching the straws of our definitions." This "chaos," in Baldwin's estimation, is an attempted honest relationship to language, which resonates in Glück's refusal to "tag" his writing practice. Glück's word "tag" has connotations to a price tag (one could rip it off with a clenched fist) and the game tag— you're IT—of children chasing each other to appoint an ostracized slowpoke. Both connotations evoke the fear of consumer markets stealing one's creative goods or toxic social dynamics taking hold. In Baldwin's image of a windstorm resulting from the chaos a category might inflict, definition is both the problem and the apparent

lifeboat in the storm. A definition might sail me out of the storm of ambivalence, a storm I readily reproduce in this book.

I paced at the edge of New Narrative like it was a lake asking me to skinny-dip. Amanda first lured me in with the work of her teachers at San Francisco State University: Dodie Bellamy, Bob Glück, and Camille Roy. The architectural plan of our relationship consisted of her transmission of books such as *Denny Smith*, a collection of Glück's short stories. On the cover of her copy rests an imperfect circle from a cup of coffee I foolishly placed on it. When passing the book around in a creative writing class, a student marveled at the coffee stain, wondering out loud if it was a mass-produced design. Almost every conversation Amanda and I had about our writing asked a version of this question: how have other writers, both older and younger, who may not be directly affiliated with this small group of friends, used tactics that we sometimes call New Narrative? We were obsessed with the loose "straws" of our lineage, as if this lineage was always up for invention. We would often talk about what it means for us to be white, and that the majority of the original New Narrative contingent is white. And what about class? While I was writing this chapter, Amanda was devising the essay "My Walk with Pussy" on Roy's writing through and about whiteness and class in her books *Swarm* and *The Rosy Medallions*.

I saw Amanda for the first time after we broke up at *A Litany for Survival: The Life and Work of Audre Lorde* (1995). I felt my body go weak. I had to escape into the bathroom. But what if I saw her in the bathroom too? I ran into Dia on the popcorn line and she said, "Don't try to

white-knuckle this, maybe you should go home." I was not leaving; I knew this screening was a rare opportunity to see a film not available online. Sinclair had told me about this film years ago—how much she loved it, how much I would love it. Ada Gay Griffin and Michelle Parkerson blend interviews with Lorde and her contemporaries, footage of her reading, teaching, and slicing unwieldy, luscious fruits. In the beginning of the film we see the ocean bordering her home in St. Croix as Lorde recites a poem while holding a jvc video camera over one eye. Her body is steady, panning the horizon, while her voice cracks. The film shows so much of Lorde's pleasure and joy while struggling against her battles with all the big fights: racism, sexism, homophobia, cancer.

Alexis De Veaux, Lorde's biographer, historicizes her reading "Love Poem" in 1973 as her coming out in literature.[9] In *A Litany for Survival*, Sonia Sanchez reflects on how risky it was for Lorde to come out, *as* she did and *when* she did; Sanchez says she will not "revise" history when speaking of how Lorde was alienated from their contemporaries who were openly homophobic. In another scene, Jewelle Gomez reflects on Lorde's genius being characterized by how she brought the political and artistic together. Lorde interrupts this medley of scenes to warn, "Don't mythologize me." Okay, okay. Her history felt so present that night. I cried continuously in this packed movie theater with people all having different experiences of the film. It was a much bigger feeling that coursed through the feeling of Amanda being there and us not being there together.

During the film, I scribbled a note to find out more about Audre Lorde mentioning that Barbara Smith asked, at the 1976 MLA convention, *can* I be a Black, Lesbian,

poet?[10] Lorde recalls feeling shocked Smith formed this as a question since her life and work had so boldly answered *yes you can*. Yet poetry thrives on the subtleties of what gets left unsaid. In hearing Smith's question, Lorde realized she had to write a book in prose. Smith encouraged a seedling for what became Lorde's "biomythography," *Zami*. Smith also soon founded Kitchen Table: A Women of Color Press in 1980. My fascination with New Narrative is similarly a fascination with Lorde's gravitation toward the urgency and documentary nature of prose. New Narrative writing is often talked about and theorized as emerging in contrast to other poetic activity in San Francisco in the late 70s, specifically Language Poetry, a writing that favored a heavily disjunctive style over a cohesive narrative of the self.[11] New Narrative took the formal word "narrative" as opposed to an identity-based word like "gay" or "queer." Just because New Narrative or Language Poetry did not put identity-based labels in their names does not preclude reckoning with how these were both white groups of writers who emerged alongside the legacies of Black Arts and Feminist Art, two national movements that *did* put race and gender, respectively, in their names.

Umbra, which coalesced in the Lower East Side from roughly 1961 to 1964, was one of many groups of artists and writers that functioned as precursors to the Black Arts Movement. I look up the word "umbra" to find that it means shade and shadow. I read in a literary encyclopedia that Umbra was named as a reference to the title of a poem by Lloyd Addison.[12] The naming of Umbra is suggestive of the aesthetic possibilities stemming from the shared identification of the mostly young, black, male poets in

the group who participated in workshops, readings, and a magazine. I learn from participants Tom Dent's and Lorenzo Thomas's histories of Umbra that the group also loosely included David Henderson, Ishmael Reed, Calvin C. Hernton, Joe Johnson, Charles Patterson, Al Haynes, Ann Guilfoyle, Raymond Patterson, Mildred Hernton, Steve Cannon, N.H. Pritchard, Askia M. Touré, Brenda Walcott, Jane Logan Poindexter, Amara Hicks, Winnie Stowers, and Maryanne Raphael—among others. When texting with Stacy about the "mostly men" nature of the list of participants Dent and Thomas provide, Stacy adds names of women she has known to be associated with Umbra. In 1978, Thomas establishes one account of the distinct nature of the group as emerging alongside the Harlem Writers Guild, which was "solidly in the black literary tradition" as well as LeRoi Jones (later Amiri Baraka), and A.B. Spellman, who had "tendencies toward the avant-garde." Thomas describes Umbra as aesthetically committed to "'non-literary' black culture." The group was inspired by music, ordinary speech, and experimentation with how poems looked on the page and in live performance.[13] While Thomas details the "diversity of personal style and tone" among young black writers in the early 60s, he recalls these writers "shared a common orientation" of "outrage" and "missionary zeal borrowed from the Southern Civil Rights struggle."[14]

Umbra was central to the formation of what is now known as the New York School, yet much of Umbra's variegated histories still demand a presence in the often whitewashed myth of New York City's 1960s bohemias. New Narrative, which coalesced roughly twenty years later, resembles Umbra's configuration of a localized group

of writers with explicit identities withheld from their group's name, while organizing around the question of developing an aesthetic from a collective sense of urgency in pronouncing their identities. Both New Narrative, a group of mostly white queer writers, and Umbra, a group of mostly male black writers, currently appear obscured from the academic canon of "American literature," but for very different reasons. Just because groups of writers are small, and remain organized for just a few years, doesn't mean their work is not hugely influential.

The Combahee River Collective Statement (1977) outlines battles black feminists have been fighting *for centuries*, and within this continuing history there are some known names but "thousands unknown."[15] The Combahee River Collective Statement made a point to foreground intersectionality over the use of discrete categories. As I try to learn from these movements, I have turned to a genre of academic writing that troubles the historicizing of literary movements by looking at their supposed margins. Cheryl Clarke writes in *"After Mecca": Women Poets and the Black Arts Movement* (2005) about the accomplishments of Black Arts leaders and their tactics of articulating clear intentions and mission statements. For example, Amiri Baraka moved to Harlem in 1965, after Malcolm X's assassination, founded the Black Arts Repertory Theatre/School (BART/S), and pronounced that a "Black Arts writer meant a decided rupture with the 'West/a grey hideous space.'"[16] Clarke hails Dudley Randall of Detroit's Broadside Press because he "recognized, produced, promoted, and preserved this autonomous cultural movement, whose central objectives were to practice black

American culture, to resist cooptation by the 'West, and to make a revolution.'"[17] Clarke focuses on black women poets from a lesbian-feminist perspective, a subject matter that "in no way clutters the literary landscapes."[18] Clarke studies just ten years (1968–78) and three central texts: Gwendolyn Brooks's *In The Mecca*, Ntozake Shange's *for colored girls who have considered suicide/when the rainbow is enuf*, and Audre Lorde's *The Black Unicorn: Poems*. All three authors received mainstream attention while experiencing highly nuanced and shifting relationships to Black Arts and Feminist Art. Clarke contends that Lorde's most productive period for writing poetry was between 1969 and 1971, when she created a body of work that "signaled her rejection of the sexism and homophobia of black nationalism and the racism and classism of mainstream white feminism."[19]

Clarke describes her approach to dialoguing with history and art through a shifting geometric image to address the problems of naming:

> I wish to imagine black American culture to
> be a system of circles constantly being redrawn
> and reshaped along race, gender, sex, class, and
> community lines—sometimes concentric and
> constricting, sometimes overlapping and inclusive,
> and sometimes spiraling out of bounds.[20]

Clarke traces her methodology of reclaiming history as borrowed from *both* the Black Arts and Feminist Arts traditions, two movements that are far from mutually exclusive but may sound separate because of how they are named. Clarke's image of "constantly redrawn circles" is a practical entry point for seeing how movements are

evolving and subjective constructions, contrary to their seemingly stuck historical placement.

Maggie Nelson's *Women, the New York School, and Other True Abstractions* is motivated by the gross omission of women-identified poets from academic surveys of the above-stated canon. She engages in close readings of poets Barbara Guest, Alice Notley, Bernadette Mayer, Eileen Myles, and painter Joan Mitchell, all of whom are white. Whiteness, however, is not addressed at length in Nelson's study, which stands in stark contrast to Clarke's feminist portrait of Black Arts. Nelson does cite how mostly white, women-identified poets in this time of second-wave feminism tended to unite despite geography or aesthetic tendencies.[21] Nelson establishes the act of naming movements as a masculinist ideology, and tracks this as a public discussion based on a 1999 conference at Barnard College, "Where Lyric Tradition Meets Language Poetry: Innovation in Contemporary Poetry by Women." Claudia Rankine and Allison Cummings, the organizers of this conference, wrote a statement that reads, "Perhaps the wish not to anatomize one's aesthetic position stems from a core belief in slippery subjectivity and a fear of reductively fixing one's position, limiting one's vision of what is possible. Could this belief, this fear, have particular urgency for women writers?"[22] With this statement in mind, Nelson tempers an awareness of not replicating the traps of "literary mythmaking" and "the logic of exclusion"[23] with her desire to record a silenced part of the New York School's history, that which she cannot help but name as "one of the first gay avant-gardes."[24]

Nelson makes a tactic of "slipperiness" by exposing her extended vacillations; included in the book's introduction

is a tale about the agony of titling her first academic tome: she analyzes the problems with prepositions such as "Women *of* the New York School" or "Women *in* the New York School" or "Women *and* the New York School" for how they made the New York School the bigger entity or Women a separate entity. She lands on the phrase "True Abstraction" in Frank O'Hara's 1959 poem "Personism" that mocked all the "isms" of the day as a sort of stopgap on the ultimate quandary of naming: book titles.

Instead of finding the marginalized within an already historicized male-dominated movement, Urayoán Noel's *In Visible Movement: Nuyorican Poetry from the Sixties to Slam* (2014) studies "a poetics strategically positioned against both institutional invisibility and abject hyper-visibility."[25] Naming is an indisputable tool in amending the violence of the academic canon. Noel historicizes while offering close readings of a large number of poets: Sandra María Esteves, Mariposa María Teresa Fernández, Lorraine Sutton, Mayda del Valle, Pedro Pietri, Jesús Papoleto Meléndez, Edwin Torres, Tato Laviera, Miguel Algarín, Victor Hernández Cruz, Felipe Luciano, Magdalena Gómez, José Angel Figueroa, Willie Perdomo, Miguel Piñero, and Louis Reyes Rivera—among others. While Noel upholds the language of defining a movement, he also examines the complications "of resistance and representation" that "a movement" implies by arguing that poets who write in a space between New York and Puerto Rico have always been negotiating "problematic visibility."[26] Noel reflects the complexity of this visibility within the tight space of his book's title: he employs the wordplay of a space between the ordinary prefix "in" and "visibility." The space between this prefix and

the word it's usually attached to invokes a pause, a site being seen and an intervention into the absence of not being seen, all the while leaving room for different audiences/readers. "In/Visibility" is a further riff off his book title and theme as a subheading to the first chapter.

Supposedly clear representations of self as pitted against experimental writing continue to fuel debates for those inherently challenging the oppressive nature of the white-straight-male story that spreads its legs wide across literature. In 1999, Duriel E. Harris, Dawn Lundy Martin, and Ronaldo V. Wilson founded the Black Took Collective in the castle at the annual Cave Canem Retreat for African American Poets in upstate New York. Black Took articulated itself as rejecting the "narrative lyric."[27] The three poet/academics wrote a manifesto entitled "A Call for Dissonance," as a mode of survival and a proposition to the group gathered for workshop and residency that year. Their call was for experimentation that would "challenge how we think about representational forms of black identity and the poetics that they engender"[28] in order to "respond to received ideas about what a black poetics is or is fantasized to be." Their manifesto interrupts notions of a cohesive black voice by asking infinite questions "about a kind of poetic struggle":

> Why the narrative lyric? Why the palatable and easily
> consumed black poem that says, this is blackness,
> definitely? Why not instead despair, a black hole,
> waste, excess as a thematic site; why not a cracking
> in the center or on the side? Why not a spit-faced
> monkey bleeding from the hip and talking with a
> southern twang? Why not the human body as poem's

material: open, full of spaces, grotesque; not beautiful
beyond its own flesh filling, never exhausting, black
space—our minds becoming blank—our bodies
brimming, scatting the scatological.[29]

These questions instigate wide-ranging possibilities for both form and content in shaping a black poetics. "Why not" as a refrain opens up the manifesto into a language of diversion. Each question of "why not" restarts the prompt as a new poem; a different image ricochets as opposed to shaping an ordered list. From subverting specific violent stereotypes to promoting infinite fields of space, Black Took advocates for writing that refuses to be easily consumed. They gravitate toward "loss, the invasion, the violent and the beautiful release of a body out of control, a body that seeps."[30] The possibilities have a quality of overflow, of leaking. "A Call for Dissonance" is followed by several pages of the members' individual writings, including poems they solicited from John Keene and Yolanda Wisher.

Dissonance continues to be enacted by Duriel E. Harris, Dawn Lundy Martin, and Ronaldo V. Wilson on the pages of the full-length books they have published since 1999.[31] To name themselves a black collective appears imperative, for they were compelled to expand what they experienced as being associated with a black poetics. Instead of avoiding the label they chose to take it on. Meanwhile, their manifesto does not explicitly address intersections of queer identities, despite both Martin's and Wilson's Small Press Distribution titles having LGBT Studies among their search terms. Harris and Martin are also a part of the anthology *Troubling the Line: Trans and Genderqueer Poetry and Poetics*. I borrow Black Took

Collective's promotion of "dissonance" as a clunky key to try to open the language of "movements" with. My key often feels like a bad copy, one that doesn't slip easily into the lock's specific grooves.

I am drawn to the moments of conflict in histories of movements precisely because most self-proclaimed collectives emerge at the site of a rupture between the work they are doing and the work of a nearby status quo. In Lynn Hershman Leeson's documentary *!Women Art Revolution*, she interviews artist Martha Wilson, who recounts a visit to Judy Chicago's Feminist Art Program[32]:

> I showed photographs of myself dressing as a man
> trying to look like a woman, photographs using
> makeup to beautify and then to deform my face
> and then Judy said, "Well what do you think of the
> work that you see here?" And there were flowers and
> breasts all over the walls and I thought it was hideous
> so I said, "It looks prescriptive to me." And then she
> said, "Don't you understand what we are trying to do
> here? We are trying to support these young women!"
> So um. I started crying. [laughs] I completely lost it.
> I couldn't believe a feminist could act like this.[33]

Wilson changes her tone of voice to a throaty roar, to demonstrate how Chicago antagonized Wilson at her suggestion of honest conversation. Chicago deemed her students' work too vulnerable for criticism. The fear of dissolution because of critique is a common thread in young movements that are, ironically, trying to solidify a critique of a dominant culture. The fact that Wilson was surprised a "[white] feminist could act like this" also exposes her assumption that feminists all act one way, or

that "[white] feminists" were immune from reproducing power structures they were supposedly liberated from. Wilson's art is inextricable from her support of performance artists in New York City with Franklin Furnace, a granting organization she founded in 1976 and continues to run, funding an enormous archive of feminist art, though it is not always called that.[34]

Instead of using a "movement" model, Black Took ignites inquiry alongside aesthetic alliances. Black Took asks a series of questions, as opposed to making definitive statements. Similarly, New Narrative never has mandated an official statement to match its feminist, new left, gay-liberationist politics. If New Narrative is, was, and will be forever in this state of in between, I am reminded of Camille Roy's use of the word "trespassing" when reflecting on New Narrative as claiming no territory, as if to highlight the power of a fleeting force. I return to Clarke's image of "constantly redrawn circles" as a map for entering subjective constructions of movements. Often pertinent histories lie outside of a movement's bounds and therefore need to be "constantly redrawn." The first sentence of Larry Neal's Black Arts manifesto stated that the movement is "radically opposed to any concept of the artist that alienates him from his community."[35] Neal's prerogative as leader, like Chicago's, was to position art as a tool to liberate their respective communities. In order to get shit done they needed to espouse a vision of collective unity. Neal's hard line also critiqued the elusive, apolitical, often white male artist of the art world establishment. Lisa Gail Collins's essay "The Art of Transformation: Parallels in the Black Arts and Feminist Art Movements" notes that

both were the "cultural corollaries or wings" of Black Power and of Women's Liberation, respectively.[36] Collins traces similarities structurally and tactically between the two movements that include anthologies, group shows, cultural leaders, theorists, and manifestos. Both movements, notably, had a national scope.

I am relieved that Collins's methodology would be impossible to follow if one were to ask: "Is there a queer arts movement and is New Narrative one of its early threads?" This question appears, I hope, only in a nightmare I had about a standardized test version of this book. Firstly, to hail New Narrative as an early thread of "queer art" would risk implying that queer history began after Stonewall. Secondly, to celebrate New Narrative as a "founder" of an aesthetic or a movement resembles the tendency of queer theory to establish a white norm. Not labeling work based on race/gender/class/sexuality/ability must be reconsidered by those privileged with historically "unlabeled" subject positions. Baldwin establishes on the first page of his 1956 novel *Giovanni's Room* the whiteness of his protagonist, David, and how his journey from New York to Paris marked a reversal of the path of colonialists. Dwight A. McBride, in his essay "Straight Black Studies," records that Baldwin was at first terrified to face his sexuality in writing (a gay male love affair drives *Giovanni's Room*), yet it empowered and "simplified" his life early on in his career. McBride cites the documentary *The Price of the Ticket*, where Baldwin explained, "I had no secrets, nobody could blackmail me. You know...you didn't tell me, I told you."[37] Baldwin's courage to openly write characters that at times reflected his subjectivities

and his early "coming out" was tied to his lifelong critique of knee-jerk modes of categorization.

Inside the current reality that Gay Liberation has been hijacked by upper-middle-class, white agendas focused on assimilation and single issues, Queer Nation's manifesto written at the height of the AIDS epidemic: "You as an alive and functioning queer are a revolutionary" feels constantly up for debate. Is being "queer" revolutionary? It really depends. *Self-identified* "queer artists" often resist assimilationist, homonationalist rhetoric. Yet this becomes very difficult to trace and back up because the word "queer" has come to stand in for so many things, for so many different people. Chris Vargas and Greg Youmans's web series *Falling in Love…with Chris and Greg* altered an episode of the reality TV show *Work of Art! The Next Great Artist* to illustrate this problem of the word "queer" as easily collapsible with the gay mainstream.[38] *Falling in Love* is an occasional web series that began in 2008 and depicts a self-effacing caricature of an odd couple: Chris encourages processing everything from his going off hormones to trying an open relationship. Greg plays the whiny, slightly uptight liberal gay whose "debt is real" from endless time in grad school (in the "Hair Breakdown Special" Greg is seen reading *From Dissertation to Book* in bed). Meanwhile, each episode of *Work of Art* begins with the judges presenting the contestants with a time-sensitive "challenge." The reality show is both devoid of irony and ripe with absurdity. Vargas and Youmans do semi-slick video editing to make an episode of *Falling in Love* by inserting themselves into *Work of Art!*'s "Pop Art Challenge." The appropriated footage as backdrop begins with the suspenseful music leading up to

a description of Andy Warhol's soup can installation at the Phillips auction house.

Vargas and Youmans paste in scenes of themselves as contestants in *Work of Art!*. They overwrite the flimsy "Pop Art" movement with the challenge to fulfill the terror pleasure in the prompt to make a "successful piece of queer art about failure."[39] Chris's piece is a metacritique of the competitive structure of reality TV shows; he speeds up and loops a clip of Chaz Bono appearing in *Dancing with the Stars*. Chris appears well-trained in the elevator pitch, telling a judge on the show, Simone, during a surprise studio visit that his work is about "trans people in the public eye and how mainstream media represents trans people." Chris's explanation of his work is rendered illegible. He does not try to win the affection of the guest judge, who uses the wrong pronoun for Bono, then asks if it's true you can tell a "tranny" by looking "at the feet to know for sure?" He instead uses Simone's transphobic response to his piece by titling it "small hands small feet." Chris's studio space is adorned with a rainbow mug and pink triangle hanging on the wall, a hint of promotion for the insignia of his "real life" Museum of Transgender Hirstory & Art (MOTHA). Greg decides to draw scenes of "Queer Failure" with colored pencil, not exactly mastering depth of field. He puts celebrities in awkward, lonely, or distressing moments. One drawing depicts Anthony Perkins feeling enervated and watching "cheesy gay movies with sexy boys on Netflix." While Perkins is drawn home-viewing in bed on his laptop, a sort of Lollipop Guild Occupy protest is going on outside his window. Another drawing depicts Joel Grey standing in a long line for a free

cheesecake sample at costco. Greg's work is slightly more legible to Simone, perhaps because it features a white male subjectivity, though Greg laughs off the visible likeness of the figures in his drawings to himself.

In their satire, Vargas and Youmans retain *Work of Art!*'s original plot of the contestant Young Sun Han's coronation for making a "true work of Art" with the dubbed line "Your piece will look amazing on the pages of Corporate Gay Weekly." Han wins the "queer art" *and* the "pop art" challenge, rendering the buzzwords interchangeable. *Falling in Love* provides a playful critique of naming art queer. Conversely, this piece could be read as a case for "queer art" as the next "pop art." Making fun of "queer art" in a web series does not disrupt its commodification; it only strengthens it. The critique Vargas and Youmans launch is toward Han's "winning" piece: a benign advertisement neither for nor against an enormous pink-and-purple glossy logo that reads "Prop 8," which invites viewers to scribble with multicolored sharpies on the poster's backside as if visiting "a tourist attraction." Han tells the cameras in a confessional about how gay marriage is a "personal issue" for him as a gay man. He also talks about wanting to make safe art that does not "take a position" about the ban against gay marriage in California, which passed on the voter ballot in 2009 and has since been declared unconstitutional.

The "queer artists" on the show lose the challenge that they edited themselves into in order to show a contrast against a "gay artist" who wants to assimilate into an American hetero-normative dream. Chris and Greg "go home" in the double elimination round to symbolically return to being misunderstood by television's mainstream.

These two "queer artists" notably represent opposing attitudes: the enthusiast (Greg) and the cynic (Chris). Their illegibility both safeguards "queer art" within the reductive art market and critiques the capitalist system of appointing a "winner" who takes home the big cash prize. Their rage and vulnerability do not make them immune to the market—they *almost* won. When tasked with the high stakes of survival and funding, are the artists even to be blamed for competing?

Every, and any, artist who is queer is doing the "cultural corollary" work Lisa Gail Collins outlines as the bedrock of social movements. Some artists label their work as representing various modes of identification. Some artists refuse labels. Some artists vacillate between labeling and not labeling their work. Many artists will be labeled in ways they would never personally utter. There are institutions that are designed to promote art with certain identifications. There are people without access to those institutions who may or may not start their own "institutions" but will never call them institutions. There are other institutions that prioritize artists who identify similarly to how the leader of that institution identifies. The expression "queer art" is most broken when considered in the context of its default prioritization of one identity over other identities based in race, class, ability, and gender.

An early draft of the this chapter was titled "I'm New Narrative and I Didn't Even Know It!" as a response to seeing, as in Vargas and Youmans's work, what are familiar to me as the New Narrative tactics of high theory blended with popular culture blended with personal relationships. This question, more a longing to connect what I am making

to what's been made before, sends me back to Baldwin's image of "clutching the straws of our definitions." Poet Steve Benson reckons with how he came to write about gay sexual desire and experience in *The Grand Piano*, a collective autobiography springing from a reading and performance series from 1976 to 1979 that bolstered Language Poetry. Steve concludes that he could not write for "the liberation of all gay people from injustice and guilt, oppression, prejudice, and shame" and thus cannot call himself a "gay writer."[40] I admit I skimmed *The Grand Piano* for not only Steve's contributions but also those of Lyn Hejinian, Rae Armantrout, and Carla Harryman. I was completely preoccupied with how Language Poets, who are more widely archived and historicized in the academy, have been significantly influenced by New Narrative.

I was similarly miffed with the high level of enthusiasm I received from a handful of white, straight, male poets about a draft of this book. I didn't know where to put their praise, like it was an object that cluttered my already small apartment. Did I quench their thirst for a history they have inevitably inherited and adopted into their writing? (I'm reminded of when Dagger, the "cool" lesbian party at Spectrum, announced the cover charge for cis-straight guys at $50. Spectrum needed a new air conditioner.) But anyway, how have writers who do not necessarily share the gay or queer subject position adopted New Narrative tactics of fictionalized gossip and reporting the minutiae of relationships and sexuality? How does this appropriation excise certain risks, because the writer's subject positions might be more celebrated and visible in literary history as opposed to being at constant risk of erasure and obscurity?

New Narrative tactics, for writers who are queer, still involve high stakes. I admit I feel possessive of New Narrative.

The specter of cultural appropriation often engineers the white male canon's movement system of glorification. Isaac Julien and Kobena Mercer write in their essay "True Confessions: A Discourse on Images of Black Male Sexuality" on the alarming absence of race from debates around photography dealing with sexuality in the mid-80s. Julien and Mercer explore their "ambivalence" with the proliferating images of gay sexuality and the erotic representations of black males: "We want to look, but don't always find the images we want to see."[41] Julien and Mercer express concern about the appropriation of racist and fascist tropes in Robert Mapplethorpe's *Black Book* photographs, which have been hotly debated for their fetishism, objectification, and othering of the photographs' subjects. A precursor to artists like Mapplethorpe producing problematic images was the appropriation of protest and liberation strategies from civil rights struggles. Mercer and Julien write that while "gays derived inspiration from the symbols of black liberation—Black Pride being translated into Gay Pride, for example—they failed to return the symbolic debt, as it were, as there was a lack of reciprocity and mutual exchange between racial and sexual politics in the 70s."[42]

In *Virtual Equality: The Mainstreaming of Gay & Lesbian Liberation* (1995), activist and lawyer Urvashi Vaid reflects on her involvement in the National Gay and Lesbian Task Force and how liberation has transformed into single issues. Vaid assesses "Don't Ask, Don't Tell" as a significant juncture of failure that reflected problems of

distribution of wealth in mainstream gay rights organizing. The fundraising work she did, as she brushed with federal power in the late 80s and early 90s, exposed to Vaid:

> the disproportionate attention commanded by the wealthy, the debasing nature of the process of fundraising, the pitfalls our political leaders encounter when investing so much energy in fundraising, and the fundamental lack of common purpose among the powerful and wealthy in our communities and those who do the unglamorous work of community organizing and political activism.[43]

Vaid then reflects on her own coming of age in the 70s. She notes that "queer identity" formation is distinct from that of "ethnic minorities, which transmit their cultural heritage through family, ritual, and tradition," because "queer identity is learned principally through the mediation of commercial enterprises."[44] Vaid then lists going to a bar, a bookstore, and a film festival as the first experiences of being surrounded by other lesbians. In "Long Note on New Narrative," Glück similarly reflects on the gay rights movement of the mid-70s as not being "destroyed by commodity culture, which was destroying so many other communities; instead, it was founded in commodity culture. We had to talk about it."[45] Steve Benson compares the commodity's relationship to specifically gay identity by noting how bisexuality was shunned simply because it complicated gay liberation's "consumer-oriented construction of sexual identity, on the presumption of an essence."[46]

The dances that New Narrative and affiliated writers have done around identity are intricately tied to an awareness of commodification and a steadfast resistance

to being "known." New Narrative, ultimately, was a small group of friends who were making work for each other and *not* a larger audience that tended to be homophobic or bent on cohesive narrative.[47] Exactly how New Narrative slips through the cracks of literary history is cause for both celebration and alarm.

José Esteban Muñoz's *Disidentifications: Queers of Color and the Performance of Politics* (1999) is a cornerstone text in this exploration of resisting "commodified" or scripted roles for artists working from multiple-subject positions. *Disidentifications* was referenced over and over at "The Non-state(s) of Queer Theory" symposium. Muñoz, the appointed keynote speaker, responded to each panel with the generous phrase "I learned so much" as symposium participants provided guided tours of their research. Papers included Anna Ghublikian's "Shallowness so thorough it's almost like depth: Quinn Morgendorffer's queer liveness," Brian Horton's "Citizens of Nowhere: Queer Dispossession and Nationalism in Popular Hindi Cinema," and Cora Johnson-Roberson's "Future Banjee: Emerging Aesthetics of Queer Black Masculinity."[48] Five out of the eleven paper titles, including "The Estrangement Principle," did not use the word "queer." Every panel had the word queer in it: "Queer Temporalities," "Queer Crossings: Mediating Nations and Publics," and "Black Queer Aesthetics." The simple presence of the word "queer" was overwhelming. The word went numb at a certain point, transmuting into wall-to-wall carpeting. After tracking the word as it multiplied and repeated, I looked down at my notebook to see what I wrote: "get contact info." I just wanted to make friends. I was grateful

that Majida Kargbo and Pier Dominguez, the symposium organizers, accepted my proposal to crash an academic space as someone not getting a Master's or PhD. I finally "got into" Brown University, where I had applied for undergraduate and graduate study and both times been rejected. I concluded that because New Narrative does not have "queer" in its title, that made it unknown to the group of graduate students at "The Non-state(s) of Queer Theory" symposium. At the same moment of learning that a tiny literary movement was "unknown," I was faced with many intricate fields of study equally unknown to me.

Since attending this symposium in 2013, New Narrative is getting its dose of history writing. The "visibility" I at first craved now feels extremely complicated.[49] Where does "my perspective" on New Narrative fit? I cannot avoid that I was searching for queer mentors, teachers, and friends when I first moved to the Bay Area. This was the first place I had ever arrived already gay. I went to the Lexington bar alone a few times, got drunk, and missed the last train back to Oakland. This wasn't exactly a pickup line. Then I was introduced to a mutual friend, Susanna, who lived in the city. I tried to hide my excitement sitting in the garden of Wild Side West when I noticed it was past midnight and I was with her; I had someone to miss BART with.

On a visit back to the Bay, Evan told me I have to read Alysia Abbott's *Fairyland: A Memoir of My Father*. We were having happy-hour margaritas at The Eagle while a series of flogging demos were performed for a small audience on the patio. Steve Abbott, Alysia's father, was a part of Bob Glück's workshops at Small Press Traffic in the early 80s and died of AIDS in 1992. Abbott was a cofounder, columnist, and

editor at *Poetry Flash*. He wrote for gay newspapers such as the *Bay Area Reporter* and (as aforementioned) published *SOUP* magazine. Evan reported amazement at just *seeing* Bruce Boone's name in a book published by Norton.[50] He was reading a library copy, or else he would have lent it to me. Six months later, Sofia Coppola bought the rights to Alysia Abbott's *Fairyland*. Aeliana sent Dodie a facebook message as we hung out at the Rusty Knot, "Who will play you?" and laughed loudly at just *asking her* this. Stacy told me she sold her copy back to Unnameable Books because she was so irritated about Alysia Abbott's misspelling of Robin Blaser's name as Robin Glaser. How *did* the copy editors at Norton not catch that?

When I imagine Sofia Coppola's film in my head, I see the scene with Sam D'Allesandro, the ultracool, heartthrob writer, as he buys booze for Alysia and her friends. In a later scene Sam will die of AIDS. I am nervous about how Bruce Boone will be portrayed, because Alysia does not exactly describe him favorably. The book chronicles her shame in having a poor, gay father who went through different fashion phases from Cockette queen[51] to leather daddy.[52] The honesty is the best part of *Fairyland*. She boils down the decisive split in the early 80s between Language Poetry and New Narrative as determined by political imperative: people were dying of AIDS and the government ignored these deaths; a sense of urgency over the articulation of politics emerged in contrast to Language Poetry's removal of the "I."[53]

Alysia saw the cool writers her father hung out with as "intruders" into their small apartment. She admits to questioning her father's very active writing life that seemed to have an air of invisibility compared to the very brand

of NPR publicity she received for *Fairyland*. When her father was preparing for the 1984 Pride parade, he asked Alysia what she thought of his outfit, which included a bandana and red lipstick. She answered with disgust, "You look *so* queer, Dad."[54] Alysia remembers her instant guilt and her father's horror at his daughter using the word, which was then a pungent slur. He repeated, "You can't say that," while she sat in silence. Alysia writes of her teenage rebelliousness as taking the form of extreme desire for a heteronormative middle-class family. She meanwhile airs her father's resentfulness toward Kathy Acker and Dennis Cooper, the more famous white writers affiliated with New Narrative, for not bringing Abbott with them when their visibility increased. Steve Abbott was one of the first people to publish both Acker and Cooper, in *SOUP*. Alysia Abbott still wants her father to get credit: "He named their style 'New Narrative.'"[55] Steve Abbott has not been donned with the fanfare of "credit" because the act of naming, in the context of New Narrative, had relatively little importance.

I listened to *Fairyland* as a free audible trial and obsessively talked about the book. I recommended the book to my mother. She loved it. The book does not celebrate New Narrative. Alysia Abbott portrays this group from the perspective of the kid who was dragged to poetry reading after poetry reading for lack of a babysitter. It's sort of a revenge story. I have this gut reaction, putting on my Judy Chicago oversized glasses, to defend all those poetry readings. Kathy Lou Schultz, who could be termed a New Narrative protégé, echoes the space between cross-genre work and the mainstream when she writes, "A distance was perceived as rupture and therefore persecuting."[56]

Tears coated my face on a red-eye flight back to New York from California when I listened to the final chapter, about Alysia's detachment while her father was on his deathbed at the Maitri hospice in San Francisco. Then I recoiled at the last two lines of the epilogue to *Fairyland*: "This queer history is my queer history. This queer history is our queer history."[57] As if we must hit ourselves over the head with such a cavernous weight. Of course it's Alysia's and mine and yours, but "ours"? Don't we need "queer histor[ies]" to exist on highly specific terms, in highly specific contexts? "Ours" obfuscates the differences. I want to police Alysia Abbott's "queer history" as if I am wearing a cheap children's Halloween costume. I did learn some "queer history" in *Fairyland*: poet Ed Dorn was explicitly homophobic. But I can't shake how Alysia Abbott's access to Norton is connected to her white straight bourgeois life that she imagines her father would disdain. While she shares this "queer history," I am preoccupied with the fact that many people also writing from this "queer history" are not offered the book deal she was. Alysia's father's friends also need their work archived and their lives entrusted with financial support and security, yet their work would be deemed unfit for the mass market. I remind myself (often) not to treat a mainstream press as an ideal just because they have wider distribution, advances, publicity.

I was eager to ask Steve Benson, "Have you read *Fairyland* yet—what was your friendship with Steve Abbott like?" He generously wrote me back about a file of letters between him and Abbott that he'd unearthed. Benson was laden with appreciation for the constant work Abbott did within the San Francisco poetry worlds of his time and expressed grief for Abbott's early death. I learned that they

had a tenuous friendship, though. Benson asked Abbott in a letter if he was "still committed to an eclectic approach" to writing, which he sees now as a "dismissive" thing to say. Benson also wrote to me about the physical texture of Abbott's letter: "He carefully crossed out by ink pen an entire paragraph of about half a page in which he then says he'd been overly dramatic with nothing to call for it."[58]

Benson cites Abbott's "eclectic approach" as a jab at Abbott's writing for not being committed enough to one aesthetic or style. Perhaps "eclectic" was code for thinking Abbott's poetry was kind of "meh." While Abbott may have been quick to name, to coin, to rally, he was promoting work of artists and writers who often had few cheerleaders willing to bridge work with larger, allied audiences. In his rhapsodic editor's notes for *SOUP*, Abbott gives shout-outs to Judy Grahn and Pat Parker, one of the few times I've seen these iconic figures—Grahn's working-class white lesbian feminist poetry and Parker's working-class black lesbian poetry—mentioned in "experimental" literary contexts. [59]

Abbott is also known for organizing, with Bruce Boone, the Left/Write Conference of 1981. Their preliminary call for participation to "some thirty writers of various ethnic and aesthetic viewpoints" was problematic and repellent for its othering of those working outside their white male norm. Abbott and Boone invited a group of organizers to create a space where "many writers of diverse communities came together, some for the very first time."[60] Abbott authored the introduction to the staple-bound, incomplete conference transcript. I checked my ink pens and rolling suitcase at the desk of the San Francisco Public Library Special Collections to marvel at how imperfect and incomplete the transcripts were. Different volunteers

transcribed different panels and so the styles of summation varied. "Regrettably," Abbott reports, "some cassette tapes were lost or the tapes ran out." In the transcript mimeograph, whole pages are at times blank. Abbott writes of the dissolution of the Left Writers Union, which formed after the conference, resulting from an argument about how to respond to a review of the conference in the magazine *Contact II* that some members believed was "racist, sexist, and homophobic." The Left Writers Union did not recover from this "major split…followed by subsequent splits."[61]

I do no close readings of core New Narrative texts in this chapter. I hope you can do that reading elsewhere. Maybe in bed, maybe sharing copies of books between lovers and friends. Any literary movement is, at the end of the day, a group of people who need each other to make their writing exist: friends, friends of friends, people who maybe want to be friends, people who used to be friends. I asked Dia, if New Narrative is a pervasive and influential style for writers and artists of our generation who are queer, why isn't New Narrative "getting credit"? She wrote back:

> Let's not do that thing where we start to think that
> our attempts at description are actually the cradle of
> the thing. You know? I think this is a real problem.
> We define a literary (or any movement) this way and
> then we think that definition is where the movement
> begins. This is convenient because it offers a clear,
> consensual delineation but it's a false security.[62]

The ethos of New Narrative helped shape Dia's dodging between, yes I'm this, and no I'm not that, ending with the warning, don't "movement" this! We are just writers, who are just people, living and working together, throwing our brains at the page and then, sometimes, throwing our pages at each other.

DETOUR SYSTEMS

there is a perception of knowing but I think it really just is
a kind of avoidance in the eyes, a buried utterance.

—Akilah Oliver[1]

How do you spell change
like frayed slogan underwear
with an emptied can of yesterday's meanings
with yesterday's names?
What does the we-bird see with
who has lost its I's?

—Audre Lorde[2]

I walk through tourists taking pictures of gaudy architecture at the New York Public Library's noncirculating branch. I try to move as quickly as possible amidst the crowds to enter a research room where I am given a shelf to store library books. When *Clamour* first arrived from the offsite storage facility, I expected it to be one of Renee Gladman's early chapbooks. Behind the library's anonymous hardcover were four issues of a finely printed "dyke zine" stripped of its original hand-stitched bindings. Unlike most zines that show signs of age after a few years, Gladman printed hers on archival paper. *Clamour*'s covers, art, and text appear vibrantly well preserved. Gladman exclaims, "Show this to your friends!" around the publication information for each issue, which she edited in San Francisco from 1996 to 1999. I immediately took a cell phone photo of a title page and texted it to Amanda: "Holy shit! Did you know about this?"

Gladman didn't write editor's notes for the first three issues, perhaps to let the social and aesthetic ties of the writers featured speak for themselves. In "See Future Issues," which vaguely resembles an editor's note in the final *Clamour*, Gladman wades at length through feelings of "ambivalence."[3] She problematizes the "mission statement" as a threat to imagination, producing a "margin" one would, ironically, become excluded from.[4]

Clamour aimed to provide a reading experience that "deviate[d] from convention…[as] a response to inconsistencies in language, culture, identity, and communities."[5] Furthermore, Gladman expressed, "I want to present the difficulties I perceive one faces when speaking of experience and knowledge in language, especially when one's sense of identity is complicated by an estrangement

from the dominant culture."[6] Estrangement functions as a beginning, a way of making something from loss and distance. *Clamour* came to me as a messenger from a near past; I found my keyword, but Gladman and I connect to "estrangement" still in vastly different ways. Fittingly, there is no movement naming in *Clamour 4*'s editor's notes. The word "clamour" runs like an electrical current alongside the word "dyke," which appears on the cover page of the first three issues. In *Clamour 2*, Gladman shifts from calling her project a "dyke zine" to "dyke jourine," a word that fuses "journal" and "zine." *Clamour 4*'s epigraph quotes Gertrude Stein and the qualifiers "dyke jourine" and "dyke zine" have disappeared. In the first three issues, on the same page that the word "dyke" appears, so do epigraphs from Ami Mattison, Dionne Brand, and Jayne Cortez, respectively; their epigraphs meditate on the struggle and power in using language as a mode of resistance against white patriarchy. Notably, the word "dyke" never appears alone. "Dyke" is always accompanied with a specific voice channeling poetry.

In "A Crowd," Gladman's poem in the first issue of *Clamour*, the narrator reports: "lots of white people / smiling because you are alone / among them." The discomfort of being tokenized runs high in this poem: "this is about / what is not theirs you are giving." I pause at my excitement in "finding" this zine, seeing myself in the "lots of white people" at this poetry reading. Gladman's publishing project was, on the one hand, for "dykes," and also *not* for me, a white reader. How much am I trespassing? How can I treat Gladman's publishing project with respect while having access to conversations in print between women

of color writers? I could *not write* about this publication. But *Clamour* became the centrifugal force moving all the other books I was reading at the library. *Clamour* became part of my understanding of how to be a writer within a community of writers, which is to say there will always be many things I will never know if I try to understand myself within a community of writers.

The contents of *Clamour* address the intersection of race, class, gender, and sexuality. At the same time, Gladman's project with language over the past twenty years challenges its fixity, or, as she writes about growing up in southwest Atlanta, "Growing up in a black city, around black people, gave me a relationship to language that I've fought to hold on to. The instinct to create a language within a language, to play with speech, to embellish, to obfuscate are among my most precious inheritances."[7] In a 2011 *BOMB* interview with Gladman, Zack Friedman jumps to the question of how her identity factors into her work's experimentation. Gladman recalls a conversation with Bhanu Kapil to answer:

> We couldn't understand, we continued to say, why
> so many people still believe that the "transparency"
> of conventional storytelling somehow allows one
> to capture what it is to exist in the world more
> authentically. Of course, this question has been
> debated within the arts for decades now, but it is
> no less pertinent and divisive today. As a "black
> lesbian poet" you enter language from a place of
> disorientation. Your grasp of the authority of the
> subject is slippery. You feel deviant. You feel the need
> to fuck with things. As you gaze into words, into

their relation, you see things that are not there to
people who have never had to prove that they should
be counted among the living. [8]

In both her Ravicka trilogy and *The Activist*, Gladman
portrays intellectuals, radicals, and poets who speak
invented languages to underscore how, even if people
speak "the same language," they may not understand one
another. A group known as the CPL (with no explanation
of what this acronym stands for) in *The Activist* uses their
secret language to spout anxieties and details about their
planned actions. This untranslatable language also exists
as a rejection of existing dominant languages. Gladman
takes an invented language one step further in the Ravicka
trilogy by creating a whole country, loosely located in
Eastern Europe, a place she insists is real and connected to
African American experience. Gladman pushes her readers
to think beyond a country's official name and presence
on maps. Before these imagined worlds became books in
circulation, she was literally building a place for her peers.

Gladman presented the hyperpersonal alongside poems,
drawings, short stories, and prose pieces in *Clamour* by
printing two letters from friends. In the first issue, Gladman
published a 1994 letter from her friend Ami Mattison, "re:
for the rant of poetry," about Mattison's multiple levels of
exhaustion after a "queer studies conference" in "white-
cold Iowa."[9] I am drawn to this letter because of its implicit
challenge of the word "queer." This letter documents a time
when "Queer Theory," as an academic field, attempted to
assert whiteness as a norm. I am also drawn to and shut
out of its privacy: Mattison writes from Atlanta to digest
a poem Gladman sent her, which "compels" and "impels"

her response.[10] *Clamour's* readers are never provided with a trace of the poem Renee sent and may imagine it as the aforementioned poem "A Crowd," which was also published in this issue. The letter centers on Mattison's experience as one of the few people of color at the "queer studies conference" and after-party. At the time of *Clamour's* first issue, this letter was two years old, which is not very old if one considers that letters are often published posthumously. Read twenty years later, in the age of instant everything, the letter sustains an intense relevancy. Mattison speaks directly toward the nuanced forms of estrangement that motivated Gladman's publishing project. Mattison highlights forms of estrangement that persist in the varied work of actualizing how one *is* a writer in the world: estrangement from the elder literary hero, estrangement from audience of new peers while presenting work, estrangement from a white queer space.

> I met Gloria, yes, Anzaldúa. I tried to say something
> that came out dull while I thought sharp describes
> the effect of speechless: knowing someone who
> doesn't know you, wanting someone who's already
> given what she has to give and she doesn't have it
> anyway. I took her address and hid it like a secret or
> a treasure. Perhaps we'll use it soon…
>
> I looked at the red carpet but turned my head for
> presentation and effect, hoped my brains wouldn't
> make a bloody mess and wished also they would,
> so nobody could leave without stains. The shame
> of their shame is my shame, Renee, and the head-
> bowing yes-umms of white guilt don't make up for it
> or take in useful meaning. White is meaningless and

all meaning-full. Do you blame me for hating and
loving and crying all the same?

 Words like theory and history and culture mark
some of us somebodies darker than others. Language
isn't everything but comes damn near close.[11]

Mattison's letter stands as a testament to the language
within friendship, to one's specific anger within struggles that
stretch in multiple directions. Mattison writes of the papers
presented and listened to at the conference, but also about
the behavior at the after-party. She recounts a white person
who presses against her, whom she did not give consent to,
but then forgives this person a little after realizing "she used
to be a white boy."[12] Mattison and Gladman together, in
their decision to print this letter, disrupt boundaries around
literature's always-shifting, imagined audiences and the
conditions of this literature's production.

In the third issue of *Clamour*, Gladman includes a
letter dated 1997 from Rebecca de Guzman that reflects
on the role of this "jourine" in their community. Guzman
is wary of cheerleading's sidekick, polite silence. She
emphasizes "rigorous critique," without which "affirmation
and celebration become another way to dismiss, to listen
without taking action, ignoring the open moments full
of contradiction and possibility."[13] This letter tempers the
celebratory force of all the labor and sociality that goes into
a serial publication: contributor to editor relationships,
design, printing, binding, publicity, and distribution.
Guzman complicates the separateness of literature by
concluding "this process of engagement needs to be as
complex as the work itself."[14] Gladman seemed to listen:
in the fourth and last issue of *Clamour*, a section named

"Footage" emerged to formalize this impulse to use prose to document her extended communities.

The word "footage" calls to mind a bulk of moving images selected from and stored out of view. Moving down the etymological list, "footage" references a delineation of space or a way to measure. As a subheading for writing, "Footage" tasks language with the slowing down of both what is chosen to be shown and what is chosen to be hidden. The last section of "Footage" is a profile on Serpent Source Foundation for Women Artists, a grassroots organization founded in 1996. Executive Director Julia Youngblood states: "We exist to fund women from poverty and working class backgrounds, women of color, disabled women, women not formally trained in the arts, and those whose work embodies a political and social-change focus." Serpent Source functioned in the model of "peers supporting peers." Gladman notes that this organization funded postproduction for two of its issues and also provided grants to some contributors of *Clamour 4*: "It seems appropriate to begin showcasing some of the organizations behind queer/experimental writing communities." I note here Gladman's use of the word "queer" as opposed to the word "dyke," of previous issues. In a continuing moment of art actively being defunded to censor artists, naming a source Gladman got support from is like providing a map. The Serpent Source letter stands out as what Gladman calls "more than literature," so that the reader would have the "sense of a fluctuating world—of the person in the world, in public, in transit."

Pamela Lu's "Report," in the "Footage" section of *Clamour 4*, reflects on the Chinese, Indian, Japanese,

Korean, and Vietnamese neighborhoods (and their restaurants) of the Bay Area to illustrate the back-and-forth import-export of cultures hybridized by globalization. She writes to make sense of the notion of place after a "feeling of familiarity and déjà vu" on her first trip to Asia.[15] Lu marvels at how teenagers in the Harajuku district of Tokyo rebel against their school uniforms with fashion statements exuding eclecticism. This style is documented in the Japanese fashion magazine then known as *Kerouac*, implying a Beat poetry influence. Unlike poetry, *Kerouac* is sold among candy bars at the corner store near Lu's hotel in Tokyo. Lu compares what she sees in the fashion street photography to the "fusion cuisine" popping up in San Francisco's SOMA, Castro, and Mission neighborhoods: "Asia was now, more than ever, giving back to the West what the West had introduced in the first place: mass-produced pop culture."[16] This consumer awareness, interchangeably embodied in anti-school-uniform outfits and language printed on menus, prompts Lu's reflection on how trends recycle into a "convergence," which ultimately influences her aesthetic sense to be "as sarcastic, plastic, and inauthentic as I feel." Lu's "Report" attempts to bring contemporary mainstream literature up to speed with what she names "a politics of discombobulation:"

> The trend of irony in contemporary cross-cultural
> current has, I think, successfully warped the linear
> narrative expectations of the kind of Asian American
> novel that became popular in the late 80s to early
> 90s and prevails to this day, as in: protagonist feels
> alienated from two disparate cultures, protagonist

comes of age by learning Old World wisdom of elders and New World smarts of peers, protagonist experiences clarity and empowerment as a result. In today's paradigm, an encounter with the Old World is likely to have more than a taste of Brave New World and leave one more confused than clarified, though perhaps no less empowered, and certainly more complicated. I'm stacking my bets on the avant-garde to develop complex enough tonal sensibilities and aesthetic techniques for dealing adequately with these kind of issues and making of their mixture an ultimately authentic experience.

Lu presents an opportunity for cultural remix to provoke formal innovations. She delights at the perpetual rebirth of what was once trendy in the global consumer juggling of junk: "I can dig out Hello Kitty™ products from the back of my childhood closet and display them with pride."

Lu's "Report" reveals a seed explored much more exhaustively in her second book, *Ambient Parking Lot*, which tracks the vacillating thrills and doldrums of a group of musicians who trek from the unique quandaries of obscurity to overexposure. The "avant-garde" that Lu stacked her bets on in 1999 is portrayed in 2011 as a "band of misfits"[17] never able to sustain self-worth. In other words, precarious market viability might feel like more of a bummer than a vague halo of success. Lu employs satire as an oxygen mask to mock the social reward systems of artistic production:

An untimely fall from ill-fitted platform shoes brought our party career to an end…we hired fawning interns from the art institute to fluff our pillows and cook

> us comfort food. In return, they earned two units of
> independent study each, along with bragging rights on
> the fringe gallery circuit.[18]

Lu's first-person-plural narration is a form of self-surveillance to expose the Ambient Parkers' wavering authenticity. The book includes lengthy digressions of the bad fan-mail variety, as if a court transcription investigating the group's ethics while deep in their process. In a radio interview with another ex-fan, a former collaborator of the Parkers exposes the physical and mental toll she experienced when doing a dance performance with the group. Besides these unflattering testimonies, the narrative of first person plural includes hilarious flourishes like the log of the hired private investigator who followed the Parkers' "salaryman" when he didn't seem to really be doing his appointed office job in order to financially support the group. Lu's Ambient Parkers ultimately criticize the activities of any avant-garde, especially when it elects to speak from the point of view of a "we."

"From Amnesia," Tisa Bryant's "Report" in *Clamour 4*, also examines the ruptures in a "we," with an excoriating portrait of how racism and classism underlie gentrification. The time and place is San Francisco's dot-com boom, which has since been renamed the tech industry. Bryant traces the steps of the "someone" who goes "unnamed," alternately the gentrifier real estate developers and politicians who grant the real estate developers access to gutting neighborhoods. Bryant's "Report" is one paragraph of block text and reads like an urgent news report about a lot of white people moving into the latino working and middle-class Mission neighborhood[19]:

Where are you, my favorite noise? Chorus of poor
women holding ink-smeared hands, gouache in their
hair, mural this eulogy. Now power couples abound,
so sexually diverse we shouldn't complain. But do.
Watch them point the finger with toy guns, toy with
resistance, accuse each other of enjoying the Seismic
Solution exemption. This is the "other" white meat's
Battle Royale, electrified Nissan mugs of latte nailed
to the café counter. Who affords invisible irony. Pet
that pedigree bitch Economy. See that picky-headed
brotha plastered on yet another plywooded chi-chi
den-in-progress. He's holding a little red sign that
says, "forget class." A tense past tearing. You look
vaguely familiar. Have I lived you? What are you
called again? How long have you been gone?[20]

The people who frequent this scene push against the
question of the mutually exclusive: "Chattering junkies.
Activist boot camp" bump into one another and/or are
one another. Bryant's prose is all-at-once, a street-level
view, relentless and scattered with details. What is seen
depends on who is doing the looking. Her language
unrolls simultaneously in slow motion and at a swift pace,
as if the two ways of walking were tied together at the
ankles. The "something someone" is never anonymous
to the people of vulnerable neighborhoods. Bryant asks
systemic racism to answer, but she uses no question
marks. The jumps and pivots of her prose watch "sexually
diverse" "power couples" demonstrate how the oppression
that faces a gay person does not exempt that gay person
from the oppression they dole out as a gentrifier. I learn
from Bryant she could hear the sound of the 26 bus line

from her apartment window and the Good Vibrations sex shop was on the ground floor of her building on Valencia Street.[21] Flash-forward to 2009, when the 26 bus line closed and luxury buses for google employees took its place.[22] People threw rocks at these buses when they first appeared.[23] Good Vibrations is still going strong. Bryant's "Amnesia" is a public space that quotes the oblivion causing objectification of people in their neighborhoods. Bryant's "tense past tearing" switches masks: adjective over noun then subject over verb. The multiple roles of words produce a grammar that spins into overlapping conflicts searching for agency.

Bryant and Lu's "Reports," as well as Guzman and Mattison's letters to Gladman, produce a picture of "clamor" that grapples with "queer issues" persisting in the moment I write this book: white supremacy, assimilation, cultural appropriation, gentrification, income inequality. I believe Gladman avoided movement naming in *Clamour* as a form of resistance to the white-straight-male-dominant cultures in literature that have established themselves through systems of naming. Gladman's statement "the illusion is that one understands 'today'"[24] reads to me as both an intervention into and a separation from the geographically ambient lineages of New College (where Gladman went to graduate school), New Narrative, and Language Poetry. Gladman's "dyke zine" is also a crucial contribution to the tradition of feminist experimental literature publishing projects such as *HOW(ever)*, *Narrativity*, *Tuumba*, and later, *Chain*.[25] I am grateful *Clamour* does not offer me a movement on which to theorize. Instead I am prompted to read texts closely and think slowly because *Clamour*'s history is still alive.

The evasiveness and doubt that pervade Gladman's "See Future Issues" read as a radical gesture if contrasted to Steve Abbott's "Remarks, Hello" (editor's notes) in the first issue of his magazine *SOUP*. Abbott *insists* on the innovation happening within its pages and subsequently coins "New Narrative" in a later issue. He introduces the work he edited as if providing the steady repetition of a television commercial's script that appears several times throughout a sitcom's broadcast:

> What unifies this work, aside from its thematic
> sequence, is what I see as a new philosophic
> seriousness yet a new attention toward popular culture;
> a new concern for craft & structure (often focusing on
> the nature of language itself) yet a new (s)punkiness.
> In short, I see a new drift in form and sensibility
> developing…new audiences must be created.[26]

The sheer number of times Abbott uses the word "new" wipes any specific meaning from his mission. Abbott could be describing any twentieth-century modernist, postmodern, or post-postmodern movement. Abbott's "new" mentality stands in opposition to Gladman's publishing writers who use experimental prose and poetry to write on struggles that have *always* been in and around what gets called literature. What Abbott claims is transformative, I cannot sense. I feel like I "had to be there." Meanwhile Gladman waited three years before reflecting in print about *Clamour*, valuing the role of talking, waiting, and watching.

Rachel Levitsky, who did an East Bay Artists Residency in the fall of 1999, speaks to the zeitgeist in *Clamour 4* as a tiptoeing toward the trouble with placement of self in

communal histories: "It's the nineties of some century so we have again forgotten how to speak. We have trouble with commitment but like to imagine ourselves in a position of control so we plant—which is interesting if you look at the folded nature."[27] The historical work of these feminist publishing projects maneuvers through metaphor as opposed to movement naming. Much has been planted and grown since *Clamour*'s last issue. The spirit of *Clamour* was carried over into Leroy Chapbooks, which, as Gladman announces in the Contributors' Notes of *Clamour*'s last issue, "aims to publish long innovative works by writers of Color (and maybe one or two White people)." Levitsky's chapbook *Cartographies of Error* was one of Leroy's first titles.[28] Gladman's Leon Works now operates as a book-length press.[29]

In a similar vein, Levitsky founded the feminist avant-garde collective Belladonna* in 1999.[30] Much of my access to works in progress and early work of women-identified experimental writers is made possible because of Belladonna*. The Belladonna* Elders Series (2008–2009) paired writers of different generations together in perfect-bound editions with an interview between the two and a public event to celebrate the book's release. erica kaufman, who worked with Rachel as a co-editor and co-curator, tells me in the margin notes of this chapter that the Elders Series was intended to provide dialogue about lineage and influence *without* necessarily naming movements and schools. Rachel responded to a draft of my book by saying let's collaborate, and we began a series of co-written critical essays called "Social Reading" in *Jacket2*.[31] The spirit of *Clamour* is also palpable in *The Encyclopedia Project*,

edited by Tisa Bryant with Miranda Mellis and Kate Schatz. A physical series of books, as opposed to a broken hyperlink or hard-to-find chapbook, *The Encyclopedia Project* invites hundreds of writers and artists to claim words of their choice within an alphabetical order. The three volumes problematize the task of "defining" by featuring the various, personalized, and associative work of the contributors.[32]

The "planting" and "folding" Rachel writes of in her prophetic text from *Clamour 4* resonates with the many seeds of small press microcultures. Yet much of this production lives in difficult-to-locate personal and institutional archives. In *Clamour 3*, Contributor's Notes began to appear. This is where I learn, in Pamela Lu's bio, of her participation in *Idiom*, a collective of a dozen or so writers producing chapbooks and an intergenerational reading series, founded by Alex Cory in 1994. Lu's bio inside *Clamour* lists a hyperlink for *Idiom*. I couldn't find the *Idiom* website on the Wayback Machine. I do find Lu's "*Idiom*: A Story of Anti-Production, or the Triumph of Sloth" on the feminist experimental literary journal *How2*, a digital extension of *HOW(ever)*.[33] *Idiom* published an early chapbook of Gladman's titled *Arlem*, a neologism that sounds a little like Harlem mixed with the noise of alarm. Lu sent me a pdf of spreads from some *Idiom* chapbooks with a caption that tells me *Arlem* is a "long poem, which revolves around the cultural and social ethos of a well-attended group poetry reading by young lesbians of color held at the Women's Building in San Francisco, circa mid-1990s."[34] The energy of Gladman's chapbook is derived from thinking alone verses thinking (or dreaming) in

conversation. Gladman writes in *Arlem*, "You once said there was a difference between what something does and what it originated to be and we would see it once the thing became public."[35]

The energy of the above-mentioned publishing projects inspires my resistance to calling art "queer" because they are driven by the desire to restructure dominant ideas of narrative not only inside the texts but in how the text is disseminated. It's disorienting for me to encounter what is increasingly termed "queer art" and to find so rarely in these encounters the writers I champion in this book. I find the macro machine of art world institutions so far out of sync with the microrhythms of writers who support other writers because that is often the only way the experimental writer's work survives.

I pointedly asked the question "Where is Renee Gladman, Pamela Lu, Tisa Bryant, Rachel Levitsky, Stacy Szymaszek (and the list goes on…)" while visiting Carlos Motta's *We Who Feel Differently* exhibition in New York. Motta's glossy 3-D archive was installed in 2012 at the eerie condo-style top floor of the New Museum. The installation included a series of benches in front of half a dozen screens and headphones playing a loop of fifty video interviews he conducted about LGBTIQQ politics and cultural production. The interviews feature well-known activists, academics, doctors, lawyers, artists, writers, and curators from Colombia, South Korea, Norway, and the United States. The benches shared the floor's rainbow carpeting as if they were the rolling hills of a comfortable classroom. Books positioned as queer classics sat on the benches, laminated for public durability.

Motta calls *We Who Feel Differently* (*WWFD*) a "database documentary" that exists as traveling installation, symposium, events programming, website, library, sporadic journal, and book. These physical and online containers for *WWFD* increase people's access to the project beyond a temporary exhibition. Similar to *Clamour*, Motta's "database documentary" challenges what is lacking from the mega-institution by creating its own version of an archive. The keyword "difference" of the project's title elucidates a resistance to both heteronormative culture and the mainstreaming of gay rights to assimilate into that culture.

The book version of *WWFD* is composed of chapters that reflect recurring themes in the interviews. Carlos Motta and his sister Cristina Motta co-edited the fifty opinionated voices, which are introduced by ellipses encased in parenthesis. The punctuation quietly sculpts excerpt upon excerpt of interviews pasted together. For example:

> Speaking about the value of art as a register of what wants to be told but also of what wants to remain hidden, Katz affirms, "(…)[36]

The interviewees' voices are reorganized as if to submerge readers in the overlapping conversations of a crowd. A new voice is often introduced into the mix with just one summarizing sentence that includes their name, title, and location. The vast majority of the book consists of quotations, which are laid out as consecutive paragraphs and present the text as an achievement of continuity as opposed to discord. The sewing together of interviews in the book questions authorship while toying with the danger of the first person plural. When I first read the *WWFD* book,

I found myself consistently losing track of who was being quoted when. Motta's project upholds the documentary idiom, producing the side effect of wondering, where's the *director's* voice?

In the chapter titled "Queering Art Discourses," an air of light manifesto pervades the editorial introduction, which defines "Queer Art" tentatively, in quotes, as a "'notion:' [of] an art that represents names, discusses, engages and insists on sexual difference."[37] What the editors name as "Queer Art" (the Mottas capitalize this phrase) has been "silenced" and "censored…by the *status quo*, the art market and institutions."[38] Yet propaganda for "queer art" that is at risk of being censored only advocates for art with definitive "queer content" on its surface. Art historian and curator Jonathan D. Katz promotes the term "Queering Art Discourses," despite how far "queering" is from a routine set of actions.[39] Katz's demand for more "queer discursive frames" must also account for what might come with the discursive frames once they supposedly arrive, which includes the resistance on the part of the "queer artists" being "framed." The discursive frames already exist and have existed on separatist fronts: the way queer people talk about and produce work are daily survival mechanisms. How this language gets adapted for various institutions feels at times a threat and at other times beside the point.

Katz is concerned with a type of overarching silencing in language that has functioned to erase white homosexuality, which cannot be cut-and-pasted to "queer" "discourse" writ large. The proposal to queer art discourses might be relevant with scenarios such as this one: when

I was discussing Bruce Boone's exemplary New Narrative story "My Walk with Bob," a few students assumed the narrator was a cis-woman simply because they are referencing "a boyfriend." This was *after* I gave a brief lecture on how Boone uses a walk with a friend and fellow writer as a time frame to discuss a wide range of issues: their childhoods, friendships, heartbreak, long-term-gay-male relationships, homophobia, and difficulty continuing a Marxist reading group.

Because there are such different and unarticulated languages being used to talk about "queer subject matter," we must be hyperaware of how the "don't censor us for our gay sex content" argument, which could easily render work with "queer subject matter," among other subject matters, seemingly nonexistent. Visibility is not the goal for many if visibility means being shoved within a context of white heteronormativity.

Motta's project broadly examines the problem of invisibility of queer subject matter across four countries' historical social contexts in 2011. The overarching goal of my project is to problematize the notion of queer subject matter by looking closely at work that may not be "visibly queer" while remaining powerful, because it is not always explicitly marked as queer. I am reminded of how in 2014 Strand Book Store tucked wide rainbow-colored bookmarks into those titles whose authors are known to be "gay." "June is Gay Pride Month," a separate sign explains. I fume when I see this flag only inside the books of cis-male identified writers. Renee Gladman's books would probably not get that rainbow bookmark. Then again, at a bookstore like the Strand, I rarely see experimental prose

writers featured on those display tables. I am reminded of my excitement upon finding *Clamour* because Renee Gladman called it "a dyke zine." I watch what tempers my exuberance around the word "queer": the suspicion the word will be synonymous with white-gay-guys or people who enjoy privileges of cisgender heterosexuality. On the other hand, the word "queer" crucially includes and affirms non-binary and trans people in ways the word "dyke" has not.

I found a striking similarity in the multiplicity of voices of Motta's "database documentary" to a polyvocal experimental prose book such as Renee Gladman's *The Activist* (2003). The plot line in *The Activist* mutates as a contested piece of information. The state claims that a group of activists, known as the CPL, is responsible for a bridge exploding. Another group called The Commuters claim the bridge is still there. *The Activist*'s rotating narrators often struggle with being stuck at a periphery. The activists find it difficult to communicate clearly with one another while plotting anticapitalist actions. Their story is told out of sequence and often subject to the interference of the vague and distrustful media. *The Activist* is primarily a commentary on how "a plan to stop the swarm of corporate America" might go awry.[40] In the chapter "Radicals Plan," the uncomfortable leader of the group, Monique Wally, does not know how to articulate to the group that the map of downtown is disappearing as they look at it:

> to tell them that the line on this map representing
> Third Street has just vanished will cause them to
> lose faith in me. And this was our most overt action!
> It will fail if encumbered by disbelief. I have to get
> us back on track.[41]

Gladman's writing often ruminates on how the authoritative line drawing replica of a city is suspicious, as is consolidating power into a single leader. The highly abstracted fiction of maps prepares readers for Gladman's proclivity for re-creating the directionless ramble. The bridge, there and not there in this book, suggests how unconnected activist struggles can feel both from dominant culture and from each other, much like the dissolution and tenuous coalition building in Lizzie Borden's 1983 film *Born in Flames*.

Toward the end of *The Activist*, Monique and Stefani are apart from the CPL while under a sort of sex-infused house arrest. The lesbian action here is understated. The lovers don't leave bed even though there are no groceries in sight and the phone is continuously ringing. Gladman has this distinct ability to make readers forget what just happened; her books create the feeling of waking up from a dream, the details of which have just slipped away. Her body of work sticks to the plan of a disappearing map. The activists' sense of individuality enters a final blur with their sociality when the plot gravitates toward personal desires that nudge their way into the political organizing.

Unlike Motta's documentary, where he relates to his subjects with a cool and professional distance to present his interviewees as strong leaders, Gladman portrays her activists with extreme intimacy to highlight their vulnerabilities. Often the activists are tired, hungry, or drugged, which results in an apparent lack of coherence in their "plan." The reader is left unsure of whether the government is even responsible for the interrogation-induced drugging, or if members of the group are just

hungover. Gladman similarly shows Monique's struggle with lucidity as the group's leader. Monique is baffled when she successfully rouses her group and its growing followers to action. The political action remains suggestively mysterious, perhaps taking place outside the book's narrative. The unrelenting support from lovers and friends performs the main event of the book's conclusion.

Why wasn't *The Activist* on the *We Who Feel Differently* webpage featuring a "Queer Bibliography"?[42] *WWFD* is adamantly not a survey; the bibliography in full transparency announces that it is compiled from solicitations and suggestions. It's impossible to "include" everything, and the margins of the supposed queer margins will shift for everyone. Considering that disclaimer, my expectation for a larger presence of experimental prose writers in Motta's project, such as Gladman, whose form may at times obscure the presence of lesbian/queer/trans/gay content, seems unfair, but I can't shake it either. I emailed Motta while writing this chapter to suggest all the authors I champion in this book. He graciously agreed to add them to the bibliography. I am not interested in offering a revised canon, because canons have historically acted like deaf hierarchies. How to make the rereading of a zine or the study of a "database-documentary" something active, moving, and approachable? Projects that resemble anthologizing highlight how "queer artists" are culled from different artistic lineages. Inclusion and exclusion are faulty frames. It just depends on who is reading or who is talking, and luckily there are a lot of people reading and talking.

If I am forced to be optimistic, increased use of the word "queer" will increase the range of materials in archives of

art and writing made by those who identify as queer. When I am forced to stare our capitalist hell in the eye, I see things like a sticker, a black circle with white text on the outside of a Phaidon Press book called *Art & Queer Culture* (2013) that has the audacity to claim it is "the *first* book to focus on the criticism and theory regarding queer visual art" (emphasis mine). We can translate this to mean "the first" coffee table-style book on queer culture a major art publishing house has produced that's not for an exhibition. I refuse to buy the book. For months I only seethe at the sight of it. I try to understand my blind anger and vague distrust of Phaidon's violation of queer history. Then I begin schlepping *Art & Queer Culture* from the library, renewing it, returning it, checking it out again. I find out in the introduction about a photography themed lesbian pulp novel called *Darkroom Dyke*, which I am still looking for a copy of (please do not hesitate to send me *Darkroom Dyke*, dear reader, if you have an extra copy laying around).

I started to wonder what it was like for the editors, Catherine Lord and Richard Meyer, to work with this publisher who must undoubtedly pitch the book far outside what I envision as the infinite and incommensurate "queer market." Once I was spewing my outrage about the sticker on the cover of *Art & Queer Culture* in the home of someone who then pointed to her copy of the book on a shelf. My critique does not want to negate the presence of the thing being critiqued. So much must have been out of Lord and Meyer's control; I doubt they are responsible for that disavowal of calling this book "the *first* book to focus on the criticism and theory regarding queer visual art."

Not long after discovering this coffee table book displayed at "the new" bookstore by MoMA PS1's ticket

kiosk, I was at my friend Paul's birthday party in a room of fags, the only trans-dyke there, close to 3 a.m. I was swaying in a noncommittal way to the unidentifiable but vaguely recognizable pop music when I asked someone what he meant when he told me, "I am a queer writer and I write about queer existence" or something like that. But what could you possibly *mean*, I exhorted; I wanted to hear in his grammar that a "queer writer" isn't *just* a defensive stripping of gender and sexuality for the sake of more infinite devices to combat his idea of normativity. He summarized José Esteban Muñoz's aspirational efforts in *Cruising Utopia* as linking the word "queer" to a future that does not exist yet. He was telling me about the book and I said yeah, I read it. He was amazed that I had read something he had. I was baffled. Isn't that the idea of this loose group of people working together on something, that we read things together?

Sometimes I fail at my dictum not to use the phrase "queer art." When I asked a librarian to retrieve the call number for *Art & Queer Culture*, he couldn't find the book in the database because I was calling it "Queer Art and Culture." I renamed it, somehow, to what I am critiquing. Usually I use the word "queer" like I use toilet paper.

QUOTATION CLOCKS

voices travelled
over the phone, spiraled into the labyrinth, my inner ear
that sat like a snail, listening. They repeated
turns and streets. I wrote their words down,
then propped the sheet of paper on the seat beside me
as I drove.

—Minnie Bruce Pratt[1]

To speak of oneself in language we are always closing our
fingers in doors...

—Renee Gladman[2]

I said in a rush that famously false realization, "I feel like I should stop being an artist and start being an activist." Caitie just laughed at me and said Dean Spade would be the first person to tell you to keep making art. We were walking to find a cheap place to eat and settled on a super deli that served reheated frozen pizza. Caitie had saved me a seat at the talk "You Gotta Serve Somebody: Rethinking Race, Queer Politics, Practice: A Critical Dialogue," a discussion between Urvashi Vaid and Spade moderated by Rosamond S. King in March 2013.[3] As Vaid and Spade sat behind a table on a stage facing the audience, they noted this was the first public conversation they had had since their friendship began, when Spade was twenty and Vaid forty. They each gave an overview of their books and their work as lawyers and activists. Spade outlined, in a rapid cadence, the tenets of Critical Trans Politics and prison abolitionist work, while Vaid reflected on her work integrating racial and economic justice movements into mainstream gay activism.

During the Q&A, King explicitly requested just *one question each*, which she collected in small bundles from the audience and summarized back to the invited speakers. One person read a long page of notes on colonialism in order to arrive at their question. At times King was tasked with extracting meaning from the circuitous thoughts of an audience member. Vaid spoke of the devastating "muteness about race" in the white gay mainstream movement. She highlighted how a postracial ideology depends on the erasure of histories and contemporary realities. She went on to say that there are tons of queer people of color organizing and creating art in all sorts of organizations, the National Queer Asian Pacific Islander Alliance (NQAPIA) as just one

example, but in forty years of funding for gay foundations, only about 8 percent of that three-quarters of a billion dollars went specifically to people of color. She then turned the question over to the moderator, which unsettled the routine of invited guest speaker as "the expert." King spoke of her experiences as an organizer of the third Yari Yari Ntoaso Conference in collaboration with the Organization of Women Writers of Africa in 2013. She also spoke about activism outside the u.s. with organizations such as the Coalition of African Lesbians (CAL) and Caribbean Forum for Liberation and Acceptance of Genders and Sexualities (CARIFLAGS), explaining:

> Some of it is invisible and some of it *needs* to be invisible and some of it is invisible to people who don't know how to see it…A lot of the organizations in the Caribbean…there's not the tradition of identity politics that there is in this country and so when people from North America and Europe say well they're not gay enough, basically, you need to be gay the way we're gay, you need to call yourself gay or lesbian, you need to call yourself queer and you need to work with anti-criminalization efforts and do a particular type of activism whereas in the Caribbean in general that's not the kind of activism that has happened. The major activist movements in the Caribbean have been anti-slavery abolition movements, nationalist movements, and Caribbean feminism. You have a lot of sexual minorities within the region who are saying not we want things because we're different but we want things because we are actually a part of you. It's a fundamentally different

approach. Even the names of the organizations, the
Coalition Advocating for the Inclusion of Sexual
Orientation in Trinidad and Tobago (CAISO),
Society Against Sexual Orientation Discrimination in
Guyana (SASOD), they don't have LGBT in the title.[4]

"Queer Politics" might have slipped into shorthand at
this discussion in New York City, but only to remind me
that "queer" is *not* an international word or framework.
King pushed beyond the point that "queer" or "lesbian"
or "trans" constantly shift meanings; she highlighted how
these words may not even be present. My sense of the
word "queer" increasingly becomes specific to the place
it is being used or not used. King encouraged awareness
beyond personal geographic uses of language in order
for the hierarchies to be dismantled within a single word.
Q&As are key sites of observation for me about how the
word "queer" is and is not functioning within discussions
that don't exclude art but also don't prioritize it.

In June 2011, when CeCe McDonald acted in self-
defense against a transphobic, racist attack, she was a
fashion design student. She was charged with second-
degree manslaughter and put in a men's prison in St. Cloud,
Minnesota—despite her identification as a woman—for
nineteen months. McDonald was released in January 2014
due to her strength and resistance and to the lobbying
efforts of many activist groups.[5] Cece McDonald's writings
throughout this experience and her leadership is an
inspiration in the prison abolitionist and transgender
communities. Her first major public appearance in New
York City was a conversation titled "'I Use My Love to
Guide Me': Surviving and Thriving in the Face of Impossible

Situations."[6] McDonald sat with Tourmaline and Dean Spade talking about her experience of becoming politicized while incarcerated. She recommended self-educating and recalled reading *The New Jim Crow: Mass Incarceration in the Age of Colorblindness.*[7] One piece of advice McDonald gave the audience: don't pretend to be an activist just because it seems cool. It's a lot of hard work.

Halfway through the Q&A, a white, queer-identified, jewish woman got the microphone and defended America as *also* a good place because it accepted her great-grandfather, who was fleeing the pogroms outside Minsk at the end of the nineteenth century. She then announced, to much of the audience's horror, "Capitalism works for us wonderfully. I found as a queer woman, my money is very very welcome. And that's why certain politics change. It sucks but it's true. How are we going to work with that? What I want to ask you is this…" McDonald then asked her to stop speaking—she had to respond to her preliminary question:

> I'm going to let you get to your question, but me
> growing up as an impoverished, Black, African-
> American, transwoman, *capitalism* wasn't my friend.
> So let me tell you, I had to struggle, literally going
> through systems, going through systems to get a
> fucking plastic card with some, with fifty dollars
> worth of food stamps, but you're good because you
> get a paycheck every month, but everyone don't get
> that. Everybody don't get a paycheck every week,
> though. And that just pissed me off. Sorry, I don't
> know you but that really did just piss me off because
> your capitalism didn't do shit for this room. For real.

So I'm just letting you know. I love you as a person, but that shit you could have kept to yourself because capitalism didn't do shit, it just created a whole bunch of problems: hierarchy, sexism, racism, all, anything you can think of, any "ism" you want to place in front of a word, go ahead cause that's where capitalism came from…People need to realize—I was always taught: think before you speak…Dean was explaining how America was made through people's coming through and running through people's shit and saying this mine, y'all got to go…Now all these displaced people gotta figure out how they gonna do, why? Because a certain culture decided that they were better than everybody else. So now we're, everybody in this room, white, non-white, now we're in here and we still fucked up…I got to deal with this shit everyday. I had to do this shit for, what, ten years? This is some real life shit…Like I was saying I was sleeping on park benches, literally eating grass to stay alive…So.[8]

The audience member eventually spoke of being recently unemployed and struggling and wanted to fit McDonald's life and story inside her own, a veritable impossibility. The crowd booed her multiple times to get her to sit down but she finally asked her "real" question about how McDonald thinks her attackers should be punished. This question evinced her inability to understand the revolutionary vision of McDonald and her experience of the criminal justice system: prisons aren't safe for anyone, not just trans people. McDonald replied, "I'm too far in the future to be worrying about people who tried to destroy me. I'm going

to let them destroy themselves." While passively arguing with McDonald, the audience member got to ask *two* questions, tell a mini life story, *and* receive a fast education in how her privileges operate within oppressive systems. Tourmaline jumped in as moderator immediately after this exchange to acknowledge, "It's a lot of labor to break this stuff down to people who don't understand it or also might be benefitting from it."

In the classic text *This Bridge Called My Back: Writings by Radical Women of Color*, Cherríe Moraga elucidates a key pattern of conflict in the evolution of the Women's Liberation movement and the "fragile" relationships between those working in the movement. People must ask themselves about their ability to oppress other people while trying to liberate themselves. Moraga calls for "a new language, better words that can more closely describe women's fear of and resistance to one another; words that will not always come out sounding like dogma."[9] Moraga resists the flavor of dogma that many overarching political and personal words adopt, especially when they exist without actions to back them up. She calls for specific accounting of the language just one person uses when talking to themselves, and while talking within a shifting group of people, whether it be on a local or international level. I took Moraga's advice and started to ask myself how I have operated in the role of oppressor.

Two years into writing this book, I realized I had avoided examining my race and class because I assumed they would be boring topics and deflate the polemical voice I strived for, despite the ambivalent voice I ended up crafting. When I first started writing this book I was not

yet ready to abandon a complacency accompanying the routine to assimilate into the idea of a white u.s.a. The story of this book is how I abandon the complacency necessary to assimilate into the idea of a white u.s.a. My parents have been expert jewish assimilators, most notably shedding their own basic command of Yiddish and its future as a functional language within secular life. "I could have been a Yiddish poetry scholar," I joke with my parents whenever I feel like they killed this plant I needed. They remind me, "You still can do that, it just doesn't seem like you *want* to." Their assimilation was a product of fleeing oppressive religious jewish communities. They were able to move into that ever-widening middle-class bracket through the model of steadfast education toward a practical profession. The only real religion they instilled in me was to be kind and to read. Read constantly.

My father, Ira, grew up in the East Bronx. He endured going to a yeshiva five blocks from his apartment until he was fourteen. He then begged to leave the rigorous jewish indoctrination to go to Jamaica High in Queens, where his family had just relocated. My grandfather wouldn't even let my dad into his butcher shop because he wanted him to get a college degree. My dad instead worked as a delivery boy for the pharmacy in high school then apprenticed at accounting firms while going to Baruch College in Manhattan (which he recalls cost $75 a semester plus the cost of books). He had a passion for playing with numbers and worked for fifty years as an accountant, forty of those years in the same firm. When I asked my father what luxuries he now enjoys, retired in Sarasota, Florida, he said owning a car and getting *The New York Times* delivered to his door.

My mother, Ellie, emigrated from Poland when she was five with her parents, who were Holocaust survivors and received the help of Hebrew Immigrant Aid Society. She was an outcast in school until she learned English. Her mother died of breast cancer when she was fifteen. She received a half scholarship from Cedar Crest College and a half scholarship from B'nai B'rith International to pay for college. She got near perfect scores on the verbal sections of all the standardized tests she took. The summer before my mom went to college, she got a temporary job at the onesie pajama factory where my grandfather worked. Another summer, she got a job at Unity House, a resort in the Poconos for the International Ladies' Garment Workers' Union (ILGWU). She sold candies and papers at the newsstand. Nearly all my grandparents, great-aunts, and uncles were garment workers. My mom became a social worker in 1973 with the Department of Public Welfare in Protective Services for children in foster care in Philadelphia. They paid for her MSW at the University of Pennsylvania. When she moved to New York, she worked for Lighthouse International, an organization for those suffering from vision loss. She got certified as a therapist and worked in a counseling center in Montclair, New Jersey, before later opening a private practice in our home. I grew up with a noise machine producing the sound of a low humming wind in the far end of the kitchen, which safeguarded confidential conversations with clients. I abided a schedule of silence when clients were entering or leaving our house through a side door.

My grandfather had savings composed of war reparations from the German government combined with

the inheritance of his brother, Ignash, who owned a brothel in Kiel, Germany. This money plus half of my father's savings miraculously paid for my undergraduate and graduate education. Anytime I think about how lucky I am not to be mired in student debt from private universities, I think about how this is partly because I was the only kid to send to college. I had a brother who died of brain cancer when I was six years old; he was eight. My father insists that even if Danny lived, he would have helped me have as little debt as possible. The fact that I don't have student loan debt is directly related to the time and space I have to be able to write this book. I currently piece together an income from private universities that charge criminal tuitions. Every semester I start over to secure classes that are not guaranteed to enroll. I currently make about $40,000 a year.

Tisa Bryant writes: "To be self-taught is to control identity formation."[10] When I started writing this book, I wanted to steer away from "academic" texts on queer theory to craft the voice of a public intellectual as opposed to the voice of a PhD dissertation. Meanwhile, I have learned so much from critiques of the academy from queer of color academics. Michael Hames-García traces how, since 1990, when certain theorists started getting excited about "queer theory" being a thing, and naming it as such,[11] "identity politics" were removed as part of a routine to "erase people of color from the center of the debate in order to reintroduce them later at the margins of gay and lesbian theory."[12] Hiram Perez also draws attention to this violent routine by demonstrating how "queer" is far from immune from racist actions. In the *Social Text* special feature "What's Queer about Queer Studies Now?" Perez deconstructs his

experiences at the Gay Shame Conference at University of Michigan in 2003, where he was the only scholar, among forty-five invited guest speakers, who was a person of color. Perez's essay titled "You Can Have My Brown Body and Eat It, Too!" restates the history within "queer theory":

> In its institutionalization as an academic discipline, queer theory took the question of its political viability off the table. But if queer is to remain an effective troubling of the normative and its attendant regimes, it must painstakingly excavate its own entrenchments in normativity...The identities "gay" or "queer" or "lesbian" do not preempt queer theorists from reinstituting masculinist biases and patriarchal privileges.[13]

Perez puts "gay" or "queer" or "lesbian" in quotation marks to remind readers of both the individual and collective minds, bodies, and histories of everyone who uses these words. The quotation marks hold the instability and specificity of *who* is using *which* words, echoing Moraga's warning about how words can fall prey to "dogma" and can be utilized against liberatory intentions.

Judith Butler appeared lonely and trapped in her mythic role as powerhouse "queer theorist" at the Dance Discourse Project in San Francisco in 2013. She sat facing a standing-room only crowd. The event began with ample praise and gratitude for Butler's participation. In a brief conversation about performance art, Butler discussed the presence of Trayvon Martin in this public conversation. George Zimmerman was acquitted for second-degree murder just days before the event. Then we watched a collaboration between Xandra Ibarra and Hentyle Yapp as well as a

performance by DavEnd. Butler gave an "unadulterated response" to the performers before they asked her "one question each." Finally, the audience was invited to weigh in. It was a long event.

Despite the intended structure, the artists were definitely studying the theorist. Ibarra, who also does burlesque performance under the moniker La Chica Boom, is a community organizer and lecturer at San Francisco Art Institute. Yapp has a PhD in Performance Studies from UC Berkeley and a JD from UCLA School of Law, specializing in Critical Race Theory and Public Interest Law. What follows is the moment where Ibarra and Yapp exposed unproductive power dynamics particular to Butler's academic frameworks.

> Hentyle Yapp: Exhaustion points…to the idea of what's the difference between a condition of being and an experience. So I think we're much less interested in showing an experience we've been through but rather the conditions that it brings us to…The question that we wanted to bring to the table today was, in the earlier discussion we brought up the idea of Trayvon Martin, obviously and I think Trayvon in many ways demonstrates a sort of trajectory of your work from performativity to precarity…Perhaps you can give a brief primer on [this work]…And then we wanted to provide another question in relation to precarity.

> Xandra Ibarra: In our performance, we lay bare the mechanics of dominant forms of white womanhood within both of our disciplines, in dance and burlesque, and we show our expertise in

performing that particular whiteness and also our simultaneous loss and also displacement with and from that whiteness, so our question is, within the U.S. context, how does white womanhood structure the precarity of racialized subjects? That's a mouthful.

Judith Butler: It's good. It's so funny. I'm really happy to take your questions. I'm going to have this discussion with you. I'm just struck at the moment by how we shift modalities. You know he goes from this fluttering fairy to being this grad student. [laughter] And I'm feeling the loss a little bit.

HY: I can show you my ass again and repeat the question. If that's better.

XI: I can read it like this for you, [reads question again in a Marilyn Monroe voice].[14]

Butler did not want to answer Ibarra and Yapp's questions. She instead talked about "noticing" how Ibarra and Yapp are both well-versed in academic discourses. Butler also wanted to talk about how she was still focused on their repetitive bouncing body movements and their remarkable physical agility, even reaching exhaustion, in their piece "Savage Monroe Duncan," which was performed in thongs, platform heels, stripper pasties, and white wigs. Butler eventually spoke about feminism in the academy, how white womanhood is disappointingly still at the center. She used the example of black feminism being separated within gender studies curriculums as one week of the course, but didn't name *whose* syllabi do that. She went on a tangent about the figure of the white dominatrix in film, and then apologized, because it was a *serious* question they were asking. Butler's response was

more a scramble through her "white womanhood" than an answer. I was reminded of how Butler refused to accept the Berlin Pride Civil Courage Prize in 2010 as a way to protest that organization's racism and I wondered why she didn't talk about that.

With friends who were there and friends who were not there, I frequently processed the above mentioned public events, to try to learn from certain patterns of thought and the ways conflict unfolds in unscripted moments. Events with deemed experts, moderators, and audiences are often, but not always, archived. The in-person conversations between friends rarely are. Caitie sent me a talk called "Reading Race" she presented on a panel with Don Mee Choi and Youna Kwak at "Thinking Its Presence: Race and Creative Writing" at the University of Montana in April 2014. Many times in the margins of this book I write "use last name," then cross it out and say "use first name." Caitie calls for listening on the part of white readers like herself and the eradication of habits of glossing, coopting, and tokenizing of nonwhite authors. She follows Toni Morrison's 1993 book of essays *Playing in the Dark: Whiteness and the Literary Imagination* and Eunsong Kim and Don Mee Choi's 2014 "Refusal=Intervention"[15] manifesto in response to the Poetry Foundation publishing "a sampler of Asian American poetry." Caitie also reports on playing tourist with the white canon in Al Filreis's Modern & Contemporary American Poetry class that the University of Pennsylvania offers free online. Filreis problematically teaches the canon as stemming from the tradition of either of two white poets, Walt Whitman or Emily Dickinson. Caitie concludes her talk with a series of questions for white readers to hold:

In a more esoteric sense, reading practices are also
ways we engage with the text as an object—behind
which a subject lies in wait. What are the points
at which we imagine a text is keeping us out or
becoming inscrutable? When do we accuse the text
of being difficult or resistant, even *impenetrable*?
What are the phrases we gloss and which are those
we take in repetition towards ecstasy?[16]

After I read Caitie's talk, I immediately thought of Josef
Kaplan's introduction for Harmony Holiday in January
2013 at the Segue Reading Series. Introduction writing can
function as a nonmonetary form of support when there
is little else in the united states to support poetry. When
hosts don't simply recite a reader's bio in a mode of robotic
professionalization, the feeling of "being read closely" is
invaluable. Yet Kaplan announced giving up at the entry
point of Holiday's work, claiming that to him, as a straight
white man, her writing was entirely inaccessible:

It's hard for me to talk about Harmony Holiday's
writing because I haven't really read it…I simply don't
have the context to give a particularly interesting or
insightful explication of what the poems (or whatever
they might be, in the book or elsewhere—prose or
otherwise) are presenting, and what effects they
might produce. I'm pretty much ignorant.[17]

Kaplan's introductions, to my astonishment, have
been celebrated in a chapbook, aptly titled *All Nightmare*,
published by Ugly Duckling Presse. Holiday's introduction
is distinct from the others in the chapbook because
Kaplan at least *read* everyone else's work. Kaplan's form
of provocation is a "conceptual" sandbox of taboo.[18] In

order to structure the outlandish, he relies on a script-like formula. For the 2012 season, the catchphrase of his introductions was "I think we can all agree [name of poet]..." The following year, his catchphrase was "It's hard for me to talk about [name of poet]..." Kaplan ends each introduction in hyperbole: "It is my absolute, esteemed pleasure to welcome [name of poet]'s writing."

The placement of poetry on the page is always a squirming placement in Holiday's work, which takes as its materiality the intricately shifting overlaps and distinctions between poetry and music. Her two books *Negro League Baseball* and *Go Find Your Father/A Famous Blues* frequently reference jazz and musicians, particularly her father, Jimmy Holiday, and his life and work as a singer-songwriter. Her poetry becomes what she names, in the Afterword of *Negro League Baseball*, a "mythorealistic place" for the conversation they were having before his early death and the conversations they continue to have around what Holiday calls "some nuance of the dialectic between oppression and decadent experimentation."[19] Holiday also reflects on being "afraid to evoke the word jazz which has become vapid and spangled through overuse and misuse." So she names it baseball.[20] Holiday twists how heavy words can be with personal history in contrast to the public consumption of artistic lineages and their attendant hierarchies. I relate to Holiday's ever-expanding formal sense, which produces not just poetry but an intricate poetics. Perhaps because her forms are so deeply specific to her experiences, she is compelled to draw her readers a map of gestures. She writes of her "endeavor toward forms that do not wish to draw attention exclusively to race, but are forced to in a context

where certain idioms of accepted and even encouraged rule-breaking are often seen as *scene*."[21] I find resonance with Holiday's content that challenges readings outside just "race" as I read work by queer people and shift the central focus from how "queerness" functions. Holiday ends this dense Afterword with the question of separatism, "What if for a time the whole league was the Negro League, and all the old rules fell prey to amnesia, so this was no longer so strange, all of us just being us."[22]

Holiday read the poem "b-sides from my idol tryouts" at Segue. I wrote down this line: "My accidents are protests they are my only protests, they are never accidents."[23] She cancels out the claim of accidents being unintentional. I read this as a wrangling with how language manifests as "protests." At times language utilizes playfulness; at times language utilizes grave truth. Her experimentation mixes the two modes but the "protests" get the last word and assert intentionality. Holiday highlights the multiplicity in her own agency; she loves the long sentence, clause upon clause building a roof that always feels the weather of its sky. What "are never accidents" when examining the racial dynamics of reading work, of white people listening to and reading "black entertainers and artists"? A critique of Kaplan's introduction already existed within her reading because it is not just one curator, one poet publicly doing something racist and sexist. When Holiday got up to the microphone, she provided her own introductory remarks. The poems she read were tied to an essay she was writing on the 1973 film *Holy Mountain*, Langston Hughes's "The Negro Artist and the Racial Mountain," and the devotional avant-garde in the Black Arts. Holiday added the disclaimer she "does not like

the term avant-garde because it fetishizes being ahead."[24]

Why didn't I talk to Kaplan about his introduction immediately afterward? I see myself on a delay. Many of the questions I had about labeling art queer became more about where and how *multiple* identities factor into public presentations of art, yet that level of complexity is often reduced or dismissed. These questions were put to the test when I began curating and hosting poetry readings. At the Harmony Holiday and Stacy Szymaszek reading in 2013, I learned how to use the sound system at Zinc Bar and picked up the zoom recorder Segue uses to archive their readings on PennSound. The following Saturday, Charity Coleman and I began our two month stint as co-curators of the 2013 winter season. I was deeply troubled that I was *a part of*, however loosely, a curatorial group that included behavior like Kaplan's. Then Charity and I began our series with two white male poets: Dana Ward and Evan Kennedy.[25] In writing this I have labeled and unlabeled Dana and Evan; both the label and the absence of it could effectively support or contradict my arguments. Evan selected Dana to read with from our provisional list of writers who had been invited and noted it would be the first time he would be put on a bill in New York City with a (very popular) white straight guy. In the past, as a gay man, he talked about being billed with trans people and lesbians. I thought this a bold thing to say out loud.

Curatorial pairings are composed of everything from busy travel schedules to readers who request to read *with* each other because they might hold affinities along aesthetic and/or identity lines. Curating often feels like grease; sometimes a curatorial decision gets things

moving, other times it's an awkward stain and every time I rub it, the stain gets a little deeper. After Dana and Evan's reading I suggested we go to Julius in the West Village— the oldest gay bar in New York City. I was thinking maybe Evan would also want to go to a gay bar. I vacillated from feeling like whoops, I just brought all these straight people to a gay bar, to being happy *I* was in a gay bar, which is often a preferable space, if not always an antiracist, feminist space. Anyway—not all the people at the reading were straight. The contingent of queers seemed very pleased with our destination. It was the first time I got to sit down and talk to Pam Dick, E. Tracy Grinnell, and Julian Talamantez Brolaski.

A few months after Holiday's reading, Caitie invited me to participate in the workshop-style event Brooklyn Ladies Text-based Salon. At first I overlooked how I would have to face my relationship to the word "lady" because it was couched in the acronym "BLT." Then I had some minor anxiety about feeling like I was in the women's locker room at the gym, those few times I've made it to the gym. I shared an early nugget from this book with the salon about how complicated and impossible it is to compare "movements," namely Black Arts and Feminist Art, yet I still turn to how these "movements" are historicized to better understand the context New Narrative writers emerged in. I also read about my gender confusion, how I had just began using the pronoun "they," but had no real plan to notify people in my life other than bumbling along inconsistently. Caitie told me afterward that she felt like a bad ally for inviting me to read in the salon. But all I did was air my own relationship to the word "lady." I didn't think she was a bad ally. I

agreed to be there and was grateful for the opportunity to articulate that just because "ladies" is in the name of a reading series, I don't have to remotely conform to "being a lady." I appreciated a space being made for sharing work around that word; I was able to articulate my commitment to feminism while being more masculine presenting. Participating in BLT was *nothing* like how frustrating it is to be misgendered daily, when for example, I am buying a banana at a deli or walking down the street.

I read with Aracelis Girmay, Julia Guez, Kyla Marshell, Katie Miles, Catherine Siller, Samantha Thornhill, and Lauren Wilkinson,[26] all writers I had not met before. The genres represented were vast, and so were the ages of readers. The differences among us were too big to quantify. My gender was just one aspect and certainly not the defining aspect of my experience of BLT: I was mostly thinking about being white. I was honored to be sharing my work inside a women-of-color space, a space I had never before been invited to share my work inside. I found immeasurable importance in feeling outside and alongside identities, genres, and their labels. "Lady" did not subsume me; in fact it helped me move beyond the fixity of one word.

In late 2014, Natalie Peart and Montana Ray, the founders of BLT, produced a statement to be circulated to guest curators that reflected on the history of their home-based salon, which was founded in 2011, a time they recall as defined by "discouraging losses [in] affordable housing and reproductive rights." Peart and Ray detail how they organize their series and how they interpret the salon's use of the word "ladies:"

> Monthly, we'd feature 8 artists who work with text

in any medium, specifically curating 70% women of color and 30% queer artists. Our initial curatorial focus was specific, yet at the same time broad, complicated, and ripe for intervention; as a result, we have had the great pleasure of hosting myriad voices, perspectives, and people and we hope to maintain a space that is intergenerational, racially diverse, gender (or non gender conforming) inclusive, and a space where discussion and conversation are fostered. We've had amazing support for the salon over the years, and one of the ways our community has grown is through the investment of guest-curators. By introducing us to new artists, guest-curators have challenged the two of us to expand our vision, specifically by encouraging us to become more explicitly inclusive of transwomen. Guest-curators have also curated gender non-conforming artists and transmen; and we welcome these artists with the understanding that everyone who participates in the salon celebrates feminine energy but need not be a "lady." Specifically, while we define "ladies" broadly and even against a gender binary, we realize this is a loaded word for members of our growing community; and certainly, not all of the artists, poets, filmmakers, & writers who share their work at the salon consider themselves ladies. To this end, we ask guests and artists to be mindful in the space: please feel free to ask a person's gender pronoun, it's the right thing to do![27]

Peart and Ray refer to this statement as valuing an

evolving "politic." BLT exists as a space for writers to meet and discuss work and support each other while also providing an impetus for conversations that are hanging in the air, ready to materialize.

The poetry worlds I frequent are far from "safe spaces." These are rooms that continuously grapple with the larger political implications of constructed spaces. In the spring of 2014, Simone White, Program Director at The Poetry Project, published "Flibbertigibbet in a White Room / Competencies," on Poetry Foundation's much-trafficked blog, *Harriet*, about how she experiences the problem of whiteness in so-called experimental poetry communities:

> Probably, it is impossible to avoid insult in the
> atmosphere of feint, desperation and clueless-ness
> that pervades this life. (Supposed to be contemplative,
> supposed to be romantic in the way it hearkens back,
> historically, materially, to an eradicated bohemia.
> Impossible, anyway to forget what any previous
> bohemia, would have been, for me, black as I am.
> Thank god for the enormity of my lateness.) To try
> is to manufacture, it is to glue, it is to piece together
> against every probability an evasive "we" that moves
> in my arms like a living animal. The more I think, the
> more I am estranged. What is a work called when it
> punishes intimacy with paranoia?[28]

Simone addresses literary production, specifically the poetics of Nathaniel Mackey and Thomas Sayers Ellis, as taking on the project of investigating blackness in all its infinite forms and power. Like Holiday, she alerts readers to the illusion of celebrated past "bohemias," as embedded in a denial of the antiblackness that has been complicit in

certain "bohemias."[29] She examines the tools of language as a "living animal," difficult to pet for all its writhing while trying "never to grasp or grip with too much paranoid ferocity on blackness itself."[30] Simone highlights her experience at a reading that featured three white poets on one of the coldest days of winter.

Simone names her frustrations with this reading, not just for being the only black person in the room, this she is familiar with, but with the "mechanism" that is creating such spaces, the social and aesthetic systems producing such rooms. How is it that some poets are producing spaces filled with almost exclusively white people in a time when we are witnessing such extreme racialized violence? Simone followed "Flibbertigibbet in a White Room / Competencies" with the conflict of examining class in shorthand as the daughter of a successful lawyer.[31] Simone's forthright account of the present and her perspective of it, while offering "no solid answers," positions her in Percy B. Shelley's often debated claim of the poet as unacknowledged legislator of the world. She boldly and generously sends the question out to her readers about how they contribute to the "mechanisms" of producing spaces for audiences to hear writing.

In July 2015, I planned to take a night off from my deadline-infused ten-hour writing days. I squeezed my polar fleece back in the cracks of my library shelf, already double-stacked with books. I passed from air-conditioning goose bumps into Bryant Park's thick heat already dialing Jess's number. He was guiding me daily through the turmoil of how to transition between interconnected themes, how to make an anecdote illustrate my idea, how to check

the transcription of a quote from a journal where my handwriting was near illegible. I am constantly breaking the rule that I am done writing and only editing. I thought all of 2015 was off-limits because I hadn't had enough time to reflect on the experiences that inevitably challenged me to reconsider the whole book.

Dirty Looks's calendar hung under a magnet on my fridge, with an inky circle around "Misadventures in Black Dyke Dating in the 90s," an event curated by Vivian Crockett. Dirty Looks: On Location holds thirty-one consecutive events every other July and describes itself as "a series of queer interventions in New York City spaces." "Misadventures"'s press materials promised "a showcase of films from the 1990s by black queer women filmmakers, exploring the trials and traumas of navigating dating and love at the intersections of race, gender, and sexuality. The films intermix humor, fiction, experimental visual tactics, and candid dialogue to examine relationships with family, community, romantic partners, and self."[32] The screening included Cheryl Dunye's *Greetings from Africa* (1994); Jocelyn Taylor's *Frankie and Jocie* (1994); Dawn Suggs's *I Never Danced the Way Girls Were Supposed To* (1992); and Shari Frilot's *What Is a Line?* (1994).

Karen and I met at the Maysles Documentary Center in Harlem. We arrived a little early and began to talk with someone sitting alone, Adrian, about whether we knew anyone renting a room. The conversation quickly shifted to how shockingly expensive housing is in New York. Seats were filling up and I turned around to see a line out the door. Vivian made an announcement that a lot of black queers would like to sit in the theater and if you identify

as otherwise, please consider trading seats with someone in the basement, where Maysles had set up a simulcast to accommodate the overcapacity crowd.

Karen and I became a part of two lines of people trading seats, roughly divided along race. We were moving and talking about our bodies in the space. The theater and the basement shifted to prioritize the audience matching the filmmakers and their subjects; Vivian commented, reparative work is being done! Sociality and ability complicated the seat rearrangements. A black person stood up and shouted, can I come up to the theater if I bring my white friend? A Colombian friend was in the upstairs theater with her white friend who was injured and couldn't use the stairs. I stood against a wall in the basement, barely able to see the screen, glancing to find Carolyn. This was the first event we were both at in New York, after dating long distance for half a year. I felt the anticipation of wanting to say I love you every time I saw her but a nervousness of not being sure how to say it.

The films had an early-work energy. I eagerly peered into that portal of the 90s, where I probably have more visual memories of popular culture than I do of my own teenage years—see baggy but tapered pants dancing along squiggly lines of a VHS player rewinding. Jocelyn Taylor's *Frankie and Jocie* was my favorite video because of Taylor's exploration of her own relationship to her brother, a sibling relationship I have always longed to know more about. The piece also explores the ways straight black men and black lesbians more broadly interact. Taylor uses a phone conversation to discuss with her brother Franklin a range of topics: how their family talks about her being

a lesbian, their mutual attraction to someone, strip clubs, and objectification of women. Between each of these overlapping topics of conversation, Taylor intersperses close-up, full-frontal interviews in front of a white studio backdrop with five other black lesbians to expand on the topics she broaches with Franklin. A triangulation builds like a buffer to Taylor's relationship to Franklin, with her interviewees calibrating their lives in relation to family and strangers. During the phone call voiceovers, Taylor focuses the camera on a hand sifting through snapshots, maybe of Frankie and Jocie in the aura of childhood happiness. Their relationship appears deeply loving with hints of divisiveness. Toward the end of the video, Franklin calls lesbians a waste and Jocelyn steps out of their conversation to become part of the group of interviewees. Jocelyn concludes by telling Franklin the upsetting story of being punched on the street by a man—a snapshot illustrates the attack with stitches making a right angle over her swollen forehead and eyebrows. The phone conversation also plays to a slowly quickening pan of a fenced playground, of the two adult siblings running through a forest, canoeing, gazing out on the national mall in silhouette, and laughing while spending time with their family.

Frilot's *What is a Line?* was the most absurdist of the group: the film processes a breakup over the course of the protagonist's train ride. BDSM flashbacks to a prior sexual encounter ignite a public masturbation scene echoing the train's velocity. In *I Never Danced the Way Girls Were Supposed To*, I remember Suggs's portraits of black lesbians in daily routines and relationships overlaid with commentary echoing straight spectators' assumptions

and questions bouncing off her subjects' indirect rebuttals. Dunye's signature video confessional format of self-analysis guides *Greetings from Africa*, interspersed with scenes showing her talking about or flirting with L, a white woman who is less than honest about her availability. In a documentary on lesbian filmmakers, *Lavender Limelight*, Dunye reflects on this short film debut as being about how "race works in the lesbian community…there are women who're into women of color who are white because they are into brown skin and, and it's a straight-up issue and it's very complicated…I wanted to bust that open."[33]

The films's themes were alive at Maysles. I remember a lighthearted humor about heartbreak and desire and a gravity regarding the material realities of race, gender, ability. The documentary form was consistently hybridized in the films's vast and specific narratives. The screening, projected onto the moment of 2015, also created many personalized documentaries amongst the audience. "Misadventures," both the screenings and the event, prompted me with the question of how white people can respectfully engage, talk about, write about, and grow from art made by black people and people of color. How to reckon, as a white person, with constant realities and histories of the white voyeur, white colonizer, and white appropriator? How was each white person individually responsible for their presence at the screening and potentially associated with any racist behavior by any white person? What does it mean to be sometimes welcome and sometimes not welcome in a black and brown space simultaneously, depending on all the different people who organize and participate in the space?

Should I have just stayed home from "Misadventures"?

I care deeply about film and photography from the 90s made by dykes. I seek out this work—which is often hard to access. I don't know how I could remain critically engaged with the world if I were only to engage with work that I personally identify with. Art needs to be seen as having many predictable and unpredictable vectors of connection to its viewers. This doesn't mean my jewishness, my gender-non-conforming-ness, my dykeyness can ever be used to minimize, cover up, or excuse the fact of my whiteness.[34] To *not* go to "Misadventures" could just as easily have suggested I was unwilling to be uncomfortable dealing with what it means to put my body in a room.

FULL UMPH

I felt as though I was rushing into a burning building to rescue the ideas I needed in my own life.

—Leslie Feinberg[1]

She had trouble with elimination.

—Rachel Levitsky[2]

Kay Ryan interrupted her poem at the 92nd Street Y to say something like, "These lines have been engraved in the Central Park Zoo." The audience mustered a collective ooh and ahh that registered on my back like an itchy blanket. Laryssa and I were in the front row, as close to Ryan as possible for my character study. I kept turning around to watch how the teenagers were reacting. Each 92nd Street Y reader also visits a public school English class and the students receive free books by the author. Ryan interrupted another poem, "That one was just published in *The New Yorker*." Ugh, I thought. I waited in the Barnes & Noble-sponsored book signing line without a book to sign. When it was my turn, I gave Ryan the pamphlet loosely containing the first two chapters of this book. I write about your work in this, I said. "Are you a student?" "No, I'm an artist." I didn't know how to explain to Ryan that I constructed, with the help of Jess, an alter ego named May Lion to satiate my hunger for traces of lesbian life in Ryan's poetry.

May Lion gave her premiere reading to a crowd of fifteen or so friends and friends of friends at the now shuttered Uncanny Valley in Long Island City in spring 2012. May went on after the solo cellist Meaner Pencil, as seen on the NYC subway. The poems "Are My Sneakers Frumpy," "I Got a Butt Plug and Neti Pot for My Birthday," "Cheese Puff Dust Under Your Nails," "Tattoos Remind Me of My Relationship to the Holocaust," and "The Height of Floss" had their first airing. I used that gel with air bubbles to slick my hair back into the shape of a bike helmet. After May's reading, I was greeted by a lengthy manologue from an audience member about how he edited his high school

literary magazine (and therefore has a special relationship to poetry). This confession was just his icebreaker before divulging that May's poem about hand sanitizer, potato chips, and latex gloves had expanded his idea of what sexual intercourse even is.

May Lion's second gig was at the Gershwin Hotel, which is near the Museum of Sex. Tucked behind the lobby is a cabaret stage facing a red, velvety, lip-shaped couch. The Prelude Festival rented the spot for their closing party in 2012. May began her set just when everyone made a dash for the bar after a musical act. May appeared as the "publisher" of Joe Ranono, an erotic poet Jess whittled into formation circa 2009, with a signature fop look: overflowing facial and chest hair, boot-cut tweed pants, a large bulge, whispy sheer scarf, and felt hat. Joe always has a different mustache. The character is directly based on the 70s-era bravado of poet Richard Brautigan. The repeated literary trope in Joe's poems is the crass imagery of an erection. His robust longings lament how excitement quickly fizzles into disappointment; all of his girlfriends are ex-girlfriends, as all of his nights out end with a blackout. Lesbian and feminist experimental theatergoers have often been horrified and baffled by Joe, the erotic poet. Why portray such triggering misogyny? Jess's parody of male entitlement in straight theater audiences is both scathing critique and coping mechanism for the ambassador role he plays between the often disparate worlds of queer and straight artistic communities. But in the imaginary world of our alter egos, Joe and May are somehow friends. We think they met at a Naropa class and May decided to publish Joe because she was sick of self-publishing.

That evening at Prelude, May Lion promoted Joe Ranono's broadside (printed at kinko's) and CD lodged in a jewel case, "Cold Sore and Other Happenings." I stood on stage without a lifeline because I did not come prepared with a reference to Kay Ryan. How would this theater crowd know the performance is based on the former Poet Laureate? May Lion swerved away from Kay Ryan to become more of an exaggeration of myself: Jess's friend enveloped in a bizarre simulacrum of our reality. I was all of a sudden playing a shunted lesbian who slipped into teacher mode, hands on my hips (hey, listen to me!) with an audience who just wanted to schmooze at the bar. I read a poem entitled "I'm Always Spelling Ranono Wrong," which included the lines:

> No recoil to euphemism
> Whole tuck or no tuck of the T-shirt conversations
> invest in firm paper.

I couldn't even get the room quiet. May Lion appeared next inside Jess's feature-length show *Without Me I'm Something* (a steady riff of Sandra Bernhard's *Without You I'm Nothing*), culminating his residency at Brooklyn Arts Exchange. Jess created the atmosphere of a crappy bar in Queens, with a buffet of Coors Light and Dunkin' Donuts coffee to the right of the stage. Jess's other alter ego, Karen Davis (played by Emily Emily Davis), an unknown white comedienne, performed an HBO Special slash Dante's-*Inferno*-length stand-up routine. Karen's costume usually consists of flared jeans, an H&M blazer, and a statement T-shirt with the line "I got this shirt when I turned 40. I hate this shirt," when, of course, she's just in her late twenties. Jess scheduled May's poem at 7:55, which equated to about

fifteen minutes before the full audience was expected to arrive. Instead of accommodating coy, slightly late arrivals, Jess wanted people to walk into an alternate reality.

A fictional Fleetwood Mac cover band, The Queens Pucks, set the mood. They called May Lion to the stage but she replied, "I'm not reading until my girlfriend is here." This unscripted resistance to reading my poem to an extremely small audience elicited a genuinely puzzled look from Lena Moy-Borgen (Stevie Nicks). She insisted. May then got up to read with a vengeance about residing at the margins of the performance as a metasatire of the marginalized lesbian poet. Marya Warshaw, the director of this non-profit, sat in the front row with her partner Jane. Even though they beamed at my lesbian satire, I became so nervous watching them watch me. What if they were offended? This fear of offending is the result of living in a time of deadening professionalism. Sandra Bernhard is *so offensive.* As I was performing I wondered, how *old* is May—is she the median age of Kay Ryan and me? I felt like an actor who didn't do their research. May became totally out of my control. Then Amanda rushed in with a birthday cake for me, alight with an attempt at thirty candles, and Jess cued the cast to sing "Happy Birthday" to May. Later that night at Ginger's, while celebrating my birthday, I read the poem to friends who missed the performance.

My Full Umph: An Almost Leather Jacket

What do I do with the report
of discomfort at The Rainbow Book Fair.
The host of the marathon reading
announced it's really important

for gay poets to read to gay people.

But I knew someone there who wasn't gay
and they told me they felt "self-conscious."

I'm clenching my butt cheeks while I read this.

Meanwhile the Holiday Inn's
cleaning routine went along as planned,
a worker vacuumed
the red and gold carpets
that swirled in a pattern
like melting frozen yogurt
heads turned from the seats
in the poetry reading's room with no windows
and someone moved to close the door.

I've never seen a flag so tall indoors.
It wasn't quite a parade.

The booksellers were haranguing
you for email addresses.
Which makes me wonder
if I will still be invited
on the *Go* magazine float
if I refuse to wear their baby tee.

I had just returned from Key West
where I have a wood cut sign for my address—
a handwritten script proclaiming,

Still Nasty

It's a modest studio apartment behind a souvenir
 shop in downtown.
My chapbook press was rusting its staples,
And reverting back to its given name: Rattail Pussy,
brainstorming outside of the trodden LAMBDA
 prizes
What is a diversion and what is a scheme?

Anyway, it's the time of year Amanda shaves her legs.
She starts first with the clippers then cleans up with
 razors
Some spring wardrobe renovations are misguided,
perhaps the heart of a scam:
Get rid of your bulky straps!
I bought a pair of underwear with a hole in the
 middle of them
for fifty dollars plus tax.

When I tried this contraption on at home
I mourned my creative spirit.
Could I not build such a re-invention of the harness,
cut a hole in high percentage spandex boxer briefs
then sew a cock ring into a flap like pocket?

Then I remembered, I don't garden,
and I don't cook recipes, just stir fries,
and it's not about doing home repair, it's about
saving some time for writing poetry.

[Raise arm and bow head; pause]

Wearing the new underwear I notice
the dampness that builds up underneath
a cross between a puddle enthralled with reflection
or the sponge dish next to the cash register,
floating and sinking in its stagnant pool.

Amanda tells me putting on a cock is like wearing
 glasses
when I was feeling down about needing appendages.

I sigh and for a special occasion put on my softpack
in the bathroom of the sushi restaurant
then we go see a film about an advertising campaign
that helps end a dictatorship.

Through my jeans we forget the softpack has a fake
 wart.
I boiled it, by accident, for too long once in a holiday
 sublet
and its tip started to melt when touching the metal pot.

The wart formed like hot fudge gels
from the coldness of full fat ice cream.

In her early performances, May Lion wore the signature
ACT UP T-shirt with a pink triangle hovering over the
dictum *Silence=Death*. This was before I really began
learning about HIV/AIDS activism. I was asking what might
be missing from May's poems but rest right at their surface,
like an optical illusion. Even though Ryan's work doesn't

have anything I can grab onto as "lesbian," she is out. I've seen her headshot propped against the stacks at the Lesbian Herstory Archives. I wish Kay Ryan wore the *Silence=Death* T-shirt at her Library of Congress readings but that is pure fantasy. I wore the shirt to test how ephemera can function as a living tool, outside vitrines. In documentation of HIV/ AIDS activism, the pink triangle married with the call to action of *Silence=Death* roam like landmarks on T-shirts, pins, flags, stickers, and posters. Six gay men are responsible for initially designing and distributing the emblem a year before the first ACT UP meeting and demonstration in 1987. The original wearable slogan then became one of the primary means of fundraising for ACT UP.[3] Evan told me that Opening Ceremony priced their reprinted *Silence=Death* T-shirts at $50, which was reduced to $15 in a sale. Now the remakes are sold out.[4] Once I saw the T-shirt in the glass box designated for merchandise at the IFC Center, next to the popcorn and candy. It must have been when *How to Survive a Plague* played there.

I kind of stole my *Silence=Death* T-shirt. The black background is washed out as if in a haze of mist. The texture is soft. The ironed-on triangle and words ripple lightly, not yet peeling off the cotton. It's often the last clean shirt left in the drawer before I do laundry. I usually wear it to bed, like I keep the radio on in my sleep, as if I could learn something in my subconscious state. A few years earlier, Amanda thought she was just wearing the shirt to sleep when she rented a cabin in Guerneville, a gay vacation town north of San Francisco that her former boss from Modern Times Bookstore Collective occasionally rents out. Amanda accidentally packed the *Silence=Death* T-shirt in

her suitcase and is still meaning to return it. When we first moved in together, I found the shirt inside an unmarked manila envelope buried under junk in our closet.

Zoe Leonard's essay in the catalogue for Jon Davies's 2012 show *Coming After* mentions feeling queasy when younger queer people pine for the activism of the late 80s and 90s.[5] Leonard points out how you cannot exactly wish to be around in a period of mass death. Davies's exhibition addressed the question of how to fathom such enormous loss. Part of that process is reckoning with how HIV/AIDS has been actively obstructed from view by the government and media. Davies writes, "These artists have a sense of themselves as part of queer genealogies and cultural lineages, and seem more interested in a dynamic play of absence and presence—the effects of bodies and atmospheres of spaces—than in identity."[6] I asked my parents why they did not talk to me about HIV/AIDS when the epidemic was at its peak. They said it was just too sad to see all these people dying; it wasn't something to talk to children about. I was unsatisfied with the answer. This seemed to be an excuse for how silence was an active participant in the epidemic.

We Who Feel Differently Journal published the issue "Time Is Not a Line: Conversations, Essays, and Images About HIV/AIDS Now" in 2014. Theodore "Ted" Kerr, the editor, writes about the 2010 Smithsonian censorship of David Wojnarowicz's film *A Fire in My Belly* as a turning point in the more recent past of HIV/AIDS activism. Kerr names the "first silence" as Reagan's refusal to acknowledge the epidemic during its first five years and the "second silence" beginning in 1996 when the "cocktail"

was created and HIV/AIDS receded from being a "public concern" to a "private experience." Kerr then introduces a range of texts and art by young activists who are part of what he terms "AIDS Crisis Revisitation."[7] Kerr warns that with this "Revisitation" comes a "repacked" past with the excision of the complexity of "collectivism, intersectionality, and feminism that the AIDS movement was built on."[8] In light of the fatal role silence played in the AIDS epidemic, Kerr challenges the message behind a mask picturing the image of Wojnarowicz's mouth sewn shut that he saw being used at a protest of *A Fire in My Belly*'s censorship:

> As powerful as these masks were, they struck me as being counter productive. David was being silenced again—even in the grave—oppressed by a government he understood as being implicit in his death, and we were joining him by being muzzled. To truly honor David, to fight for and with him, shouldn't we have been chanting through masks with the mouths ripped open? Talking to some of the protesters I understood that they were trying to represent what oppression felt like for them.[9]

While stories of the AIDS epidemic continue to emerge in the forms of oral histories, feature length documentaries, exhibitions, and ephemera,[10] they must be treated with awareness of how different those informational forms are from individual survivors' lived experience. To wear a mask performs a gesture that blocks a view, making a cartoon of perception. Kerr specifically warns against romantically recycling images as a cover-up. Kerr implies that with the continuation of "AIDS Crisis Revisitation," effective activist

movements must be built on "collectivism, intersectionality, and feminism."

In light of my nascent engagement with the complex histories and presents of HIV/AIDS activism, I decided to stop wearing the *Silence=Death* shirt when performing as May Lion. I needed to pause and ask if I was "repacking" iconography as an uncaptioned image. Was I wearing the T-shirt to signal that May Lion was two generations older than I and a participant in ACT UP, as well as later groups like the Lesbian Avengers, fierce pussy, and the Coalition to Free Aileen Wuornos? The pink triangle and the *Silence=Death* slogan read as both code to those familiar with the history of HIV/AIDS activism and a provocation to those not familiar with this history. If the shirt is evidence of having witnessed the loss of thousands of people from a disease that is still not over—can the T-shirt ever function in a satirical realm? There are many more *current* T-shirts May could be wearing to represent contemporary grassroots activist groups. How much work can political slogans on a T-shirt or tote bag *do*?

Essex Hemphill's essay "If I Simply Wanted Status, I'd Wear Calvin Klein" reflects on the experience of wearing a T-shirt in Washington, D.C., blasting "FAG CLUB." Hemphill was "featuring heavy transgression in a town of government secrets, political intrigue, and kinky sex."[11] By the time Hemphill came back to his neighborhood of Mt. Pleasant, he had forgotten he was wearing the FAG CLUB shirt, until a young boy responded at the supermarket. The confrontation at first felt like an attack: "'Look, everybody, there's a faggot in the store!'" Hemphill bravely walked the aisles and paid for the items on his list. To his surprise,

the boy then approached with loving excitement to ask about where he could get a shirt like that for his cousin—unfortunately, only in San Francisco.

I hesitated to wear my *Silence=Death* T-shirt, a shirt that speaks to the legacy of Hemphill's writing, activism, and early death from AIDS because I was not trying to pretend *I was there.* Conversely, one could argue that I am paranoid about the shirt's appropriation of past struggle. *Silence=Death* is still a relevant statement and one I am not afraid to make. The fact that this was a "real" shirt from the early 90s, one accidentally stolen from a lesbian mentor of Amanda's, made me feel like I was tampering with "the archive." May Lion's costume choice turned into a confused time-warp drag. May represents one of my first intergenerational conversations—and it was an imaginary conversation that made me seek out real conversations about dyke visibility, the AIDS epidemic, and how they intersect.

Nathaniel Siegel was one of the organizers of the marathon reading at the Rainbow Book Fair mentioned in May Lion's poem. I met Nathaniel at a talk I gave on this book in November 2012 at The Poetry Project.[12] At the bar afterward, he handed me a statement he had printed on ivory resume paper: "If a gay artist doesn't self-censor himself in life and creates works true to his soul and then fails to leave proper instructions to the heirs of his estate he can expect the possibility of his works being censored or simply hidden away from view after his death." Siegel had produced and distributed this statement in response to the censorship of *A Fire in My Belly.* He also gave me his real estate business card on which he wrote "gay poet"

and "activist" in ballpoint pen, wrapping the margins of the embossed contact information. In the Q&A after my talk, he asked if I was self-censoring because of a need to *create* a lesbian poet alter ego who writes lesbian content. The alter ego is not an isolation tank but a clunky tool. May satirizes the polarization of a "political poet" and an "apolitical poet." In May's most recent performance, she wore a T-shirt with an iron-on photo of Leslie Feinberg lying on a bed with the poet Minnie Bruce Pratt, hir longtime partner and wife. May wore the shirt as a dedication to Feinberg the week ze died.[13]

Surfaces are loaded. I feel compelled to differentiate May Lion wearing a *Silence=Death* T-shirt from Alex Dimitrov's decision to put a photo from David Wojnarowicz's *Rimbaud in New York* series on the cover of his 2013 book *Begging for It*. This photo was a surprising choice for Dimitrov, who has so carefully stated: "I happen to be queer but that doesn't make me a queer poet. Some of my poems are political but that doesn't make me a political poet."[14] Wojnarowicz's photo is of his friend Brian Butterick seated at a table in a diner. Butterick faces the camera holding half a burger in his hand as though between bites, but the slightly oversized mask of Rimbaud blocks the food from entering his mouth. Behind the diner table, a tiered cake display, a decadent landscape of icing mountains glows brightly. When I saw Ted Rees in New York right after Dimitrov's book came out, it felt urgent to talk to him about the cover of *Begging for It*, but I could tell this was highly emotional for Ted, whose poetry and criticism often create spiritual encounters with Wojnarowicz's rage and legacy. Ted sent me the letter he wrote to Dimitrov, the publisher Four Way Books, and

P.P.O.W. (the gallery that manages Wojnarowicz's estate), explaining how Dimitrov's choice to use this cover image evinces appropriation, ignorance, and colonialism. Ted points to the larger context: "It is often forgotten, though, that Wojnarowicz's rage was intimately connected with his work and his critical thought, and that this anger did not begin and end with the disease that would eventually take his life."[15]

Dimitrov has been known for organizing the Wilde Boys Salon, an invite-only event in New York City from 2009 to 2013, which championed mostly white-gay-masculinity. Dimitrov's friend Jameson Fitzpatrick's 2012 Lambda Literary post "Anne Sexton, Aesthetics, and the Economy of Beauty," was challenged by many bloggers for its thinly veiled racist and classist defense of an interest in "beauty." Saeed Jones exposed Fitzpatrick's arguments as being about bodies, not bodies of work, in his response "All the Pretty Ones," which was also published on Lambda Literary. In it, Jones defended Eduardo Corral's poetry and brave commentary in a *Ploughshares* interview where he discussed his disappointment in how many of his queer poet peers "value looks over talent. The cool kids form clubs, become gatekeepers." While Wilde Boys was not named by Corral, Fitzpatrick framed Corral's words as an attack on Dimitrov. In response to the brewing online debates, Lucas de Lima wrote "On Beauty, Excess, and the Limits of Identity Politics in Lambda and Beyond" to point out the rhetoric on both sides of the argument as limiting to notions of a "queer" aesthetics.[16]

A year earlier, I saw Dimitrov at the first Occupy Wall Street open mic-style poetry reading Aeliana helped

organize. I asked him pointedly, "So are you inviting lesbians to your salon yet?" I then received an email with information about the next salon, featuring Eileen Myles. I responded with the question, "Can I bring my friend Jess?" And the answer was "No." I should have said we are husbands. I almost picked up low-proof deli wine on my way, the kind that tastes like rock candy. When I walked in there was a full bar on a white tablecloth. I was like, "Wow this is fancy," and someone murmured with genuine disappointment, "Well, it *used* to be catered." I didn't know anyone there so I created a mythic divide between me and the gay boys in skinny jeans. They all seemed to work for well-funded literary non-profits and magazines. I gravitated toward a white nerdy dyke standing by the bathroom. I realized once I began talking to her about her current project that she was Jennie Livingston.

Anyway, I was there to ask Myles a question—I was there for "research." Dimitrov and Rachel Silveri conducted a talk show-style conversation with Myles, interspersed with requests for them to read new and old poems. Then I eagerly entered the Q&A. I began by reading a line from Myles's latest book, *Inferno (A Poet's Novel)*: "I was meanwhile trying to learn to be a poet and didn't want to be waylaid into being gay because I wouldn't be taken seriously."[17] I wanted to know why I was having the same thought if three decades had passed and there has been supposedly so much "progress" for gay people. Myles answered in such a terrifying way, terrifying because it was brief and true: something like, it's because of homophobia, internal, mostly. Then I got pretty drunk. I remember staring into the salon host's photo album of his vacation to

Italy with his boyfriend—the kind you can special order in the shape and design of a children's book.

My performance schtick of May Lion has become a means of channeling the discomfort I felt while being one of a handful of lesbians in a crowded room of mostly white gay men at Wilde Boys. Or the anger I felt when I saw Dimitrov a few years later and he didn't recognize me. Then he realized—yes, we *had* met (several times). By way of an excuse, he told me "You look good," in a voice curling with confusion, which I translated to mean, "You look like more of a gay boy than a lesbian." May Lion only grows further away from Kay Ryan as she channels the frustration I felt when *The New York Times* "Style" section feature came out on the salon including the singeing sentence: "Interest in the salon surged, lesbians were invited and other patrons offered their homes."[18] Lesbians had to be "let in."

My mind jumps to "But Does It Matter," a discussion on social change and art inside the exhibition *NOT OVER: 25 Years of Visual AIDS*.[19] I also went to this event alone and felt restlessly aware of my age and my nascent engagement with activist communities in New York. Visual AIDS events have felt like a life preserver as I write this book because the organization provides space for intergenerational conversations with an ever-growing archive as the centerpiece.[20] In the discussion at La MaMa that day, I remember how Charles Long began to cry when talking about a friend who had just passed. At another point Long told the group that he has finally returned to his art practice after many years of separating and deprioritizing art-making from his time-consuming work as a community organizer and activist. I recall Nancy Brooks Brody, a

member of the fierce pussy collective, speaking about the trauma of mass death for survivors being characterized by not having time to sit with the loss of the individual. She spoke of running into a friend on the street, telling them she had just lost someone and their responding with an "Oh yeah, I lost someone too." She would say, "No, I lost SOME one." The people were different, even though they both died.

Patrick "Pato" Hebert recaps the heart of the panel discussion in a flash interview on the Visual AIDS blog. Hebert attests that the "NOT OVER" of the exhibit's title speaks to "the disproportionate impact of AIDS on communities of color, queer people, sex workers and folks who inject drugs. Stigma and discrimination are not over. But neither are the power of our imaginations and the viability of our shared efforts." Hebert has been executing his vision with projects like *Corpus Magazine*, which began in 2002 with Jaime Cortez and George Ayala, as part of AIDS Project Los Angeles's educational wing, which works to "revitalize prevention discourse and action with gay men through publications." In an interview with Cyd Nova, I learned more about *Corpus*, which took the form of a literary and art journal featuring the work of HIV+ people of color in order to "push hard against the deficit frameworks that were being used to describe queer communities of color and instead saunter, speak, and spit in forked tongues from within those very communities."[21]

In the Q&A after "But Does It Matter," someone who looked young raised his hand to talk. I remember hoping he wouldn't ask "a stupid question." I felt people looking at me while they looked at him. He was sitting right behind me.

At one point, someone used the metaphor of a bomb going off in reference to the intergenerational dialogues around the scale of loss people live with. Charles Long talked about how we are all going to fuck up this dialogue in some way because it is just so sensitive.

Just a few days before, I ran into photographer Editha Mesina on the sidewalk outside Rosalind Fox Solomon's *Portraits in a Time of AIDS, 1988* at Bruce Silverstein Gallery in Chelsea. Editha and I briefly shared an office at NYU that fall. "This is my favorite body of work of Rosalind's—I worked for Rosalind as an assistant ten years ago," I said. Editha was leaving the show and I was approaching. "My brother died of AIDS," Editha said. I took that in. I asked a few questions about him. I don't remember the answers. We parted ways, as if a timer had gone off signaling the end of the brief interval allotted for conversation when running into someone on the street. Until that moment I hadn't known someone who also had a brother who died. Of anything. I've always been the only one who has silence or something heavy to say when I get asked if I have any siblings. I started to think about the many people who have lost siblings at a young age to AIDS.

Listening to discussions around HIV/AIDS at first reminded me of how I listen to conversations about the Holocaust. A haunting silence composes the middle zone of this forced venn diagram. The only information I have of my mother's parents' survival is that a Catholic family risked their lives to hide them on a farm before my grandparents ended up in a camp. My grandfather's story is not even "a story" because it was unspeakable for him. When Steven Spielberg's crew came to my grandfather's

apartment, he stormed out, refusing to be a part of that archive. The last time I saw my grandfather I asked about how he survived the war and he said nothing. We were driving back from a hardware store after getting a part to fix the running toilet in his apartment. When we got out of the car, I saw he had peed his pants. In exchange for not having a story to represent his traumas, I understand personal historical information as defined by its limitations via language.

After the talk "But Does It Matter" I found respite in Jack Waters and Peter Cramer's *Short Memory/No History* mixed-media installation included in the *NOT OVER* show. I parted two tarps as if I were entering someone's small studio apartment where the bed is the only place to sit. In the center of the installation lay an open suitcase as hearth, which overflowed with alternative gay newspapers, zines, and health pamphlets produced by groups like the AIDS Treatment Data Network. Collages culled from Peter's photo documentation of demonstrations, art shows, and daily life stretched from floor to ceiling. Pill bottles formed an overflowing stream with Jack and Peter's names on the labels. On a shelf next to the bed sat a waxy red delicious apple and a tupperware container of pens, white-out, and markers. A digital camera's screen cycled through documentation of previous *Short Memory/No History* installations as if the images were its internal organs.[22] The range of visual material turned my eyes into a stethoscope.

Jack appeared inside the installation. He invited me to mark comments on an unpublished essay of his that I was holding, which was presented as just one object among many inside the installation. I needed time to

absorb the material—I needed years. I looked down and saw that someone had corrected the spelling of the name Wojnarowicz. The porousness of Jack's proposition gave me permission to stare into his essay tracking language around politics and art. I harbored a fascination with Jack's notes-to-self about inserting dates, checking information. I was offered an intimate view into an artist's documentation of the drastic changes in "queer culture" starting in the 90s, as opposed to all the distant and finished books I was trying to speed-read. As he got up to leave, Jack gave me his card, a slim rectangle of a thickness between cardstock and computer paper.

When I first tried to read "Short Memory/No History: An Essay on Queer Culture" inside the installation, I would get through a page or two of Jack's writing then slip back into the environment. I felt like I was among people and it would be rude to read instead of engaging in conversation. I cheated by taking cell phone photos of each page. Then I asked Jack for the electronic file of the essay. In the section "MOUTHPIECES: Permutations of the Queer Press," Jack tracks the metaphor of the "mutating pink triangle" on the cover of *OutWeek Magazine*:

> Week by week, the triangle gradually diminishes until three months later, in March the triangle has disappeared altogether. In December 1990 the triangle makes a reappearance as a smaller logo on the upper left corner. In the process, the covers heading inscription goes from "NYC's Lesbian and Gay News Magazine" to "The Lesbian and Gay Magazine."[23]

I was reminded of my fascination with the categories "Gay Fiction" or "Queer Literature" stamped (or not)

on book covers. Amidst Jack's chronicling of which gay publications are "advertisement heavy," in the section "THE MARGINS OF THE MARGINAL," he heralds and names much smaller-scale zines from the late 80s and 90s such as *Pussy Grazer, Pansy Beat, My Comrade/Sister*, and *HIV Plus. The Brenda and Glennda* public access TV show also get a shout-out.[24] But Jack does not simply glorify the small-scale, recalling that these cultural productions did not have "easy births." Inside the template of events listings, Jack parses how political struggles play out according to who holds the wallet. For example, the 1999 "Pride Guide" had limited editorial content due to the need for more advertising opportunities. He contrasts larger media companies such as the website PlanetOut with the local newspaper *Gay City News*, where he was a founding writer in 1994. Jack is like a referee for the assimilationist tide of New York's gay presses. He targets his critique to *OutWeek*'s editor James Collard's specious promoting of the term "post-gay," to which a whole forum at The New School was devoted in 1998. When I first saw the term "post-gay" couched in Jack's analysis of the neologism's indifferent lack of urgency to sexuality, I wondered how and if this conversation could be in conversation with my resistance to labeling art queer:

> If not sexuality, what is there to be passionate about? Collard's litany of brand products, clothing, vodka, cars, and choice real estate illustrates his point that consumption, not social equality is what post-gay identifies with… The forum for all intents functioned as a market research seminar probing the viability of reactionary politics.[25]

Jack notes that at the "post-gay" New School event there was "no mention at all of AIDS."[26] He traces "post-gay" as an evolution from "post-out" to argue how words that at first signify dissonance are quickly "polished," "sanitized," and "commodified."[27]

Two years after I first encountered the installation, I met with Jack and Peter for an interview at the community garden Le Petit Versailles that they founded, maintain, and use to host events connected to their non-profit Allied Productions, Inc.[28] I learned that the original installation of *Short Memory/No History* was made in 2000 to mark ten years since Jack and Peter were diagnosed with HIV.[29] Jack explained the piece as both a "replication of the way we lived in the peak of the epidemic" and "this memorial to ourselves." Peter further reflected on the installation as an opportunity to present all the stuff they had been saving, from his vast archive of images to objects like their friend Gordon Kurtti's sweater. The objects and images in *Short Memory/No History* translate to lost and reified boundaries between the personal and recognizable—the ephemera mixes with the essays as they overlap and reference each other. The installation is a live/work space that is not cleaned up for its guests in order to transmit a dream state.[30] *Short Memory/No History* actively resists the historical amnesia that the cocktail ushered in.

The original installation was also a viewing room for Jack and Peter's single channel documentary *Short Memory/No History—AIDS, Art, Activism*. The half-hour film features Jack interviewing Robert Vazquez-Pacheco, Esther Kaplan, Sarah Schulman, and Sandra Elgear. Jack and Peter told me they deliberately featured women and

people of color involved in ACT UP and working in creative fields. These voices were increasingly absent in the late 90s, when a gay niche market took over the public discourse that had until recently been inhabited by dissidence toward corporate and government neglect of people with HIV/AIDS. The film begins with a silent and rapid slide show of Cramer's photographs. A sequence: handwritten postcards and letters from their kitchen table; backwards baseball caps in a march framing the sign 2 AIDS DEATHS PER MINUTE WORLDWIDE; a close-up of an Art Positive sticker-poster that reads AIDS IS KILLING ARTISTS NOW HOMOPHOBIA IS KILLING ART.[31]

Jack and Peter edited the film to contrast lapses of memory against memories that are impossible to forget. Elgear reflects on being one of the few women at an early ACT UP meeting. Kaplan reflects on at times being fetishized for her gender in ACT UP. Vazquez-Pacheco recalls how he left Gran Fury after they chose to keep white beauty queens behind the slogan "Women Get AIDS." The group, which was white-male-dominated, did not listen to his feedback that women of color would not identify with this image. The film ends with Jack interviewing strangers like a television news reporter at the scene of the crime: the 2000 Millennium March for Equality in Washington, D.C., which appears more like a street fair than a protest. Peter's camera zooms in on what a vendor names as the most popular item for sale at a booth of souvenirs: a white beanie baby bear with a rainbow across its chest.

In our interview, Jack and Peter talked about the dramatic shift that occurred after large numbers of gay people demanded their rights. This visibility also produced

a group of people to not only target products to but to base products on. I asked Jack and Peter if they thought the "post-gay" moment was a ludicrous blip, where a small section of the population—white, wealthy gay men in positions of power in the media—had announced that they had assimilated fully. Jack does not think the idea of "post-gay" is over; he explained the excision of "gay" from "political struggle" became something that was not spoken. This was the environment from which "queer became a very convenient term, in service to this capitalist mainstream."[32]

"Post" as a prefix does not stand as a solution to the problem of calling art "queer." The "post" impulse is a dangerous one, as "post-race" demonstrates in its quickness to erase ever present histories and realities of oppression. "Post-queer" will be thrown around in similarly complex ways with contradictory intentions. Calling art "queer" may signal anything from a market friendly set of aesthetics to the determination to fight that market as Jack and Peter's *Short Memory/No History* so vigilantly demonstrates.

Thelma Golden, the director and chief curator of the Studio Museum in Harlem, envisioned her *Freestyle* (2001) exhibition as featuring a younger generation who complicated and resisted being labeled "black artists." Golden writes in the *Freestyle* catalogue, "'post-black' was shorthand for post-black art, which was shorthand for a discourse that could fill volumes. For me, to approach a conversation about 'black art,' ultimately meant embracing and rejecting the notion of such a thing at the very same time."[33] Seven years had passed since Golden curated the controversial *Black Male* (1994) show at the Whitney, in

which Jack's film *The Male GaYze* was included. The point not to lose when Golden tentatively coined "post-black," layered in many conditionals, as if to solidify its multiplicity, is "post-black's" contingency on a friendship that builds codes to talk about art. "Post-black" was something she talked about when hanging out with her close friend Glenn Ligon; the phrase was born in the context of their "shared love of absurd uses of language."[34]

Many people before Golden, Ligon, and Collard undoubtedly uttered "post-black" and "post-gay." I am drawn not so much to the buzzwords but to these origin stories: the former in an exhibition catalogue attempting to critique the commercial forces of a hypercapitalist society and the latter in a gay glossy weekly that had very few boundaries between its ads and its editorials. As Golden writes in the *Freestyle* catalogue about the shared influences of the artists she selected: "They live in a world where their particular cultural specificity is marketed to the planet and sold back to them."[35] Golden and Ligon's term expresses a desire to critique the nuances of how identity is both yours and relentlessly up for grabs. "Post-black" prioritizes agile critique of misconceptions and preconceptions around blackness in art. "Post-gay" disavowed this nuance to make something catchy like an advertisement, controversy included. In his essays, Jack makes the link between "post-gay" and the rapid naming and fictionalization of art movements based on location such as the "80s East Village art movement" and "Neo Geo." Jack warns against movements that are market-driven and lack manifestos, passions, or friendships: "Geography alone does not a movement make. Nor does hype."[36]

"Notes on Queer Formalism," an online article by William J. Simmons, renders a dull desire to name *something, anything*. His watered-down Sontag-inspired "Notes on Camp" statements are framed as what "queer formalism" is *not*. Welcome to the trap. He cancels himself out, pruning the thorns of the word "queer's" un-definability. Yet Simmons persists by naming "queer formalism" in the art of Leidy Churchman, Nicole Eisenman, Amy Sillman, and Elise Adibi. The term sprang from Sillman's mouth at one point (and undoubtedly many others'), but all Simmons can conclude is that "queer formalism" "represents the possibility of a new way to discuss art in a nuanced, inclusive fashion." His examples could therefore be limitless, despite the fact that he chose these deserving artists to group. Simmons's need to point out these specific artists readily deflates an openness to "queer formalism." The only rationale I could find in Simmons's naming the work he lumps together is his own pleasure in marking a territory of thought, a predictable art historical/critical gesture that only sometimes serves the artist. His references to Jackson Pollock and Clement Greenberg don't feel like anything new or revolutionary, as he claims "queer formalism" is. Simmons is most excited and animated in his prose when describing specific works of art, such as Sillman's *Me & Ugly Mountain* (2003): "At once an abstraction and a landscape, the mountain is filled with orgiastic ideas, lines, and colors. It literally erupts on the face of the most essential mark— the horizon line—like a newly formed pimple."[37] After reading Simmons's essay (an essay a handful of people told me to read), I am resolute about avoiding the uttering of the phrase "queer formalism." I adamantly promote more close readings of works of art.

Artists who are queer and who have ample time, money, and connections do not seem to battle with entry into art institutions. In 2015, "queer" is synonymous with something art institutions *want* to consume, especially when "queer" is combined with the attractiveness of words like "formalism." Museums, galleries, and collectors love a buzzword like "Queer Formalism" because it provides another category of "marginalized art" to mark off their list and deflect criticism away from their histories of exclusion.[38]

On December 1, 2013, "Day With(out) Art: TALK, WALK, SING," I met Katie at Artists Space for a circle discussion to commemorate World AIDS Day. The three-part event was organized by curator Risa Puleo in conjunction with fierce pussy's window exhibition *For the Record* at Printed Matter. The show included an edition of postcards, stickers, and newspapers with a text that began, "if he were alive today he would be at this opening if she were alive today you'd be texting her right now if he were alive today he would be going gray..."[39] Members of the fierce pussy collective talked about writing corrections letters to *The New York Times* for not capitalizing ACT UP or identifying the root of the acronym, AIDS Coalition to Unleash Power. When the *Times* writes "Act Up," it is like they are misspelling thousands of names. Some people my age talked about caretaking for their parents and parents' friends with HIV. Christa Orth read a passage from *The Gifts of the Body*, a book by Rebecca Brown where the narrator is a caretaker for an elderly woman. She then asked us to write memories on 8.5 x 11 paper with sharpie markers. People in the circle held up words or condensed phrases like *Parting Glances* or *Bagels*. Cathy Busby spoke

about her recently released artist book *Steve's Vinyl*, which archived her brother's record collection and an exhibition she made to give away the records. Poet Orlando Ferrand talked about walking in the city for inspiration and writing as a way to cope with grief.[40]

Alex Fialho then led a tribute walk from Chinatown to SoHo to Greenwich Village to Chelsea. We stopped at buildings and landmarks where people who died of AIDS lived and worked. Outside the former New Museum on Broadway, Alex screamed without a megaphone, visibly needing water, amid the shopping crowds, to recite statistics and quotations from the original window display of ACT UP's *Let the Record Show. . .*, curated by William Olander.[41] As soon as Alex finished his reading, a street vendor in front of us shouted something like, "If you listened to god you wouldn't get AIDS." The older members of the group immediately responded in ragged unison of booooooos and nooooos. I was quiet and watched, perhaps because I am less accustomed to such blatant homophobia. On Houston Street, as we moved as a group, switching conversation partners in a smooth consortium, I asked Cathy about her brother Steve and the book launch at Printed Matter. This was the first time I've asked someone *how* they answer the question, "Do you have siblings?" Cathy talked about having other siblings still living, so her answer is always yes, but depending on the mood or the person, she may add, "We are three but we used to be four."

Halfway through the walk, I talked with Risa about my ever-digressing research for this book. She told me she also wrote about problems with the word "queer" in her essay "The F Word: Queering Formalism" as part of

a catalogue that documents Lisi Raskin's series "Mobile Observation." Risa wrote about commissioning and hosting the construction of Raskin's project in a backyard in Austin, Texas. In her close reading of Raskin's work, Risa prefers "queering formalism," the verb form, "as it implies a process of applying one methodology to another." Risa hazards against arguments like William J. Simmons's in her conclusion: "To get any closer in language to the experience of *Armada* would constitute another, more dramatic failure: the formalizing of queerness."[42] The moment of parsing a verb versus an adjective, in print, in speech, translates to a moment of bonding. I see your word forms and I will treat them delicately.

People delivering food for restaurants joined our semicircle as they locked up their bikes and rang bells in front of both Keith Haring's apartment on LaGuardia Place and again at Cookie Mueller's on Bleecker Street. The walk ended at the Christopher Street Piers at the site of Marsha "Pay It No Mind" Johnson's death, a public space, which stood in stark contrast to the building facades we previously visited. Tourmaline spoke about Street Transvestite Action Revolutionaries (STAR), founded by Sylvia Rivera and Marsha P. Johnson, as part of her research for the film *Happy Birthday, Marsha!* that she had been making with Sasha Wortzel.[43] Elegance Bratton spoke about his documentary *Pier Kids: The Life*, which celebrated meeting its fundraising goal just that day.[44] We had been walking long enough for the sun to set from its midday brightness. The streetlights and rushing headlights lit the West Side Highway on an unseasonably warm winter day. The group crossed the wide street and entered a mellow late-afternoon dance party at The Rusty Knot.

The New Museum's show XFR STN, in late 2013, featured machines that transferred old media to new formats, which were open to the public, albeit on sign-up sheets that filled up quickly. Part of the show's public programming included a screening of films from Naked Eye Cinema, of which Jack Waters and Peter Cramer are members.[45] On the panel after the screening, Jack described using film stock that was maybe expired or maybe partially exposed or maybe processed wrong. Those lapses in film quality didn't "transfer" well. Meanwhile, Jack spoke of needing digital versions to apply for grants and to share them with people like me. At times in the screening it felt like we were watching something through a smudged lens. In the Q&A someone from the audience shouted "dull" when the panelists began to discuss the quality of print film when transferred to digital video. This person did not raise their hand. I scribbled to Dia in my notebook, "best moment!"

Jack and Peter also recalled resisting the language Sarah Schulman and Jim Hubbard were using to recruit "queer film" in the early days of organizing The New York Lesbian & Gay Experimental Film Festival. Co-directors Shari Frilot and Karim Aïnouz added the name MIX in 1993 to the title since the festival was founded in 1987. The name switched again in 2007 to MIX NYC: New York Queer Experimental Film Festival.[46] Naked Eye Cinema is what they came up with when they didn't want to call themselves anything. In my memory, I turn around in my seat and see Schulman and Hubbard in the audience. I imagined them smiling a little. But I don't remember if Schulman and Hubbard were there, or if it was Hubbard

and not Schulman. I only vaguely sensed this disagreement about how Naked Eye Cinema can be called queer or not called queer. Of course they were making "queer work," yet it was not always "called" that. I guessed this type of disagreement didn't break any friendships as I looked around from one folding chair in the audience to another. I could try to fact-check this, but the fact doesn't seem to be the point. I felt lost inside ideas of gossip transferring to history transferring to opinion.

TO ACT THE INSTANT

We were both the narrators and spectators of our own experiences, though we aspired in the long run to be neither.

—Pamela Lu[1]

I loved seeing a pen die, rather than losing it, like usual.

—Eileen Myles[2]

In the fall of 2013, I brazenly emailed Fran Lebowitz's agent with an inquiry about her reading for The Poetry Project's Wednesday Night series. The reply read something like "I only book Fran for $25,000 gigs." I must be exaggerating. I got through to Fran's personal assistant, who responded with one line: "Can you resend this invitation spelling Fran's last name correctly?" I thought I knew how to spell every jewish last name without ever checking.

Fran handles business on the phone. She never even got a typewriter—that's where she's at with machines. She agreed to do an event where she would just talk. She doesn't exactly do "readings" in the traditional sense, considering she hasn't published a book for years. Fran has revised the onus of "writer's block" as a problem of labor in the medium: why *write* when you can just talk? To skip to the final act of articulation saves a lot of time, but only if you have Fran's skill of instant articulation. Meanwhile my hand was shaking as I held a script while on the phone with her, which only made me stumble more.

Fran prefers someone to warm her up with a brief interview before the audience Q&A. There is a boxing ring energy to it. As the Wednesday Night host, I offered to interview her. I got some anxiety prescription drugs that weren't strong enough. For months, I thought, "What would *you* ask Fran Lebowitz?" as if it were a religious axiom translated into a bracelet that would never biodegrade. And then something weird happened where I ended up asking her about Susan Sontag. I wanted to know if Fran had read her journals and what she thought about them. Fran replied, "I'm not that interested in other people, period." I asked, "Even Susan Sontag?" and she said, "*Especially* Susan Sontag." There was a roar of laughter.

I had a compliment to throw into the fire: "You have such great author photos, Fran." I was thinking of the full-bleed photo on the back of *Metropolitan Life* where she posed, sitting in a chair turned backwards, in front of a stone wall inscribed AUTHOR, with her legs spread wide across the chair's back. I thought there would be a story in what it was like to be photographed by Peter Hujar. The night before the event, I went searching for the catalogue the Grey Art Gallery published after Hujar's death with a selection of his portraits.[3] I couldn't find Fran's portrait in the book even though she was listed in the plates. I flipped through the book again, trying to move less ravenously. The pages of this catalogue must have stuck together, I reasoned. Then I felt a chunky ragged edge. While staring into this off-white cavity, the torn-out page hovered as if an arm had fallen asleep. I imagined the photo hanging in a dorm room of a young dyke. I imagined the photo burning in the electronic fireplace of John Sexton, the despised president of New York University, whose library I snuck into.

When I got home, I looked up Hujar's portrait of Fran. She props herself up on her forearms in bed. She is topless under the comforter, which she holds over her chest like a flowy evening gown. The bed is her runway, as if Hujar envisioned a moment of glamour in portraying her insomnia. Fran's pale skin is contrasted against a wallpaper pattern of heavy black and white diamonds. What looks like a psychedelic photo studio backdrop is just her childhood bedroom in New Jersey. Fran appears to be in her twenties. I imagine they did the photo shoot after Hujar came home with her for a holiday like Rosh Hashanah.

Fran and I talked most productively about the way people take pictures now. She agrees to be photographed on the street when people spot her. The last question on my flashcards stared back at me. I wanted to skip it but something didn't let me. "What do you think about labeling art queer?" Fran looked a little bothered and baffled. "I hope you don't have the impression I was at the forefront of this fight." She thinks any labels are confining, obviously. I knew her answer, but I wanted her on record. I felt so selfish after the event. I felt like I should have gotten one of her friends to warm her up for the crowd.

The Q&A opened up to the audience. Typical questions for Fran: What to do about the glass buildings in the Lower East Side, what book are you reading, should I even get a liberal arts degree? The last question was about how much space she has or doesn't have in her new apartment. She was at The Poetry Project while in the process of moving ten thousand books, her library, from one East Village apartment that was having a condo erected right next to it, to another one next to a church. A church that would be illegal to tear down and build an NYU dorm in its place. Fran checked. In response to the question, Fran said something like I have always lived alone and that is remarkable as a lesbian. She put the microphone down on the podium and walked off the stage.

I pushed through the crowd to hide in the single stall bathroom in the back of the sanctuary. I saw Aeliana, who immediately reported overhearing a poet grumble as he was walking out, "They should have had a straight person interview her." Did I make Fran Lebowitz come out? I have watched nearly every interview with her on the Internet to

date. Fran pointedly challenges the framework of "coming out" by putting a premium on privacy. She just holds court in her custom-made blazer, jeans, white button-down shirt and cowboy boots. It's not exactly a mystery. Martin Scorsese's documentary *Public Speaking* includes a statement, in response to a question about gay marriage, that *implies* her sexuality: "I'd vote for it because I know people want it, but personally, not me. Nor do I want to go into the military."[4] Also buried, way down in the search results for Fran, is an excerpt of the same documentary with dubbed lines of Fran "coming out." I had contradicted almost everything I've argued against labels by asking questions that prodded Fran Lebowitz to publicly acknowledge her gayness; it was not thrilling to be in a public conversation with her. It was excruciating.

In a ragged copy of Seymour Kleinberg's *Alienated Affections: Being Gay in America* (1980), I found a two-by-three-inch bookmark stamped "We met at the EAST SIDE SAUNA" with three lines below it left blank for a name, address and phone number. This seemingly old tool, the calling card, was tucked inside a book whose title included a synonym for estrangement. It worked on me like a soothing ointment. I posed a critique of the phrase "queer art" because I felt outside what I imagined to be a fixed group. I was not ready to admit five years ago, when taking on the question of labeling *anything* queer, that I was yearning for histories not readily available.

Finding Joshua Gamson's 1995 essay "Must Identity Movements Self-Destruct? A Queer Dilemma" seemed like a climax to my research. Gamson studied the arguments inside letters to the editor in gay San Francisco newspapers

about the naming of the 1993 Pride Parade "The Year of the Queer." Prejudices toward transwomen and bisexuals were voiced from lesbians who felt "threatened by the muddying of male/female and gay/straight categorizations." Meanwhile, letters from older gay men voiced memories of the word "queer" being used with the intent of physical and verbal violence. Gamson reflects: "The debates make concrete the anxiety queerness can provoke…It is by keeping sexual and gender categories hard and clear that gains are made…Necessary and dangerous distortions and moves to both fix and unfix them are reasonable."[5]

Intermittently, I have "found" some piece of information or history to echo my questions. This act of discovery works like the momentous music in a movie making viewers *feel* the emotions and the plot coming together. Pieces of information from the past prompt me to meditate on the present, or the role of someone who watches. But as the photographer I find the frame ungenerous and the camera's blind spots distracting. I feel compelled to take the picture but then feel mired in the question of *what to do with this*. This book chips away at the instability of categorization, which gets mixed up in recognizing and naming. David Wojnarowicz "never called" himself "a photographer" and if someone asked him if he was "a photographer" he would reply, "I sometimes make photographs." Wojnarowicz explains this as a tactic to avoid being examined and commodified by the "ART WORLD."[6] This is not unlike my insistence on a more tangled syntax: "artists who are queer." I am taking a picture of a landscape to include where the photographer stands. Photography epitomizes unstable, multiple identities right now. Anyone with a camera in

their pocket is *becoming* a photographer. This is similar to queerness not being so contained or separate but bleeding into everywhere. "Queer" is particularly uncontrollable as it increasingly exists in daily language. This fluctuation results in a broad cultural anxiety to define the words "queer" and "photographer."

Jess told me he refreshes the page over and over again on netflix's gay and lesbian section. I ask if Wu Tsang's *Wildness*[7] is there yet. No. José Esteban Muñoz said in his keynote address at that Brown University Graduate Symposium in 2013 that *Wildness* was going to be on netflix soon. I missed all the screenings when it came out. To miss any event can feel like I am missing the moment I am living in. I have thought at times that a work of art made by one queer person could deliver a revelation. The revelation is code for wanting to escape the feeling of living inside a continuum that mixes together and tastes weird. The expression "queer art" has the *most* meaning for those artists who use it to describe their own work. I began this essay with the goal of preventing the articulation of "queer art" when it stands unexamined because I wanted to stop "queer art" from becoming a known or given set of agendas. What I ended up with is an argument for a wider range of possibilities of associations with what comes to mind when the utterance "queer art" inevitably surfaces.

Catherine Opie has been a poster child for "queer art," as evidenced by her work's appearance on the covers of *Art & Queer Culture* and *Lesbian Art in America: A Contemporary History.* Yet, in an interview with Andrea Bowers in the A.R.T. Press (Art Resources Transfer) Between Artists series, Opie says, "I don't call myself

a queer artist. But I'm also proud of being queer and adding to the visual dictionary of our community." In reflecting on the expectation people had of her to photograph the so-called radical queer communities she is a part of, she points out, "It's just as important to photograph immigration marches or peace marches."[8] I saw Opie give the same artist talk twice over the course of writing this book. I heard her retell many stories about many photos—she really crams a lot of projects into her road show. I was baffled by Opie's apparent pleasure with the Guggenheim's gift shop, which for the occasion of her retrospective had fabricated baseball hats based on a gothic-font "dyke" tattoo from the photo she took of the back of her friend's neck, in 1993, when "dyke" was more slur than chic. Opie delighted in the fact that this hat was corrupting a historically straight art institution. I was horrified by the commodity value of something with "dyke" emblazoned on it.

I will never look at a work of art and say, "This is queer—full stop." Anytime the utterance "queer art" appears as a proclamation of something stable, it is a mirage. Definition is the press release talking. Let us write press releases and read them out loud while laughing at ourselves. Am I accidentally writing a manifesto for a "queer art" movement? Such a manifesto is impossible. Forever a fiction. There are too many manifestos that don't even look like manifestos to know about. I am not interested in being a spokesperson. To quote another ragged paperback for its sheer outdatedness, Dennis Altman wrote in *The Homosexualization of America*, "Prophecy is a dangerous venture."[9] Studying art made by queer people, both informally and deeply, is a

smokescreen of relentless incompleteness. For everything I zoom in on there is the not-yet-published, not-yet-curated work. Everything I found at one point fascinating, I may grow detached from. What gets said off the record then transcribed from memory for the record manifests as my vision of being the record.

While talking to new or old friends after an art event or in a swirl of thought while reading, I sometimes get this clairvoyant burst: *this is what my book is about*. Then this feeling evaporates or I forget to write down the theory I arrived at. Most recent scribble: "Everything theory: at this time one must address everything if they are to say anything." *This is what my book is about*: getting hot with anger while calling *The New York Times* corrections hotline about the review of a show. The reviewer got a performer's pronoun wrong.[10] *The New York Times* did not print or post my correction. *This is what my book is about:* flippantly asking, "Are we even archiving anymore?" after a *No, Dear* magazine release reading. "Yes!" Katie said, "What about the Lesbian Herstory Archives?" Their biannual book sale spreads the archive wide, where they sell everything they have duplicates of from their net of donations. Katie arrives early to get the best books. I went a few weeks later with her to initiate my participation in this ritual. I found *The Sophie Horowitz Story*, Sarah Schulman's first novel from 1984, and read it like addictive pulp. The searching-never-ends book is about a "Feminist News" journalist who becomes ensnared in the complexities of covering a bank robbery and the underground revolutionaries who escaped.

This is what my book is about: finding Sophie, who is portrayed as a nascent activist, one who doesn't *actually*

have a plan for "the revolution." She is both comically unrealistic yet racing to have the most incisive analysis. When her lesbian newspaper gig cuts her loose, she brainstorms pornography-related moneymaking schemes:

> I certainly didn't want to make an unnecessary
> contribution to the world of things that men jerk
> off to. I wanted it to be meaningless to men and
> wonderful for women…I, for example, masturbate
> to *The New York Times*.[11]

Sophie's best friend, Chris, the editor of *Feminist News*, abandons her story because Sophie's beat, Laura Wolfe and Germaine Covington, are affiliated with the "patriarchal" radicals. Also, the FBI is parked outside their office. Our protagonist can't let the story just lie in the hands of the mainstream press because the fact that Laura Wolfe is a dyke won't be included with nuance and dignity.

The novel's backdrop includes organizations and movements at various stages of historical development such as Black Power, Students for a Democratic Society (SDS), Women's Liberation, Gay Liberation, the May 19th Communist Organization, and December 4th movement. In Sophie's hunt for "the story," we meet people who are evaluated based on how they waffled in their radicalism, while Sophie navigates her own confused role as a writer and activist. Sophie concocts a plan to get into the apartment of Seymour, the mediocre *Village Voice* journalist who fabricated an interview with Covington before she was (falsely) declared dead by the headline "Cop Killer OD's in Jailhouse Orgy." Sophie and her girlfriend, Lilian, dress as gay men and follow the *Village Voice* journalist as he scrapes the surface of

the early 80s Meatpacking District leather-bar circuit. At first this investigative reporting provides Sophie with such meandering lustful observations as: "The leather was strong and soft. Like Lilian."[12] While looking around in drag at this subculture, Sophie prophesies that leather is exiting its shiny trend stage, and "maybe paper"[13] will take its place as the new outfit. Sophie gets Seymour wasted enough to bring him home. They put a nearby BDSM mask on his face as he passes out so they can steal a pile of papers from his desk.

The next morning, via the faithful front-page headline, Sophie enters "the most severe panic of her middle-class life,"[14] when she learns that the *Village Voice* journalist, sometime after she and Lilian returned him to his bed, was murdered and dumped in the Hudson River. Meanwhile, the network of revolutionaries she isn't *quite* cool with are using her as a pawn. Their trap: keep the young lesbian obsessed with the unattainable: the hard-core Laura Wolfe or Vivian, "the straight woman." Sophie is blinded by her search for the story until her neighbor Mrs. Noseworthy, who happens to be a bestselling mystery novelist, luckily intervenes to solve "the story" for her.

Schulman's fast-paced plot is punctuated with sex and inexpensive jewish comfort food. Sometimes the sour cream falls by the dollop into the bathtub with Lilian. In her manic deadline state, Sophie lusts not only for her girlfriend but for blintzes, fried sauerkraut pierogis, cheesecake, borscht "all-the-way," kasha varnishkes, pumpernickel rolls, knishes (*not* microwaved), bialys, and cold potato kugel. Schulman handles Sophie's desire for food and sex as messy and overflowing in contrast to Sophie's precise drive for proximity to the dykiest of the revolutionaries.

Amidst this extreme-sport-style determination is a curious character trait: Sophie has *no* brand preference of cigarettes to smoke. Throughout the novel we see our protagonist inhale Camel "straights," Newports, Marlboros, Drum, Pall Malls, Winstons, Virginia Slims, and Salem Lights. Schulman spotlights Sophie's indifference toward choosing a brand when the murderer is about to be revealed. Vivian (Laura Wolfe's best friend and lead informant) runs into the drugstore to get a prescription and asks, "What brand?" of cigarettes and Sophie replies, "Doesn't matter." Vivian comes back with Luckys. The no-brand of smokes chants a low hum of resistance to the steady creeping in of gay marketability; this parasite on the radicalism of gay liberation comes to be the theme of Schulman's body of work in the coming decades.

Thirty years after *The Sophie Horowitz Story*, Schulman published *The Gentrification of the Mind: Witness to a Lost Imagination*, a book of nonfiction on the AIDS epidemic within artistic communities and the strategic destruction of neighborhoods like the East Village by real estate developers and city governments. I vacillate between learning from Schulman and critiquing her dichotomous thinking, especially in her depiction of generational divides in queer communities. Schulman watches, from inside her group of peers, a younger generation of queers at the opening for a show chronicling the artistic and design committees in ACT UP at White Columns gallery in 2010:

> Before me I saw two distinctly different experiences,
> separated by the gulf of action fueled by suffering on
> the one hand, and the threat of pacifying assimilation
> on the other. When the ACT UPers were in their

twenties, they were dying…The younger people loved ACT UP. But in some fundamental way they couldn't relate to it. They didn't understand what we had experienced. They had never been that oppressed. They had never been that profoundly oppressed. And yet, they wanted to relate.[15]

After this observation, Schulman tells the story of crossing over the generational divide by going out for drinks with six young "queer artists" who appeared to have plenty of professional success and familial support. But they were hungry to know her "story" as an activist and a writer. The six artists at times get condensed into one person; they switch from plural to singular, perhaps to aid Schulman's point, perhaps because they really did unify in their curiosity. I don't know. I wasn't one of those "young queer artists."

Schulman asked the group at the bar, "What is it that you want to know?" and the answer: "I wonder what it means about me."[16] The "it" of this sentence stands for so much: decades of activism, grieving, risking everything in one's art and life to fight homophobia and its deadly effects on the gay community. I want to know *which* young queer artist said this. Schulman portrays a world where my generation floats around with "professional instincts" to navigate out "the queer content" in their work as if queer content is always or ever that quantifiable.[17]

Schulman further reflects on the generational divide when a young gay man comes to her for input on a film he wants to make about an artist who died of AIDS. He lists the famous artists he's thinking about, then asks for recommendations about any other lesser-known artists. Schulman replies, "There are thousands." This hits me in

an intensely grave way. I forgive Schulman for being so extreme because her perspective makes sense. How can there be nuance if one survived an epidemic we are *still* fighting? Below is another incriminating portrait of a young queer who asked Schulman for an interview of which she was "surprised" by the muted "tenor":

> There was no urgency. He didn't have—as I expected
> he would—theories or ideas or passions that he
> wanted to talk over. I had hoped that he would bring
> new ideas into my life, but instead he wanted them
> from me. He didn't have something that he *needed* to
> know. He just wanted me to give him the interview.
> Recite my stories.[18]

I quietly wondered if the anonymous artist depicted was Carlos Motta, simply because I saw Schulman in the *We Who Feel Differently* interview archive and because Motta is such a visible "queer artist" right now, he is the first person who pops into my head to project this portrayal onto. Schulman exposes "young queer artists" searching for their gay and queer history as stuck within a prism of narcissism. Ironically, this prism is allotted to them because of Schulman's generation of queer activism. To Schulman, the privilege and comfort of navigating through a generalized "experience rooted in a lack of consciousness"[19] hauntingly mirrors the behavior of an urban gentrifier. While I am willing to accept this as a loose theory, it does not and cannot hold water across "my generation." There are young queers who are profoundly oppressed in this country, who battle racialized violence, the prison industrial complex, living with HIV, transphobic healthcare systems, homelessness and poverty—there is a

young generation of queer people who are activists and also artists and artists who are also activists. Schulman wrote *The Mind* so "young queer artists" would be provoked not only to disagree with her portrayal of them as the spoils of suburbia but to provide a detailed account of how they work hard to learn histories, all the while trying to survive in the present.

I felt as if I was unprepared for a test when I saw Sarah Schulman walk in to the lobby of The Kitchen right after I affixed my stupid clip-on bow tie. I was on the benefit committee in 2014 for Tina's theater company, Half Straddle, though I got only one friend, Rachel, to buy a ticket. After some small talk, I broke the news, "So, I am writing about your first book." Sarah said, "Well, you know it's based on the 1981 aborted Brink's robbery." "What?" I asked. It didn't say that anywhere in *The Sophie Horowitz Story*, which I had read twice. I felt like Sophie, caught in my own youth, set up in my story about Schulman to become exactly what I was fighting against: the "young queer artist" oblivious of history. I rushed home to see if wikipedia could save me. Sarah told me to go the Lesbian Herstory Archives, but all I had to do was pull her book *My American History* off my shelf. I found the *Womanews* article she wrote about the Brink's robbery. "Nyack and a History of Strategies Disputed" is included in the top hits of her journalism among other articles such as "Adrienne Rich Transformed by Nicaraguan Visit," "Koch Ready to Close More Bathhouses," "*Joy of Gay Sex* Removed from Brooklyn Libraries," and "AIDS and the Responsibility of the Writer."[20] The revolutionary characters in *The Sophie Horowitz Story* seem to be drawn from a fascination

with an older generation of civil rights activists and their political struggles that Schulman was, by virtue of her age, too young to be a part of.[21]

I toss Patrick Califia's *Macho Sluts* at Stephanie: "You should read this." Aeliana had once said the same thing to me when lending me her copy that looked like it had been through a few thunderstorms. I felt happy watching Stephanie inhale the first twenty pages. She was just finishing her time at Smith College and able to read really fast. I asked her for a review. She started making fun of how Califia describes a hard nipple as a raisin. "Ew, that's gross, this is supposed to be erotica? It's *not* hot." I felt like a parent at the dining room table, snatching the book from her, angrily thinking, "Respect your elders." But isn't critique a form of respect? I have caught myself making generalizations about queers who are ten years younger than me who seem disinterested in their "histories." But it's not whole generations who lack a deference for "queer history," it's just some people. A white gay student in my *Writing as Photography* class showed up to a midterm meeting in drag for a show he was doing on campus later that day. It felt like it didn't matter that I'm gay and his teacher, whereas for me that would have been game changing. I asked him where he performs. "You wouldn't know," he replied. He was trying to explain what Bushwig is and I just had to stop him. "I KNOW WHAT BUSHWIG IS." Then I told him he may be smart and funny but his sentence structures are a mess because he is always in a rush. "Just go," I said. There will always be things people from different generations cannot understand about the other generation's "time," just as there will always be things one cannot understand of other people's life experiences in one's own time.

I was walking uptown on Fifth Avenue in Millions March NYC on December 13, 2014, after grand juries announced that the cops who murdered both Eric Garner and Michael Brown would not be brought to trial. Before I arrived I saw how many people were photographing and posting the eight-panel composite image of Eric Garner's eyes.[22] When I passed this signage in the march, there was a rare pocket of space in a crowd of tens of thousands. The space was created for those who answered the impulse to take a picture that would include the width of all eight panels that built the image of Garner's eyes. Garner's act of looking proliferates as one of the most-circulated images from this march. Black Lives Matter, a political project, mantra, and hashtag that was co-founded by Alicia Garza, Opal Tometi, and Patrisse Cullors in 2013, functions as a continuation of centuries of resistance against anti-black violence. The continued protests and media produced by those leading widespread grassroots organizations[23] against anti-black and anti-brown police tactics, murders, and mass incarceration work in resistance to a mainstream media that for the most part constructs news for the white imaginary. As I walked in solidarity with Black Lives Matter, I was reminded of going in the opposite direction, downtown on Fifth Avenue, in the celebratory pace of dyke march. While in the same city, marching on the same avenue, I had such different purposes and experiences.

In 2013, I followed the path from the West Side to the East Side and back west for Trans Day of Action for Social and Economic Justice and then Drag March. In Sheridan Square, someone handed me a xerox of the lyrics to "Somewhere Over the Rainbow," but I wasn't singing.

Jess and I walked to Julius recalling memories from a year earlier when we left a bear bar on Christopher Street for its inhospitable energy: "Ladies, why aren't you at Henrietta Hudson?" I shouted something back about how we aren't "ladies"; Jess took it lightly. Going to Pride is like getting a physical. We decided on French Roast and ordered martinis. Pilar showed up talking about the annual Pride party at their work, The Spotted Pig, a moderately fancy restaurant in the West Village. The manager announced to the staff that they were getting an ice luge in the shape of a "tranny." Pilar confronted the manager (a gay man) about this word choice as offensive and uninformed. The manager was receptive to Pilar's feedback, and an epic conversation over text message ensued, for the duration of our hangout. Pilar began reading the messages as they were coming in and the table would compose replies about how the restaurant could change the ice luge to be *less* offensive. The Spotted Pig had originally ordered a cis-female form with a strap-on. Jess and Pilar went outside to talk about hormones. I ordered a cheese plate.

The next day fellow researchers were acting confused about all the noise in the New York Public Library's Wertheim Study, a place of pristine silence. Where was that horn and whistling and drumming coming from? "It's dyke march!" I announced before leaving the room. The code of silence is otherwise broken only when security guards come in at 5:45 to say, "The library is now closed."

Cameras were bouncing on chests and covering people's faces. Those who were exceptionally dressed appeared ready to pose. I didn't know how to pose. Handcrafted signs beckoned the cameras: "Gay Marriage

does not Equal the Voting Rights Act;" "Death Metal Dykes for Davis;" "Transwomen Are Our Sisters." I was thinking about those who pointedly do not go to dyke march because there have been incidents of transmisogyny. A handful of signs at the march directly address dykes and institutions that are not inclusive of transwomen. It's hard to take pictures of people moving. I thought about those who didn't come to the march because they were working. Or those who were avoiding ex-partners or dates that had gone awry. People holding signs were happy to pause for a photograph to help further manifest the future of the sign. Katie and Rachel both needed to hold their "Free Bradley Manning" banner because it was a few feet wide (the following year, Katie's sign read "Free Jane Doe, Free Chelsea Manning"). They had another sign that read "Voting Rights For All" that they were trying to unload. "Do you need a sign? Do you want a sign?" Katie asked eagerly as soon as I saw her. "I can't," I said, "I'm taking pictures." Taking pictures is *like* holding a sign but really it is just something that takes up both my hands. My choice to photograph became a layover between saying something in the moment and gesturing a future memory of the moment.

I saw passersby who happened upon the march take pictures almost without hesitation as if a city landmark appeared out of nowhere. We entrapped their floatation device of a tour bus. I had a hard time getting the pictures I wanted, which were mostly of friends. I found it complicated to take pictures of people I didn't know, even if I watched other people take their pictures. I asked Dia to hold still. While focusing, she became detached from

the flow of the march and temporarily lost who she came with. Because my camera is not automatic I took a picture of Stacy and Helaine, then Helaine came into my spot so I could be in a picture with Stacy. No, that was a different year. I stood behind SJ, who was holding a poster with an Audre Lorde quote: "It is not our differences that divide us. It is our inability to recognize, accept, and celebrate those differences." SJ told me about writing the quote out on the train. The letters gradually shrank in size as the space on the poster decreased. The sun was descending in a fictional red-orange, acting like a spotlight on Lorde's words. The sign's permanent marker bled through to its backside. I began to focus when the march stopped to let crosstown traffic pass.

Once I got the film processed, I was surprised I had taken fewer pictures than I wanted to. Or fewer pictures than I expected I would take. I had come to the march with rolls of extra film jiggling in the right pocket of my cut-off shorts as a purposeful bulge. I decided to give some pictures to the friends inside them. Most of the pictures felt cacophonous, especially the ones with all the other people taking pictures inside of them. So the pictures sat near my desk in a pile of papers with no filing system in sight. They had to wait to mean something.

NOTES

1 kari edwards, *a day in the life of p* (Honolulu: Subpress Collective, 2002), 62.

2 Stacy Szymaszek, *Hyperglossia* (Brooklyn: Litmus Press, 2009), 55.

3 "Homoground is dedicated to promoting equality and visibility for all people through music and art while maintaining a creative medium for queer & allied artists and music lovers worldwide." "About," *Homoground,* Web.

4 "Homobiles is a California NPO 501c3 committed to providing secure and reliable transit to the SF Bay Area LGBTIQQ community and its allies....Donation is 100% voluntary & is not a condition of service. No one turned away for lack of funds. Operating 24 hours / 7 days a week with support of the Homobiles volunteer staff." *Homobiles,* Web.

5 "The Lesbian Lexicon Project is a humorous pocket guide to queer slang. It features well-known phrases and some previously undocumented gems, including 'dopplebangers': people who only sleep with people who look like them, and 'whatever-the-fuck-I-want-gomy': the practice of doing whatever the fuck one wants while pretending they are in a consensual, polyamorous (or monogamous) relationship." "The Lesbian Lexicon," Third Edition by Stevie Anntonym, "Catalog," *Microcosm Publishing*, Web.

6 In my celebration of dykes, I pointedly stand in resistance to lesbians who practice transmisogyny and exclude transwomen. The history and work of "lesbians" is extremely varied. As a dyke *and* a trans person, I use the words "dyke" and "lesbian" in this book, in support, admiration and love for transwomen, non-binary, and gender-non-conforming people.

7 Laurie Weeks, *Zipper Mouth* (New York: The Feminist Press, 2011), Front and Back Covers.

8 Sam D'Allesandro, *The Wild Creatures: Collected Stories of Sam D'Allesandro*, ed. Kevin Killian (San Francisco: Suspect Thoughts Press, 2005), Back Cover.

9 Alvin Orloff's whole blurb, on the inner first page, reads: "*The Wild Creatures* is enough to give anyone a crush on Sam D'Allesandro. His voice is beguilingly intimate, but never gossipy or confessional—perfect for its spare, focused little stories. He describes relationships with an attention to emotional nuance that makes his characters seem both unique and eerily familiar. His thoughts glimmer with a lucid, unsentimental intelligence and freshness. This is what queer literature looks like freed from pretension and banality."

10 Gloria Anzaldúa, "To(o) Queer the Writer—Loca, Escritora y Chicana," in *The Gloria Anzaldúa Reader*, ed. AnaLouise Keating (Durham: Duke University Press, 2009), 163.

11 Ibid.

12 Renee Gladman, *Newcomer Can't Swim* (Berkeley: Kelsey Street Press, 2007), Back Cover.

13 Maggie Nelson, *The Art of Cruelty: A Reckoning* (New York: W.W. Norton & Co., 2012), 87-89.

14 Meanwhile, Nelson's *The Argonauts* (2015) is a book of poetry, prose and "autotheory," as Graywolf Press calls it. Nelson focuses on the instability of naming things queer through her analysis of motherhood and being in partnership with Harry Dodge. *The Argonauts* is explicitly marketed as queer to both queer and non-queer audiences. The mainstream has notably been primed for queer content since Nelson's *The Art of Cruelty* came out.

15 Aaron Shurin, *A Door* (Jersey City: Talisman House, Publishers, 2000), Back Cover.

16 kari edwards, "a narrative of resistance," from *Biting the Error: Writers Explore Narrative*, ed. Mary Burger, Robert

Glück, Gail Scott, and Camille Roy (Toronto: Coach House Books, 2004), 266.

17 Akilah Oliver, *The Putterer's Notebook* (Brooklyn: Belladonna*, 2008), 17.

18 Trace Peterson, "Becoming a Trans Poet: Samuel Ace, Max Wolf Valerio, and kari edwards," TSQ* *Transgender Studies Quarterly*, no. 4 (2014): 527-8.

19 Trace Peterson, *Violet Speech* (New York: 2nd Avenue Press, 2011), 7-15.

20 Alok Vaid-Menon and Janani Balasubramanian, "The U.S. Is So Behind the Times: What We Can Learn from the Queer Palestinian Movement," *DarkMatter*, Web.

21 As of 2015, DarkMatter's two chapbooks include *Rainbows Are Just Refracted White Light* and *It Gets Bitter.*

22 Sarah Rosenthal, *A Community Writing Itself: Conversations with Vanguard Writers of the Bay Area* (McLean: Dalkey Archive Press, 2010), 99.

23 Pamela Lu, "My Narrative," *Narrativity 1*, ed. Mary Burger, Bob Glück, and Camille Roy, Web.

24 Tisa Bryant, *Unexplained Presence* (Providence: Leon Works, 2007). Cover artwork by Wura-Natasha Ogunji.

25 Ibid., x.

26 Ibid., ix.

27 Ibid., 37.

28 Ibid., ix.

29 Ibid., 56.

30 Ibid., 55.

31 Ibid., 59.

32 AA Bronson's facebook page, February 26, 2011, "Queer Cinema from the Collection Today and Yesterday," film screening, Museum of Modern Art, New York, March 11-17, 2011.

33 Jon Davies, "Masculine Mystique," Fillip 16 (2012): 96-105. It's rare that a gay cis-male calls out gay male misogyny with their use of the word queer. Jon Davies does an excellent job of continuing the conversation that started in response to Bronson's "Queer Cinema" curation with an essay on AA Bronson and Peter Hobbs's publication *Queer Spirits*.

34 Ted Rees, email to the author, March 31, 2011. The reading was a part of Sara Larsen and David Brazil's series in Oakland, which got relocated to Rees's house on Saturday, August 7, 2010.

35 Paul Mpagi Sepuya, email to the author, March 1, 2011.

36 Barbara Smith, "Toward a Black Feminist Criticism" in *The Truth That Never Hurts: Writings on Race, Gender and Freedom* (New Brunswick: Rutgers University Press, 1998), 3.

37 Ibid., 8; Ellen Moers, *Literary Women: The Great Writers* (Oxford: Oxford University Press, 1977); Patricia Spacks, *The Female Imagination* (New York: Alfred A. Knopf, 1975); Mary Ellmann, *Thinking about Women* (San Diego: Harcourt, Brace & World, 1968).

38 Elizabeth Alexander, *The black interior: essays* (Saint Paul: Graywolf Press, 2004), 40.

39 Trace Peterson and TC Tolbert's open call for work required a poetics statement: "Our assumption is that the writing of trans and gender queer folks has something more than coincidence in common with the experimental, the

radical, and the innovative in poetry and poetics (as we idiosyncratically define these categories), and with your help we'd like to manifest that something (or somethings) in a gender queer multipoetics, a critical mass of trans fabulousness." "Open Call: Anthology of Trans and Genderqueer Poetry," August 26, 2011, Web.

40 Trish Salah's *Lyric Sexology Vol. 1* won the 2014 Trans Fiction award. Salah published the book with Roof Books, whose tagline is "the best in language since 1976." Roof is a press I associate with "poetry" as opposed to "fiction." I make this point that a book of trans-disciplinary poetry and prose won a Trans Fiction award to suggest that part of the problem with the Lammys is how it upholds genre as fact in its award systems.

41 Trace Peterson, "Being Unreadable and Being Read: An Introduction," in *Troubling the Line: Trans and Genderqueer Poetry and Poetics*, ed. Trace Peterson and TC Tolbert (Callicoon: Nightboat Books, 2013), 17. Peterson cites her TENDENCIES: Poetics and Practice series at the CUNY Grad Center when Samuel Ace pointed out in 2010 there was no Trans Poetry Lambda Literary award despite Lambda giving Trans Fiction and Trans Nonfiction awards.

42 Jen Benka and Carol Mirakove, interview with the author, March 6, 2011. Benka and Mirakove's full call for work: "As admirers of your work, we are writing in hopes that you'll be a part of *Generation XX*, an anthology we are editing of poems, stories, essays, and comics by lesbians who were born between 1965 and 1981. In the book we want to collect the most provocative writings of our generation. We also hope the collection will debunk some of the stereotypes of our generation promoted by marketers and pundits, namely, that we are apathetic and that we are passive consumers. Furthermore, lesbians have alternately been ignored or put forth as the new chic. We want to strengthen our visibility and to all the more encourage gay women and girls to write out."

43 "The Hurtful Healer: The Correspondence Issue," Invisible-Exports, January 14-February 13, 2011. Ali Liebegott, Allyson Mitchell, Bernadette Mayer, Carolee Schneemann, Catherine Lord, Chuck Nanney, Daniel Feinberg & Rhyne Piggot, David Wojnarowicz, Dr. Weeks, Eileen Myles, Gary Gissler, Genesis Breyer P-Orridge, Glen Fogel, Harmony Hammond, I.U.D. (Lizzi Bougatsos & Sadie Laska), Jack Smith, Jibz Cameron aka Dynasty Handbag, K8 Hardy, Kara Walker, Kathe Burkhart, Kathleen Hanna, Kathy Acker/Dennis Cooper, Laura Parnes, Leidy Churchman, Louise Fishman, Mike Albo, Nao Bustamante, Nicola Tyson, Simon Fujiwara, Tobi Vail, William Powhida, Zackary Drucker, Zoe Leonard, and others.

44 Julie Fogarty, "Interview - Cheryl Dunye by Julie Fogarty," *Bend Over Magazine: Feminism, Sexuality, and Queer Art* 5 (2010).

45 *The Watermelon Woman,* dir. Cheryl Dunye (First Run Features, 1997), 83:50.

46 Kara Keeling, "Joining the Lesbians," in *Black Queer Studies: A Critical Anthology,* ed. E. Patrick Johnson and Mae G. Henderson (Durham: Duke University Press, 2005), 219-20.

47 *The Owls,* dir. Cheryl Dunye (Parliament Film Collective, 2009), 65:30.

48 T.L. Cowan and Jasmine Rault. "Trading Credit for Debt: Queer History-Making and Debt Culture." *WSQ: Women's Studies Quarterly* 42, no. 1 (2014): 294-310. All the photos of Fae Richards were fabricated for the film in collaboration with Zoe Leonard. Cowan and Rault consider a recent exhibition where Leonard's *The Fae Richards Photo Archive* was removed from the Leslie Lohman Museum in the "Rare & Raw" 2013 exhibit after the opening when the Eileen Harris Norton Collection suddenly changed their loan agreement with the museum.

1 Camille Roy, *The Rosy Medallions* (Berkeley: Kelsey Street Press, 1995), 27.

2 Dawn Lundy Martin, *The Morning Hour* (New York: The Poetry Society of America, 2003), 8.

3 Holland Cotter, "Sexuality in Modernism: The (Partial) History," *The New York Times,* December 10, 2010. Cotter writes, "The whole enterprise looked like an exercise in Hall of Fame-building, rather than like an effort to chip away at the very idea of hierarchy and exclusion."

4 Robert Atkins, "Goodbye Lesbian/Gay History, Hello 'Queer Sensibility': Meditating on Curatorial Practice," *College Art Association Journal* 55, No. 4 (1995): 80-85. Atkins criticizes curators Lawrence Rinder and Nayland Blake of the Berkeley Art Museum's 1995 "In a Different Light," as well as *Art in America*'s "After Stonewall," which was a "package of 12 interviews conceived and realized by Holland Cotter...At its most problematic, the contemporary-oral-history format obviates any give and take. This reader yearned, for instance, for Cotter's response to Hugh Steers's observation that 'gay art is a marketing label . . . it's important to discuss it and expose the fallacy of lumping us all together.'"

5 Chuck Mobley, Julia Haas, Alison Maurer, Irene Gustafson, Jonathan D. Katz, Kim Anno, Julian Carter, and Robert Atkins, "Emergency Screening: *A Fire in My Belly* — a short film by David Wojnarowicz and Panel Discussion," SF Camerawork, December 10, 2010.

6 "Suggestions of a Life Being Lived," SF Camerawork, San Francisco, CA, September 9 - October 23, 2010. Exhibit featured Steven Miller, Tara Mateik, Killer Banshee, Gay Shame, Kirstyn Russell, Jeannie Simms, Lenn Keller, Mercury Vapor Studios, Chris Vargas, Greg Youmans, Jason Fritz

Michael, Aay Preston-Myint, Allyson Mitchell, Eric Stanley, Torsten Zenas Burns, and Darrin Martin.

7 Adrienne Skye Roberts, in discussion with the author, October 13, 2010.

8 *Suggestions of a Life Being Lived*, ed. Danny Orendorff and Adrienne Skye Roberts (San Francisco: SF Camerawork, 2011), 13.

9 Ibid., 34.

10 Jonathan D. Katz, *Hide/Seek: Difference and Desire in American Portraiture* (Washington, DC: Smithsonian Books, 2011), 23. Katz quoting Abbott in an interview with Kaucyila Brooke. Katz also cites Tee A. Corinne's self-published 1996 book *The Lesbian Eye of Berenice Abbott*.

11 Peter Hujar, "Susan Sontag," "Hide/Seek: Difference and Desire in American Portraiture" (Washington, DC: National Portrait Gallery), 2010, Museum Exhibit Label.

12 Susan Sontag, *Reborn: Journals and Notebooks, 1947-1963,* ed. David Rieff (New York: Farrar, Straus and Giroux, 2008), 221.

13 Lisa Levy, "Critical Intimacy: Comparing the Paradoxical Obituaries of Susan Sontag," *The Believer,* April 2006. Terry Castle eulogized Sontag in a very "out" way by reflecting on difficulty in their friendship in *The London Review of Books* in 2005. Castle also cites Allan Gurganus's *The Advocate* obituary, which expresses the wish that Sontag came out.

14 Sontag, *Reborn*, 221.

15 Sarah Schulman, *Ties that Bind: Familial Homophobia and Its Consequences* (New York: The New Press, 2009), 122.

16 "More About Kay Ryan: Poet Laureate Consultant in Poetry, 2008-2010," The Poetry and Literature Center at the Library of Congress, Web.

17 *The Poet's View: Intimate Profiles of Five Major Poets*, dir. Mel Stuart (Filmmakers Library, 2009), 95:00.

18 Kay Ryan, *Dragon Acts to Dragon Ends* (Fairfax: Taylor Street Press, 1983), 26.

19 Ryan, *The Best of It (*New York: Grove Press, 2010), 110-11.

20 Ibid.

21 Ryan, interview by Ian Mylchreest, *KNPR's State of Nevada,* 88.9 KNPR FM, November 4, 2009.

22 Danielle Evennou, "The Elephant in the Room: Kay Ryan," *Beltway: Poetry Quarterly* 10 (2009), Vol. 4, Web.

23 Eileen Myles, "Poetry in the 80s," *Eileen Myles*, June 2012, 7-8, Web.

24 Myles, "How to Run for President of the United States of America," *e-flux*, 1995, Web.

25 Sharon Olds, "Open Letter to Laura Bush," *The Nation,* September 19, 2005. Sharon Olds declined an invitation by Laura Bush to the White House in protest of the Iraq war.

26 Kevin Quashie, *The Sovereignty of Quiet: Beyond Resistance in Black Culture* (New Brunswick: Rutgers University Press, 2012), 97.

27 Richard Blanco, interviewed by Terry Gross, *Fresh Air*, NPR, February 18, 2013, radio.

28 *T'Aint Nobody's Bizness: Queer Blues Divas of the 1920s,* dir. Robert Philipson (San Francisco: Shoga Films Foundation, 2013).

29 Jocelyn Saidenberg, email to the author, February 22, 2016.

30 Saidenberg, *Mortal City* (San Diego: Parenthesis Writing Series, 1998), 7.

31 Saidenberg, *Dead Letter* (New York: Roof Books, 2014), 15.

32 *Judith Butler: Philosophical Encounters of the Third Kind*, dir. Paule Zajdermann (First Run/Icarus Films, 2006), 52:00.

33 Jacqueline Francis, *Making Race: Modernism and "Racial Art" in America* (Seattle: University of Washington Press, 2012), 10.

1 Aaron H. Devor, *FTM: Female-to-Male Transsexuals in Society*
 *(*Bloomington: Indiana University Press, 1999), xviii.

2 James Baldwin, *Giovanni's Room* (New York: Vintage Books,
 1956/2013), 25.

3 "Poetry Benefit for Queer Detainee Empowerment Project,"
 April 26, 2014, Bureau of General Services—Queer Division,
 New York. Janani Balasubramanian, Jamila Hammami, and
 Hannah Nugent organized this fundraiser reading which
 Carolyn Ferrucci hosted. I read with Janani Balasubramanian,
 Aeliana Nicole Boyer, Corrine Fitzpatrick, Amanda Davidson,
 Mel Elberg, Clara Lipfert, Morgan Vo, and Tennessee Jones.

4 "Panel Discussions—Creating Queer / Curating Queer,"
 Queer New York International Arts Festival, September 29,
 2013. Carla Peterson, Tere O'Connor, T.L. Cowan, Susana
 Cook, Dan Fishback, 2Fik, Jay Wegman, Zvonimir Dobrović,
 and others.

5 Queer Nation, "Queers Read This (Queer Nation Manifesto),"
 flier, 1990, Web.

6 "Summer Intensive," *The Shandaken Project*, Web.
 "The participants in the Shandaken Project's Summer
 Intensive: Chris Bogia, Katherine Brewer Ball,
 Zanna Gilbert, Jonah Groeneboer, Gordon Hall, Sara
 Magenheimer, Christopher Stiegler. This program will be
 guided by the question: How can artists and organizations
 maintain relational subject-positions while producing
 culture in our current historical moment?"

7 "About," *The Shandaken Project*, Web. The Shandaken
 Project values process over product in a free retreat for
 those who "assault the classic lines drawn around
 discrete disciplines."

8 "About QAM," *Queer/Art/Mentorship*, Web.

9 Xeňa Stanislavovna Semjonová, email to the author, September 18, 2014.

10 Danielle Linzer, "Signs of the Times: All Gender Restrooms at the Whitney," *Whitney Museum of American Art*, April 18, 2014, Web.

11 "Archive," Center for Experimental Lectures, Web. Previous lecturers include Anthony Elms, Edie Fake, Andy Roche, Math Bass, Travis Boyer, Alexis Blair Penney, Jamillah James, Christine Sun Kim, Eugenie Tsai, Tom Finkelpearl, Jesse Prinz, Corrine Fitzpatrick, Stephen Lichty, R. Lyon, Marc Handelman, Sophia Cleary, Chris Domenick, Alhena Katsof, Christoph Cox, Sergei Tcherepnin, Zoe Leonard, Susan Howe, Amy Sillman, Lizzie Feidelson, and Katherine Hubbard.

12 Trish Salah, email to the author, Rachel Pollack, and Stephanie Young, planning the "Trans Lit Now" talk at Mills College, February 17, 2015. Trish also spoke on the panel about her work in the Decolonizing and Decriminalizing Trans Genres conference at University of Winnipeg in February 2015.

13 Zoe Tuck, email to the author and Trish Salah, March 15, 2015.

14 Trans People of Color Coalition and Human Rights Campaign, *Addressing Anti-Transgender Violence: Exploring Realities, Challenges and Solutions for Policymakers and Community Advocates*, 2015, Web. "Among the 53 known transgender victims from 2013 to 2015, at least 46 were transgender people of color. At least 46 were transgender women. 39 were under the age of 35 at the time of their deaths." This report provides an incomplete list of "only the known victims" and does not include the victims of "countless hate crimes." The Anti-Violence Project (avp.org)

provides community alerts, fact sheets, reports, and press releases about LGBTQ and HIV-Affected Hate Violence. The Anti-Violence Project resources are indispensable, especially when the police and press often misname and misgender victims of hate violence.

15 Sylvia Rivera, "Y'all better quiet down!"(1973), *vimeo*, 4:07, uploaded by Tourmaline.

16 Dean Spade, *Normal Life: Administrative Violence, Critical Trans Politics and the Limits of Law* (Brooklyn: South End Press, 2011), 107.

17 *Heresies #3, Lesbian Art and Artists* 1, no. 3 (1977): 3.

18 Alex Fiahlo, "Fire Island Artist Residency Comes into Its Own, Pt 2," *ARTFCITY*, August 28, 2012, Web.

19 Michael H. Miller, "Ghosts in the Sex Forest: The First LGBT Artist Residency Makes a Home on Fire Island," *The New York Observer*, December 6, 2011, Web.

20 Aleksandra Mir, "Homophobic: Christian Holstad Talks to Aleksandra Mir," in *Collage: The Unmonumental Picture*, ed. Richard Flood, Massimiliano Gioni, and Laura Hoptman (New York: The New Museum, 2007), 46-55.

21 Suzanne Stein and David Brazil invited me to read in the Berkeley Art Museum / Pacific Film Archive (BAM/PFA) RE@DS series on March 16, 2012.

22 Siobhan B. Somerville, *Queering the Color Line: Race and the Invention of Homosexuality in American Culture* (Durham: Duke University Press, 2000), 131-2.

23 "rAdIcAl prEsEncE: BLACK PERFORMANCE IN CONTEMPORARY ART," *Radical Presence NY*, Web. This exhibition was presented in two parts: Part I at New York

University's Grey Art Gallery (September 10 - December 7, 2013) and Part II at The Studio Museum in Harlem (November 14, 2013 - March 9, 2014).

24 Robin Cembalest, "Adrian Piper Pulls Out of Black Performance-Art Show," *ARTnews*, October 25, 2013, Web.

25 Cassie Peterson, "The Failed Firebird," *Self & Other: The Politics of Power. The Architecture of Resistance. The Aesthetics of Emptiness. And Other Discursive InQUEERies…,* May 21, 2013, Web.

26 Jill Johnston, *Lesbian Nation: The Feminist Solution* (New York: Simon and Schuster, 1974), 105.

27 José Esteban Muñoz, *Cruising Utopia: The Then and There of Queer Futurity* (New York: NYU Press, 2009), 116.

28 Ibid., 115.

29 Ibid., 122.

30 "About," *n/a*, Web.

31 O. Stevens, *Black Noise: The Conscious Babble of O. Stevens* (Oakland: Black Noise Press, 2012), 8.

1 Tisa Bryant, "The Curator," in Belladonna* Elders Series #3 (Brooklyn: Belladonna*, 2009), 21.

2 Gail Scott, *My Paris* (Mclean: Dalkey Archive Press, 2003), 9.

3 Kaplan Harris, "Avant-Garde Interrupted: A New Narrative after AIDS," *Contemporary Literature 52*, no. 4 (2011): 630-57. Harris attributes New Narrative's obscurity to just how radical Bruce Boone and Steve Abbott were as political dissidents; academia thought it too risky to read their work. Harris also points out how the deaths and grieving from AIDS derailed literary production. Rob Halpern, "Realism and Utopia: Sex, Writing, and Activism in New Narrative," *Journal of Narrative Theory 41*, no. 1 (2011): 82-124. Halpern also offers a great resource on Boone, specifically how he wrote critical work on Frank O'Hara, highlighting the gay content, while other critics would avoid mention of that content.

4 Camille Roy, introduction to *Biting the Error*, ed. Mary Burger, Robert Glück, Camille Roy, and Gail Scott (Toronto: Coach House Books, 2004), 8.

5 Audre Lorde, *Zami: A New Spelling of My Name* (Berkeley: Crossing Press, 1982), 108.

6 Alexis De Veaux, *Warrior Poet: A Biography of Audre Lorde* (New York: W. W. Norton & Company, 2004), xiv.

7 Robert Glück, "Long Note on New Narrative," in *Biting the Error* (Toronto: Coach House Books, 2004), 34.

8 James Baldwin, "Everybody's Protest Novel," in *Notes of a Native Son* (Boston: Beacon Press, 1955), 19.

9 De Veaux, 139.

10 Ibid., 187.

11 Kaplan Harris, "The Small Press Traffic school of dissimulation: New Narrative, New Sentence, New Left," *Jacket2*, Web. There are plenty of exceptions to my crass overgeneralization about Language Poetry, notably the oeuvres of Lyn Hejinian, Carla Harryman, and Steve Benson. I remain committed to this overgeneralization for the sake of depicting how "Langpo" *seems* in my mind. Harris: "At its most rudimentary this [Language] poetry was intended to explore the materialism of language by disrupting signification, syntax, and grammatical structure, thus resurrecting a space for agency outside the contractual powers of normative communication. Although New Narrative writers were invested in a queer future that can hardly be called normative, their reliance on narrative techniques identified with realism resulted in an impasse with language-centered poetics." Harris's essay "New Narrative and the Making of Language Poetry," *American Literature 81,* no. 4, December 2009 also covers the overlaps of these two literary movements.

12 *Encyclopedia of the New York School Poets* (New York: Facts On File, 2009), 482.

13 Ibid.

14 Lorenzo Thomas, "The Shadow World: New York's Umbra Workshop & Origins of the Black Arts Movement," *Callaloo* no. 4 (1978): 54.

15 Combahee River Collective, "The Combahee River Collective Statement," *Circuitous*, Web.

16 Cheryl Clarke, *"After Mecca": Women Poets and the Black Arts Movement* (New Brunswick: Rutgers University Press, 2005), 12.

17 Ibid., 17.

18 Ibid., 1.

19 Ibid., 128.

20 Ibid., 48.

21 Maggie Nelson, *Women, the New York School, and Other True Abstractions* (Iowa City: University of Iowa Press, 2007), xvii.

22 Ibid., xvi. Nelson quoting Claudia Rankine and Allison Cummings, "Afterward and Conception," published in *Fence Magazine*, Spring-Summer 2000, 125-26. Nelson also cites Alice Notley in conversation with Judith Goldman on the topic.

23 Ibid., xvi.

24 Ibid., xix.

25 Urayoán Noel, *In Visible Movement: Nuyorican Poetry From the Sixties to Slam* (Iowa City: University of Iowa Press, 2014), 2.

26 Ibid.

27 Duriel E. Harris, Dawn Lundy Martin, Ronaldo V. Wilson, "A Call for Dissonance" in *A Best of Fence, The First 9 Years*, ed. Rebecca Wolff, Caroline Crumpacker, Katy Lederer, Frances Richard, Matthew Rohrer, Christopher Stackhouse, Max Winter, and Jason Zuzga (Albany: Fence Books, 2009), 132.

28 Ibid.

29 Ibid., 133.

30 Ibid.

31 Duriel E. Harris: *Drag* (2003), *Amnesiac: Poems* (2010); Dawn Lundy Martin: *A Gathering of Matter / A Matter of Gathering* (2007), *Discipline* (2011), *Life in a Box is a Pretty Life* (2014); Ronaldo V. Wilson: *Poems of the Black Object* (2009), *Narrative of the Life of the Brown Boy and the White Man* (2008), *Farther Traveler* (2015).

32 The Feminist Art Program was born in 1970 at Fresno State University and soon migrated, with Miriam Schapiro as its co-director, to CalArts.

33 *!Women Art Revolution*, dir. Lynn Hershman Leeson (Zeitgeist Films, 2010), video.

34 "Franklin Furnace: on a mission to make the world safe for avant-garde art," *Franklin Furnace*, Web.

35 Larry Neal, "The Black Arts Movement," *The Drama Review: TDR 12*, No. 4, Black Theatre (Summer 1968): 28.

36 Lisa Gail Collins, "The Art of Transformation: Parallels in the Black Arts and Feminist Art Movements," in *New Thoughts on the Black Arts Movement* (New Brunswick: Rutgers University Press, 2006), 281.

37 Dwight A. McBride, "Straight Black Studies" in *Black Queer Studies: A Critical Anthology*, ed. E. Patrick Johnson and Mae G. Henderson (Durham: Duke University Press, 2005), 72. James Baldwin quoted in Karen Thorsen's 1989 documentary *James Baldwin: The Price of the Ticket.*

38 Chris Vargas and Greg Youmans, "Work of Art! Reality TV Special," *Falling in Love…With Chris and Greg*, video, 13:47. 2012, Web.

39 Vargas and Youmans's "new challenge" mocks the now common cultural trope championed by Jack Halberstam in his book *The Queer Art of Failure* (Durham: Duke University Press, 2011).

40 Steve Benson, *The Grand Piano Part 6* (Berkeley: Mode A), 25.

41 Kobena Mercer and Isaac Julien, "True Confessions," *Black Male*, ed. Thelma Golden (Whitney Museum of American Art, Harry N. Abrams, Inc., New York, 1994), 192. Originally published in *Ten. 8,* no. 22 (Summer 1986).

42 Ibid.

43 Urvashi Vaid, *Virtual Equality: The Mainstreaming of Gay & Lesbian Liberation* (New York: Anchor Books, Doubleday, 1995), 243.

44 Ibid., 245.

45 Glück, "Long Note on New Narrative," 26.

46 Benson, *The Grand Piano Part 6*, 24.

47 D'Allesandro, *The Wild Creatures,* 15. In the introduction Kevin Killian writes, "Bob Glück, Bruce Boone, Dodie Bellamy, Steve Abbott, Carla Harryman, Francesca Rosa, Marsha Campbell, Camille Roy, and a bit afield Kathy Acker, Dennis Cooper, Brad Gooch, and many others. We were all in this 'thing' together." Michael Amnasan is another name that pops up when lists of names are recited of New Narrative writers.

48 The other paper titles at The Non-State(s) of Queer Theory included: Horace D. Ballard, Jr.'s "Post Romantic Ekphrasis: The Queer Art of Time," Katherine Cooper's "Presence, Dependency and Humor in Dawn Kasper's 'This Could Be Something if I Let It,'" Dudgrick Bevins' "Trans National

Cartooning: Transgender Narratives in Sequential Art from Home and Abroad," Joseph Russo's "The Utility of Faggotry: Queer 'Expertise' & Caricature," Pia Sahni's "'No Life Without Wife': Diasporic Heteronormativity and the Good Indian in Gurinda Chadha's *Bride and Prejudice,*" Timothy Griffiths "Queer, Black Politics, Queer Black Communities; Samuel Delaney's Utopia," Micah Salkind's "'Is it all over my face?' Intersectional Diasporas at Chicago's Old School Reunion Picnic."

49 Dodie Bellamy and Kevin Killian are editing a New Narrative anthology forthcoming from Nightboat Books in 2017. ON Contemporary Poetics is collecting essays and interviews on New Narrative, ed. Robin Tremblay-McGaw and Rob Halpern, who initially prompted this chapter. Kaplan Harris is writing a book tentatively titled "The Age of Activism." Dianne Chisholm in *Queer Constellations: Subcultural Space in the Wake of the City* (2004) writes on Gail Scott, Bob Glück, Sarah Schulman, Eileen Myles, and others.

50 Boone weighed in on *Fairyland* via the comment section of an amazon review with "a couple of bones to pick" about the title's insensitivity of punning on a slur towards gay men. Boone reflects on Terry Gross's Fresh Air interview with Alysia that exposed her selfishness, particularly when her father was sick and asked her to return home from college and she delayed her return.

51 See Bill Weber and David Weissman's 2002 documentary *The Cockettes* on a psychedelic theater group from the 60s & 70s in San Francisco.

52 Hal Fischer, *Gay Semiotics* (San Francisco: NFS Press, 1977).

53 Alysia Abbott, *Fairyland: A Memoir of My Father* (New York: W. W. Norton & Company, 2013), 151.

54 Ibid., 158.

55 Ibid., 150.

56 Kathy Lou Schultz, *Some Vague Wife* (Berkeley: Atelos, 2002), 54.

57 Ibid., 317.

58 Steve Benson, email to the author, February 23, 2014.

59 Steve Abbott, "Notes on Boundaries, New Narrative," *SOUP*, 1985, 81. "New Narrative shatters linearity, proceeds by flashes, enigmas, and yields to a florid crying-out theme of suffering-horror."

60 *Left Write! Edited Transcripts of 1981 Left Write Conference,* ed. Steve Abbott (San Francisco: The Conference Steering Committee, 1982).

61 Ibid.

62 Dia Felix, email to the author, May 27, 2013.

DETOUR SYSTEMS

1 Akilah Oliver, *A Toast in the House of Friends* (Minneapolis: Coffee House Press, 2009), 87.

2 Audre Lorde, *Undersong: Chosen Poems, Old and New, Revised Edition* (New York: W.W. Norton, 1992), 135.

3 Renee Gladman, "See Future Issues," *Clamour 4* (Spring 1999): 5.

4 Ibid.

5 Ibid., 6.

6 Ibid.

7 Renee Gladman, "Language and Landscape: Renee Gladman by Zack Friedman," *BOMB - Artists in Conversation*, December 24, 2011, Web.

8 Ibid.

9 Ami Mattison to Renee Gladman, November 21, 1994, *Clamour 1* (Fall 1996): 49.

10 Ibid.

11 Ibid.

12 Ibid., 50.

13 Rebecca de Guzman to Renee Gladman, December 3, 1997, *Clamour 3* (Winter 1998): 73.

14 Ibid.

15 Pamela Lu, "Report IV," *Clamour 4* (Spring 1999): 75.

16 Ibid., 76.

17 Pamela Lu, *Ambient Parking Lot* (Chicago: Kenning Editions, 2011), 146.

18 Ibid., 45.

19 Fernando Martí, "The Mission District—A History of Resistance for the Mission Anti-Displacement Coalition, Aquí Estamos y No Nos Vamos! 230 Years of Resistencia en la Misión," December 2006, Web. Martí charts the Mission District's changing populations and their resistance to displacement. His history begins with the Ohlone people in 1776, and continues to detail historical events and shifts in the neighborhood including: the Mexican-American War and the Treaty of Guadalupe-Hidalgo, which made vulnerable the Mexican land-grant ranchos in the Mission; the industrial workers of the Gold Rush; the mid to late 20th-century arrival of Nicaraguenses, Salvadoreños, and Guatemaltecos; to the creation of the Coalition for Jobs, Arts, and Housing that formed in the 90s; and the Mission Anti-Displacement Coalition that formed in 2000.

20 Tisa Bryant, "Amnesia," *Clamour 4*, (Spring 1999), 73.

21 Bryant, email to the author, February 22, 2016.

22 Alissa Figueroa and Deia De Brito, "Last Call for the 26-Valencia," *Mission Local*, December 4, 2009, Web.

23 Kurtis Alexander, "Tech buses blocked, vandalized in protests," *SFGate*, December 20, 2013, Web.

24 Gladman, "See Future Issues," 5.

25 "HOW(ever) Archives," *How2 Journal*, founded and edited by Kathleen Fraser from 1983 to 1992 with guest, associate and contributing editors: Frances Jaffer, Beverly Dahlen,

Rachel Blau DuPlessis, Carolyn Burke, Susan Gevirtz, Chris Tysh, Diane Glancy, Adalaide Morris, Myung Mi Kim, and Meredith Stricker.

Narrativity, ed. Mary Burger, Robert Glück, Camille Roy, and Gail Scott. *Narrativity* was a web journal on a backchannel of San Francisco State University's website.

"About Tuumba," ed. Lyn Hejinian from 1976 to 1984, *Duration Press*, Web.

"Chain," ed. Jena Osman and Juliana Spahr from 1994 to 2005, *Jacket2 Reissues*, Web.

26 Steve Abbott, "Remarks/Hello," *SOUP 1* (1980), 1.

27 Rachel Levitsky, "The Continued Adventures of Yaya and Grace: One Disaster at a Time," ed. Renee Gladman, *Clamour 4* (Spring 1999): 21-35.

28 Leroy chapbook titles: Rachel Levitsky, *Cartographies of Error*; Roberto Tejada, *Gift & Verdict*; Summi Kaipa, *The Epics*; Hoa Nguyen, *Parrot Drum*; Taylor Brady, *33549*; Bhanu Kapil, *Autobiography of a Cyborg*; C.S. Giscombe, *inland*; Linh Dinh, *a small triumph over lassitude*; Deborah Richards, *Parable*; Camille Roy, *Cheap Speech.*

29 Leon Works titles: Hans Faverey, *Chrysanthemums, Rowers*; Bhanu Kapil, *Incubation: A Space for Monsters*; Mary Burger, *Sonny*; Tisa Bryant, *Unexplained Presence*; Melissa Buzzeo, *What Began Us*; Fred Moten, *Hughson's Tavern.*

30 "About Us," *Belladonna**, Web. "A reading series and independent press that promotes the work of women writers who are adventurous, experimental, politically involved, multi-form, multicultural, multi-gendered, impossible to define, delicious to talk about, unpredictable, and dangerous

with language. Belladonna* was founded as a reading and salon series by Rachel Levitsky at Bluestockings Bookstore on New York City's Lower East Side in 1999. In 2000, in collaboration with Boog Literature, Belladonna* began to publish commemorative 'chaplets' of the readers' work. erica kaufman joined Levitsky as co-curator/editor in 2002. Then in 2005, the series moved its events to the downtown performance venue, Dixon Place. Since 2010, the group has operated as the Belladonna* Collaborative, a ten-person editorial board. At the time of writing, the bulk of the group's NYC activity was organized by Krystal Languell and Saretta Morgan."

31 "Social Reading," *Jacket2*, Web. "Ariel Goldberg and Rachel Levitsky are having conversations about writing that has some urgency to it. This project digs into the political and aesthetic necessity in corresponding on what might be called subaltern, queer, prose, hybrid, or unpublished writing. From 2013 to 2014, we wrote on Syd Staiti, Cheena Marie Lo, Julie Patton, HR Hegnauer, Jake Pam Dick, and Moyra Davey."

32 "About," *Encyclopedia Project*, Web. "A groundbreaking literary and visual experience in three volumes, spanning A-Z, featuring experimental prose and visual art by hundreds of contributors. Each volume is a hybrid of the reference book, literary journal, and art book."

33 Pamela Lu, "Idiom," *HOW2*, Web. "Due to lack of funds, and years of overly ambitious print projects, *Idiom* switched to the then-new frontier of web publishing."

34 Pamela Lu, email to the author, January 14, 2015.

35 Gladman, "Arlem" in *An Anthology of New (American) Poets,* ed. Lisa Jarnot, Leonard Schwartz, and Chris Stroffolino (Jersey City: Talisman House, 1998), 76.

36 Jonathan D. Katz, "Queering Art Discourses," *We Who Feel Differently,* ed. Carlos Motta and Cristina Motta (Oslo: Ctrl+Z Publishing, 2011), 77.

37 Ibid.

38 Ibid.

39 Risa Puleo, "The F Word: Queering Formalism," in *Lisi Raskin: Mobile Observation* (Milan: Galleria Riccardo Crespi, 2010).

40 Renee Gladman, *The Activist* (San Francisco: Krupskaya, 2003), 80.

41 Ibid., 79.

42 "About," *We Who Feel Differently,* Web.

QUOTATION CLOCKS

1 Minnie Bruce Pratt, *We Say We Love Each Other* (San Francisco: Other Spinsters Ink, 1985), 5.

2 Renee Gladman, "Arlem" in *An Anthology of New (American) Poets*, ed. Lisa Jarnot, Leonard Schwartz, and Chris Stroffolino (Jersey City: Talisman House, 1998), 71.

3 Urvashi Vaid and Dean Spade, "You Gotta Serve Somebody," Lecture, Center for Lesbian and Gay Studies (CLAGS) at City University of New York, the Graduate Center, March 22, 2013.

4 Rosamond S. King, "You Gotta Serve Somebody: Rethinking Race, Queer Politics, and Practice," YouTube video, 1:58:54, posted by "The Center for Lesbian and Gay Studies," July 24, 2013.

5 The Transgender Youth Support Network in Minnesota created the Free CeCe campaign which inspired an international community of activists to fight for CeCe McDonald's release. Laverne Cox and Jacqueline Gares are making the documentary *Free CeCe!* to tell her story and bring attention to the violence transwomen of color face everyday in this country.

6 "I Use My Love to Guide Me," Barnard Center for Research on Women, April 21, 2013, The New School, New York. "This event was part of the series No One is Disposable, which features conversations on trans activism and prison abolition with BCRW activist fellow Tourmaline. Co-sponsored by the Barnard Center for Research on Women, the Office of Social Justice Initiatives at The New School, the Sylvia Rivera Law Project, the Center for the Study of Gender and Sexuality at NYU, the Center for Gender and Sexuality Law at Columbia Law School, and the Transgender Youth Support Network."

7 Cece McDonald, "Foreword," *Captive Genders: Trans Embodiment and the Prison Industrial Complex, Expanded Second Edition,* ed. Eric A. Stanley and Nat Smith (Oakland: AK Press, 2015), 1. McDonald expands on what she read while in prison: "I began reading books about revolutionary politics, like the autobiographies of Assata Shakur and Huey P. Newton, Angela Davis's *Are Prisons Obsolete?,* and the first edition of *Captive Genders.* It was here that I learned about Miss Major, who helped lead the Stonewall Uprising, and how strong women of color like her were kicked out of the official story by transphobia, racism, sexism, and so many other things that dull the light of our intellectual past."

8 Cece McDonald, "I Use My Love to Guide Me," Barnard Center for Research on Women, April 21, 2013, The New School, New York.

9 Cherríe Moraga, "La Güera" in *This Bridge Called My Back: Writings by Radical Women of Color* (New York: Kitchen Table Women of Color Press, 1981), 28-32.

10 Tisa Bryant, "Autodidact," in *Encyclopedia Volume I, A–E* (Providence: Encyclomedia, 2006), 66.

11 Teresa de Lauretis, "Queer Theory. Lesbian and Gay Sexualities: An Introduction," *Differences: A Journal of Feminist Cultural Studies 3,* no. 2 (Summer 1991): iii-xviii. De Lauretis's Introduction is cited as one moment when "queer theory" was born in print. The journal was based on papers given at a conference "Theorizing Lesbian and Gay Sexualities" in 1990 at University of California, Santa Cruz.

12 Michael Hames-García, "Queer Theory Revisited," in *Gay Latino Studies: A Critical Reader* (Durham: Duke University Press, 2011), 25.

13 Hiram Perez, "You Can Have My Brown Body and Eat It, Too!," *Social Text* 23, nos. 3-4 (Fall-Winter 2005): 175-179.

14 "Dance Discourse Project #167: 18: 2013," mp3, 1:36:53, from a CounterPULSE discussion, posted July 18, 2013, Web.

15 Eunsong Kim and Don Mee Choi, "Refusal=Intervention: 'Asian American Poetry' is not a manageable category—it is not a list," "The Margins," March 7, 2014, *Asian American Writers' Workshop*, Web. Kim & Choi write: "We want more reading of Asian American, Chicano, Latino, Black, Native, Arab American, Queer, trans poetics—and we will continue to contest the convenience of list making, the violence of white knowledge production, and the management of Othering. The Poetry Foundation is a space that has much catching up to do—and we ask that it catches up without putting us through its imperial timeline, gaze."

16 Caitie Moore, "Reading Race," panel presentation, Thinking Its Presence: Race and Creative Writing, University of Montana, Missoula, MT, April 10-12, 2014.

17 Josef Kaplan, *All Nightmare* (Brooklyn: Ugly Duckling Presse, 2014), 36.

18 Steven Zultanski, co-curator with Kaplan in this Segue series, describes Kaplan's introductions in the chapbook's preface as "occasionally mildly insulting to the reader" and "distractingly bombastic," tacitly condoning Kaplan's racism. Another assault in Kaplan's cheap spectacle ridden poetics is his poem "How I Think It Happens" where he details absurdist, abject, violent, and grotesque sex scenes between lesbians, repeating the word lesbian with many bad adjectives, for both their offensiveness and intentional lack of craft. Read at The Poetry Project on December 10, 2012.

19 Harmony Holiday, *Negro League Baseball* (Albany: Fence Books, 2011), 88.

20 Ibid.

21 Ibid.

22 Ibid.

23 "Harmony Holiday," mp3, 20:20, audio recording from Segue at Zinc Bar, NYC, January 26, 2013, PennSound.

24 Ibid.

25 "Segue Reading Series Archive: Winter/Spring 2013," The Segue Foundation, Dana Ward & Evan Kennedy; Nada Gordon & Dia Felix; Steve Benson & Teresa Carmody; Fred Moten & Tonya Foster; Lisa Robertson & E. Tracy Grinnell; Susan Gevirtz & Trish Salah; Leopoldine Core & Ted Rees; Fiona Templeton & Syd Staiti.

26 The March 23, 2013 BLT salon was guest-curated by Caitie Moore & Nalini Abhiraman.

27 Email interview with Natalie Peart and Montana Ray, June 16, 2015.

28 Simone White, "Flibbertigibbet in a White Room / Competencies," *Harriet*, April 16, 2014, Web.

29 Ibid.

30 Ibid.

31 Simone White, "Hey, erica kaufman! (Part I)," *Harriet*, May 1, 2014, Web.

32 "Dirty Looks on Location," *Dirty Looks*, "Programs," Web.

33 Cheryl Dunye, *Lavender Limelight: Lesbians in Film*. dir. Marc Mauceri (First Run Features, 1997).

34 Jackie Wang, "Against Innocence," *LIES: A Journal of Materialist Feminism* I (2012): 146.

1 Leslie Feinberg, *Stone Butch Blues* (Ithaca: Firebrand Books, 1993), 239.

2 Rachel Levitsky, "The Continued Adventures of Yaya and Grace: One Disaster at a Time," ed. Renee Gladman, *Clamour 4* (San Francisco: 1999), 21-35.

3 Douglas Crimp and Adam Rolston, *AIDS Demographics (*Seattle: Bay Press 1990), 14-15.

4 "ACT UP - Silence = Death Tee," Opening Ceremony, Web.

5 Zoe Leonard, "Muscle Memory," *Coming After: Queer Time, Arriving Too Late and the Spectre of the Recent Past* (Toronto: The Power Plant, 2012), 67.

6 Jon Davies, "A Proposal by Jon Davies," *Independent Curators International*, 2010, Web.

7 Ted Kerr, "Introduction to *Time Is Not a Line: Conversations, Essays, and Images about HIV/AIDS* Now," *We Who Feel Differently* 3 (2014), Web. In this issue: Xaviera Simmons, Pato Hebert in conversation with Cyd Nova, Aimar Arriola, Kenyon Farrow, Nathan Lee and Carlos Motta, and Bryn Kelly.

8 Ibid.

9 Ibid.

10 "ACT UP Oral History Project," *ACT UP Oral History Project*, Web; *United In Anger,* dir. Jim Hubbard (Pittsburgh: Andy Warhol Foundation for the Visual Arts Inc., 2012), video; *Sex Positive*, dir. Daryl Wein (Los Angeles: Regent Releasing, 2008), video; *We Were Here*, dir. David Weissman (San Francisco: The Film Collaborative, 2011), video; "AIDS in New York: The First Five Years," New York Historical

Society Museum and Library, June 7 - September 15, 2013; "ACT UP New York: Activism, Art, and the AIDS Crisis, 1987–1993," Carpenter Center for the Visual Arts, Cambridge, MA, October 15 - December 23, 2009.

11 Essex Hemphill, *Ceremonies: Prose and Poetry* (San Francisco: Cleis Press, 1992), 121.

12 Corrine Fitzpatrick hosted my talk on *The Estrangement Principle* in November 2012 at The Poetry Project.

13 Karen Narefsky, "Remember Me As a Revolutionary Communist," *Jacobin*, December 18, 2014, Web.

14 Rauan Klassnik, "Alex Dimitrov: 'It's My Book,'" HTMLGIANT, September 5, 2013, Web.

15 Ted Rees, Letter to Alex Dimitrov, 2013, used with permission; Rees, *Outlaws Drift in Every Vehicle of Thought* (Oakland: Trafficker Press, 2013).

16 Jameson Fitzpatrick, "Anne Sexton, Aesthetics, and the Economy of Beauty," *Lambda Literary,* May 23, 2012, Web; Saeed Jones, "All the Pretty Ones," *Lambda Literary,* May 24, 2012, Web; Lucas de Lima, "On Beauty, Excess, and the Limits of Identity Politics in Lambda and Beyond," *Montevidayo,* May 26, 2012, Web; Collin Kelley, "The Folly of cliques, beauty & comparisons," *Collin Kelley: Modern Confessional,* May 24, 2012, Web; Steve Fellner, "On Jameson Fitzpatrick, Eduardo C. Corral, Alex Dimitrov, and the Lambda Literary Review," *Pansy Poetics,* May 24, 2012, Web.

17 Eileen Myles, *Inferno (A Poet's Novel)* (New York: OR Books, 2010), 191.

18 Patrick Huguenin, "The Wilde Boys Salon, for Poetry or Maybe a Hot Date," *The New York Times,* November 2, 2011.

19 Charles Long, Nancy Brooks Brody, and Pato Hebert,
 moderated by Todd Lester, "But Does It Matter,"
 discussion in conjunction with the exhibition "NOT
 OVER, 25 Years of Visual AIDS," curated by Kris Nuzzi
 and Sur Rodney (Sur), La MaMa Galleria, New York, NY,
 June 1 - 20, 2013.

20 "Art. AIDS. Action.," *Visual AIDS*, "About," Web. Visual
 AIDS' official mission is to "[utilize] art to fight AIDS by
 provoking dialogue, supporting HIV+ artists, and preserving
 a legacy, because AIDS is not over."

21 Pato Hebert, in conversation with Cyd Nova, "A Wedge
 Holding Open a Very Small Window," *We Who Feel
 Differently*, no. 3 (2014), Web.

22 Peter Cramer and Jack Waters, *Short Memory/No History*,
 "NOT OVER," La MaMa Galleria, New York, 2013.

23 Jack Waters "MOUTHPIECES: Permutations of the Queer
 Press," *Short Memory/No History* (2001), 3.

24 Ibid., 5. Waters notes "the August/September 2000 issue
 of *HIV Plus* marked a change in the magazine's focus. The
 cover logo added the word 'life' to the previous 'research +
 treatment' slogan."

25 Ibid., 9.

26 Ibid., 13.

27 Peter Cramer and Jack Waters in discussion with the author,
 June 3, 2015.

28 "History," *Allied Productions, Inc.*, Web.

29 The first installation of "Short Memory/No History" was
 hosted by the Shedhalle gallery in Zurich, Switzerland in

2000, for the show "Critical Art Practices." "Short Memory/ No History" was also a video installation "We Remember" in NYC's Donnell Library windows.

30 Peter Cramer and Jack Waters in discussion with the author, June 3, 2015.

31 Inter-spliced between interviews is footage from Cheap Art, Testing the Limits, ACT UP, and Gran Fury.

32 Peter Cramer and Jack Waters in discussion with the author, June 3, 2015.

33 Thelma Golden, *Freestyle* (New York: Studio Museum in Harlem, 2001), 14.

34 Ibid.

35 Ibid., 15.

36 Waters, "MOUTHPIECES," 9.

37 William J. Simmons, "Notes on Queer Formalism," *Big Red & Shiny* 15, no. 2 (2013), Web.

38 Gordon Hall in "Object Lessons," *Art Journal 72*, no. 4 (Winter 2013): 47-57. Hall problematizes "queer formalism" or the labeling of art as queer as "the glitter problem." For more on "queer formalism" see William J. Simmons, "Taxi Ride to Gauguin: An Interview with Amy Sillman & Nicole Eisenman," *Haunt* 1, no. 1 (2014): 32-35 and "Queer Formalisms: Jennifer Doyle and David Getsy in Conversation," *Art Journal* 72, no. 4 (Winter 2013): 32-35.

39 "if they were alive today they could tell you about getting arrested at City Hall if she were alive today you'd be so her type if he were alive today she would have finished writing that book if he were alive today he would have you on your

knees if he were alive today you'd still be arguing about that
if he were alive today he'd still be living with AIDS if they
were alive today they'd be outside smoking if he were alive
today he'd be going dancing later if he were alive today you'd
still be sharing an office if she were alive today she'd never
let you get away with that if she were alive today maybe she'd
have a gallery by now if he were alive today he'd have his arm
around you if she were alive today she still wouldn't have
health insurance if she were alive today she'd know exactly
what to say if he were alive today he'd laugh at that if he were
alive today he'd be in this picture." fierce pussy *For the Record*
flier and newsprint pamphlet.

40 Cathy Busby, *Steve's Vinyl* (Vancouver: Emily Carr University
 Press, 2014).

41 William Olander curated "Let the Record Show: the Window
 on Broadway by ACT UP" at the New Museum, November
 20, 1987 – January 24, 1988. Olander was also a founder of
 Visual AIDS.

42 Risa Puleo, "The F Word: Queering Formalism," in *Lisi Raskin:
 Mobile Observation* (Milan: Galleria Riccardo Crespi, 2010).

43 *Happy Birthday, Marsha!,* dir. Tourmaline and Sasha
 Wortzel (New York: 2016), video. Cast: Mya Taylor
 (Marsha "Pay it No Mind" Johnson), Eve Lindley (Sylvia
 Rivera), Cherno Biko (Andorra Marks), Rios O'Leary-
 Tagiuri (Bambi L'Amour), Cyrus Grace Dunham (Junior),
 with appearances by Stefanie Rivera, Gabriel Foster, Miss
 Egypt, Jimmy Camicia, Jay Toole, and others. "A film
 about legendary transgender artist and activist Marsha 'Pay
 it No Mind' Johnson and her life in the hours before the
 1969 Stonewall Riots in New York City."

44 *Pier Kids: The Life*, dir. Elegance Bratton (New York: 2016),
 video. "*Pier Kids: The Life* follows the director over the

course of three years as he films three gay and transgender youth of color who have become, like the director once was, homeless on the same street the Gay Rights Movement began so long ago."

45 "Naked Eye Cinema Night," New Museum, August 13, 2013, "Selected Early Works by the Core Makers of Naked Eye Cinema, The Extension of the Film Program at ABC No Rio," *The Film Makers Cooperative*, July 24, 2006. Members of the Naked Eye Cinema group include Peter Cramer, Leslie Lowe, Jack Waters, Bradley Eros, Aline Mare, Carl George, and Kembra Pfahler.

46 "About MIX," MIX NYC, Web.

TO ACT THE INSTANT

1 Pamela Lu, *Pamela: A Novel* (Berkeley: Atelos, 1998), 48.

2 Eileen Myles, *Chelsea Girls* (Santa Rosa: Black Sparrow Press, 1994), 23.

3 Peter Hujar, *Peter Hujar: Essays by Stephen Koch and Thomas Sokolowski. Interviews with Fran Lebowitz and Vince Aletti* (New York: Grey Art Gallery & Study Center, New York University, 1990), 23.

4 *Public Speaking*, dir. Martin Scorsese (New York: HBO, 2010), 80:00.

5 Joshua Gamson, "Must Identity Movements Self Destruct? A Queer Dilemma," *Social Problems* 42, no. 3 (1995): 398, 401.

6 David Wojnarowicz, *Close to the Knives: A Memoir of Disintegration* (New York: Vintage Books, 1991), 138-9.

7 *Wildness*, dir. Wu Tsang (Los Angeles: Class Productions and Now Unlimited, 2012), 72:00.

8 Catherine Opie, *Andrea Bowers & Catherine Opie (Between Artists)* (Los Angeles: A.R.T. Press, 2008), 36.

9 Dennis Altman, *The Homosexualization of America* (Boston: Beacon Press, 1983), 224.

10 Charles Isherwood, "Beneath Pink Parasols, Identity in Stark Form," *The New York Times*, January 16, 2012, Web. The review in question was for Young Jean Lee's *Untitled Feminist Show*.

11 Sarah Schulman, *The Sophie Horowitz Story* (Tallahassee: The Naiad Press, 1984), 108.

12 Ibid., 31.

13 Ibid., 35.

14 Ibid., 48.

15 Sarah Schulman, *The Gentrification of the Mind: Witness to
 a Lost Imagination* (Berkeley: University of California Press,
 2012), 6-7.

16 Ibid., 7.

17 Sarah Schulman, *Israel/Palestine & The Queer International*
 (Durham: Duke University Press, 2012), 24. "John [Greyson]
 belongs to a category of gay and lesbian artist that I call
 'credible.' By this I mean that they have consistently produced
 artistically engaged work with authentic queer content *and*
 that they treat other openly gay thinkers and artists with a
 recognition and respect denied them by the straight world."

18 Schulman, *Gentrification*, 9.

19 Ibid., 11.

20 Sarah Schulman, *My American History: Lesbian and Gay Life
 During the Reagan/Bush Years* (New York: Routledge, 1994).

21 Sarah Schulman, email to the author, June 14, 2015.
 Schulman confirmed her Germaine Covington character
 is loosely based on Bernardine Dohrn. Laura Wolfe's
 character is loosely based on Eve Rosahn's case and the
 gestalt of a peripheral group of radical feminist activists
 Schulman imagined to be gay who she would see around
 the East Village, usually at Veselka.

22 The artist who goes by the name JR conceptualized this image
 of Eric Garner's eyes.

23 To name a few other important grassroots organizations for racial justice: Millennial Activists United, Dream Defenders, Malcolm X Grassroots Movement, Million Hoodies for Justice, Hands Up United, Mapping Police Violence, Advancement Project, Black Workers for Justice, and the Black Youth Project.

ACKNOWLEDGEMENTS

At nearly every moment I was writing this book it felt impossible to write this book. Thank you to everyone who has (and will) engage in conversation with me around this ongoing work. I am beyond words with gratitude for all the ways you have helped my thinking grow:

Jess Barbagallo, Amanda Davidson, Sarah Rodigari, Rachel Levitsky, Stacy Szymaszek, Elizabeth Hayes, Carolyn Ferrucci, Stephen Motika, Lindsey Boldt, Adrienne Garbini, Cheena Marie Lo, Susanna Troxler, Sinclair Shigg, Aeliana Nicole Boyer, Lana Povitz, Evan Kennedy, Jay Barksdale, Pamela Lu, Gina Abelkop, Lucas de Lima, Risa Puleo, Karen Lepri, Dia Felix, Sunita Prasad, Laryssa Husiak, Caitlin Rose Sweet, Syd Staiti, Helaine Gawlica, Nico Peck, Chris Giarmo, Steve Benson, Clara Lipfert, Jasmin Risk, Krystal Languell, Caitie Moore, Jocelyn Saidenberg, Camille Roy, Adrienne Skye Roberts, Margaret Tedesco, Peter Cramer, Jack Waters, Eileen Myles, Nicholas Andre Sung, Sarah Schulman, Majida Kargbo, Pier Dominguez, Hannah Buonaguro, Suzanne Stein, David Brazil, Saretta Morgan, Carla Herrera-Prats, ZerJío JonZalés, Irving Dominguez, Miguel Jara, Aranzazu Pola Manríquez, Stephanie Greene, Ella Sutherland, Vivian Crockett, David Hawkins, Corrine Fitzpatrick, Ren Evans, Sy Wagon, Zackary Drucker, Katie Miles, erica kaufman, Kaplan Harris, Amos Mac, Alex DeCarli, Casey Llewellyn, Trish Salah, Zoe Tuck, Trace Peterson, TC Tolbert, Juliana Spahr, Sarah Jaffe, Stephanie Young, Matt Runkle, Ted Rees, Julian Talamantez Brolaski, Christopher Carroll, E. Tracy Grinnell, Masha Gutkin, Paul Mpagi Sepuya, kathryn l. pringle, Erin Morrill, Jen Benka, Carol Mirakove, Erin Wilson, Zoey Kroll, Rhani Lee Remedes, Cedar Sigo, Zachary Lucero, Ian Lewandowski, Reynaldo Mejias, and Darlene Tapia.

ARIEL GOLDBERG's other publications include *The Photographer* and *Picture Cameras.* They have received research fellowships at the New York Public Library's Wertheim Study and Allen Room, a Franklin Furnace Fund grant for a series of slideshow performances, and have been an artist in residence at Headlands Center for the Arts and SOMA in Mexico City. Goldberg is based in New York City and has taught writing at Pratt Institute, Columbia University, and The New School. They have been a curator at The Poetry Project, the Leslie-Lohman Museum of Art, and the Jewish History Museum in Tucson, Arizona. Since publication of *The Estrangement Principle*, Goldberg's writing has appeared in *Afterimage*, *e-flux*, *Artforum* and *Art in America*. They are working on a novel about the intimate worlds of art critic Elizabeth McCausland, photographer Berenice Abbott, and the New York Photo League.

photo by Ian Lewandowski

NIGHTBOAT BOOKS

Nightboat Books, a nonprofit organization, seeks to develop audiences for writers whose work resists convention and transcends boundaries. We publish books rich with poignancy, intelligence, and risk. Please visit our website, www.nightboat.org, to learn about our titles and how you can support our future publications.

The following individuals have supported the publication of this book. We thank them for their generosity and commitment to the mission of Nightboat Books:

Elizabeth Motika
Benjamin Taylor
Anonymous

In addition, this book has been made possible, in part, by grants from The National Endowment for the Arts and The New York State Council on the Arts Literature Program.

ART WORKS.

National Endowment for the Arts
arts.gov